B53 012 824 3

PaintShop Pro X4 for Photographers

PaintShop Pro X4 for Photographers

Ken McMahon

Focal Press is an imprint of Elsevier The Boulevard, Langford Lane, Kidlington, Oxford, OX5 1GB 225 Wyman Street, Waltham, MA 02451, USA

First published 2012

Copyright © 2012 Ken McMahon. Published by Elsevier Ltd. All rights reserved.

The right of Ken McMahon to be identified as the author of this work has been asserted in accordance with the Copyright, Designs and Patents Act 1988.

No part of this publication may be reproduced or transmitted in any form or by any means, electronic or mechanical, including photocopying, recording, or any information storage and retrieval system, without permission in writing from the publisher. Details on how to seek permission, further information about the Publisher's permissions policies and our arrangement with organizations such as the Copyright Clearance Center and the Copyright Licensing Agency, can be found at our website: www.elsevier.com/permissions.

This book and the individual contributions contained in it are protected under copyright by the Publisher (other than as may be noted herein).

Notices

Knowledge and best practice in this field are constantly changing. As new research and experience broaden our understanding, changes in research methods, professional practices, or medical treatment may become necessary.

Practitioners and researchers must always rely on their own experience and knowledge in evaluating and using any information, methods, compounds, or experiments described herein. In using such information or methods they should be mindful of their own safety and the safety of others, including parties for whom they have a professional responsibility.

To the fullest extent of the law, neither the Publisher nor the authors, contributors, or editors, assume any liability for any injury and/or damage to persons or property as a matter of products liability, negligence or otherwise, or from any use or operation of any methods, products, instructions, or ideas contained in the material herein.

British Library Cataloguing in Publication Data

A catalogue record for this book is available from the British Library

Library of Congress Number: 2011943009

ISBN: 978-0-240-52387-3

For information on all Focal Press publications visit our website at www.focalpress.com

Printed and bound in China

12 13 14 15 10 9 8 7 6 5 4 3 2 1

Working together to grow libraries in developing countries

www.elsevier.com | www.bookaid.org | www.sabre.org

ELSEVIER

BOOK AID

Sabre Foundation

ROTHERHAM LIBRARY SERVICE	
B53012824	
Bertrams	21/02/2012
AN	£18.99
BSU	006.686

Contents

n	troduction	xiii
Cł	napter 1: The Basics	1
	What's Covered in this Chapter	1
	Introduction: Basic Tools and Functions	4
	The Manage Workspace	5
	The Adjust Workspace	8
	The Edit Workspace	9
	The Learning Center	10
	The Menu Bar	11
	Toolbars	12
	Photo Toolbar	14
	Effects Toolbar	14
	Script Toolbar	14
	Web Toolbar	15
	Tool Options and Other Palettes	15
	New and Enhanced Features	16
	HDR Tools	16
	Photo Blend	17
	Selective Focus	17
	Vignette	17
	Fill Light/Clarity	18
	Facebook and Flickr Sharing	18
	Camera RAW Lab	18
	Quick Review	18
	Tabbed Workspaces	19
	Nearly New Features	
	Multiphoto Editing	
	Smart Carver	
	Object Extractor	20
	Vibrancy	
	On-Image Text Editing	20
	Raw Format Support	21

Auto-Preserve Originals	21
Layer Styles	21
Visible Watermarks	22
Save for Office and Copy Special	22
Color Changer Tool	22
Skin Smoothing	23
Riff File Format Support	23
Time Machine	23
Film and Filters	24
Depth of Field	24
Other Features	24
Smart Photo Fix	25
Makeover Tools	25
Red-Eye Tool	25
Object Remover	25
One Step Purple Fringe Fix	25
High Pass Sharpen	25
Color Balance	25
Black and White and Infrared Conversion Filters	26
One Step Noise Removal	26
16-bit Support	26
Color Management	26
IPTC Metadata Support	26
File Open Pre-Processing	26
Step-by-Step Projects	27
Exploring the Learning Center	27
Straightening an Image	29
Perspective Correction	31
Cropping Pictures	32
Chapter 2: The Manage Workspace	35
What's Covered in this Chapter	
The Navigation Palette	
Using the Computer Tab	
Using the Collections Tab	
Using the Info Palette	
Adding a Rating	

Adding Keyword Tags	39
Adding a Caption	40
The EXIF Tab	40
IPTC	41
Searching and Smart Collections	42
Using Search and Advanced Searching	42
Saving Searches as Smart Collections	43
Working with Camera RAW Images	45
Step-by-Step Projects	49
Managing Metadata	49
Captioning, Rating, and Tagging Photos	49
Using the Organizer Applying a Series of Image Edits to	
Multiple Photos	54
Chapter 3: Improving Your Photos	
What's Covered in this Chapter	
Adjust or Edit?	
Using the Adjust Workspace	
Smart Photo Fix	
Color Balance	
Brightness/Contrast	
Fill Light/Clarity	
Local Tone Mapping	
High Pass Sharpen	
Digital Noise Removal	
Using the Histogram	
Using the Edit Workspace	
Tools for Correcting Color Problems	
Color Balance	
Channel Mixer	
Fade Correction	
Red/Green/Blue	
Hue/Saturation/Lightness	
Hue Map	
Tools for Correcting Exposure Problems	
Brightness/Contrast	
Clarify	75

Curves	
Highlight/Midtone/Shadow	
Histogram Adjustment	
Histogram Equalize and Histogram Stretch	
Levels	
Threshold	77
Using Fill Flash and Backlighting	
The Fill Flash Filter	79
The Backlighting Filter	79
Making Photos (Appear) Sharper	80
High Pass Sharpening	83
Adding Soft Focus Effects	84
Step-by-Step Projects	86
Using Smart Photo Fix Improving Your Photos	86
Using the High Pass Sharpen Filter Sharpening Photos	94
Using Camera RAW Lab Restoring Detail in Overexposed Pl	hotos97
Chapter 4: Image Manipulation	103
What's Covered in this Chapter	103
Removing Scratches and Blemishes from Scans	104
Controlling Digital Noise	107
Retouching Using the Clone Brush	111
Cloning in Practice	112
Other Tools to Try	114
Creating Black-and-White Pictures	115
Tinting Black-and-White Photos	118
How It's Done	118
Creating Color Overlay Effects	121
Using the Warp Tools	122
Scripting	124
Step-by-Step Projects	128
Restoring Badly Damaged Photos	128
Hand-Coloring Black-and-White Photos	132
Chapter 5: Using Selections	137
What's Covered in this Chapter	
Understanding Selections: Adding Creative Power	
Using the Geometric Selection Tools	144

Adding to the Selection	144
The Magic Wand Tool	144
Alpha Channels and Masks	146
Masks	148
Step-by-Step Projects	149
Creating an Artificial Point of Focus	149
Fixing an Overexposed Sky	150
HDR Photo Merge	153
Object Cutout	161
Chapter 6: Combining Images	163
What's Covered in this Chapter	163
Understanding Layers	164
Who Uses Layers?	165
What Can You Do with Layers?	165
Combining Pictures	167
Advanced Layout Tools	169
Using Adjustment Layers	171
Adjustment Layer Types	173
Advantages of Adjustment Layers	173
Creating Layer Blend Mode Effects	173
Using Mask Layers	174
Modifying Masks	177
Combining Layers	178
Saving Masks	178
Step-by-Step Projects	180
Creating the Perfect Shadow	180
Creating Graduated Effects with Masks	184
Chapter 7: Text and Shapes	189
What's Covered in this Chapter	189
How Text and Vectors Work	190
Adding Basic Text	190
Special Text Effects	193
Layer Styles	194
Special Effects Filters	195
Using Filter Effects: A Warning	196
Adding Text to a Path	197

Editing Text Shapes	198
Making Selections from Text	199
Vectors: Learning the Basics	200
Working with the Pen Tool	202
Step-by-Step Projects	206
Creating a Type Effect Using Text Selections	206
Chapter 8: Special Effects	209
What's Covered in this Chapter	
Using the Materials Palette	
Working with Brush Tools	215
Using the Art Media Brushes	218
Deformation Tools	220
Lens Correction Filters	222
Applying Filter Effects	223
Adding Lighting Effects	229
Step-by-Step Projects	232
Creating Realistic Depth Effects Using Displacement Maps	232
Having Fun with the Picture Tube	237
How to Create a Picture Tube File	237
Further Fun	240
Adding Edge and Framing Effects	240
Technique: How to Add an Edge or Frame to a Picture	240
Using the Color Changer Tool	242
Chapter 9: Printing	245
What's Covered in this Chapter	245
Image Resolution	246
Shuffling Pixels	247
Resampling	249
Down-sampling	249
Up-sampling	250
Printing with PaintShop Pro	250
Color Management	253
Color Profiles	254
Calibration	254
Color Management in PaintShop Pro X4	256

Printing Using Color Management	257
No Profile?	258
Step-by-Step Projects	260
Printing Multiple Photos with Print Layout	260
Chapter 10: The Web	
What's Covered in this Chapter	
Sharing Photos on the Web	266
Uploading Photos to Flickr	266
Uploading Photos to Facebook	269
Creating Your Own Images for the Web	
How the Web Displays Images	272
Web File Formats	274
JPEG in Depth	275
Using the JPEG Optimizer	275
Judging Picture Quality	277
Estimating Download Time	277
GIF in Depth	279
Using the GIF Optimizer	279
Dare to Dither	281
Try Transparency	281
Step-by-Step Projects	283
Protecting Your Photos	283
Adding a Copyright Message and Watermark	283
Appendix 1: Jargon Buster	
Appendix 2: Keyboard Shortcuts	
General	295
Paste	295
View	
lmage	
Adjust	296
Layers	296
la dan	207

Introduction

You're probably used to hearing about how digital photography has made things so much easier and extended the boundaries of what it's possible to achieve with a camera. Although this is undoubtedly true, there are times when it all seems to have become a lot more complicated. What do you do with thousands of photos scattered among an assortment of hard drives, CDs, DVDs, and memory cards? Why do photos of scenes that looked stunning at the time often appear a bit lackluster? And why do printed photos often look nothing like what you see on screen?

If you're looking for answers to questions like these, then PaintShop Pro X4 has the tools you need, and *PaintShop Pro X4 for Photographers* will show you how to get the most from them with real-world examples and step-by-step projects.

Possibly you already have PaintShop Pro X4, have experimented a little, but want to learn more about how it works and how you can use it to organize and edit your photos. One of PaintShop Pro's great strengths is that it's really easy to use but also has a raft of powerful advanced editing tools. In this book I've tried to reflect that approach, and after a thorough introduction covering the basics I move on to look at some intermediate projects including basic retouching, then I graduate to more advanced techniques using selections, layers, masking, and special effects. I also look at working with camera RAW files so, if you have a DSLR or advanced compact that can shoot RAW, you'll learn what the benefits and downsides are and how to go about it.

In PaintShop Pro X4 for Photographers, I've tried to do much more than simply explain how PaintShop Pro X4 works. In each of the chapters, I've taken a practical approach to demonstrating tools and techniques so that you can learn how to use the program to do the things you want with your own digital photos. At the end of each chapter you'll find a series of step-by-step projects that demonstrate many of the techniques covered.

This is the sixth edition of *PaintShop Pro for Photographers* I've written. In each edition I've covered new features, introduced new projects that use them, and updated existing projects to work with the latest version. This means that, as well as being up to date, this is a book you can use with older versions of the program. If you've got PaintShop Pro 9, X, X1, X2, or X3, there's plenty you'll still find useful.

With so many opportunities to take, edit, and share pictures, it's an exciting time to be involved in photography. I hope you'll find *PaintShop Pro X4 for Photographers* a useful, informative, and enjoyable guide.

CHAPTER 1

The Basics Introducing PaintShop Pro X4

What's Covered in this Chapter

- This chapter explains what PaintShop Pro X4 can do and how it works. If you're new to the program, I'd strongly recommend you start at the beginning and read this chapter right through. It'll put you in a much better position when it comes to some of the basic photo editing explored in Chapter 2. In fact, for beginners, taking things in a linear fashion, chapter by chapter, is the best way to use the book, as the simple stuff is dealt with early on and things advance gradually as you go.
- Unlike the other chapters, there isn't a lot of hands-on stuff here; it's
 mostly an explanation of how PaintShop Pro X4 works. All the same, I'd
 recommend you prop the book open in front of you while you're at your
 computer so you can play with the menus, tools, and features while you're
 reading about them.

- First off, the chapter covers PaintShop Pro X4's basic tools, including the Learning Center, which is by far the best place to start if you're new to the application. If you're in a big hurry to get started on your own stuff, by the time you reach page 11 you'll know enough to download your photos from your camera and carry out basic guided tasks using the Learning Center.
- Next are brief descriptions of some of PaintShop Pro X4's more advanced editing tools. Then we take a look at the features Corel has introduced in this latest version of the program, so if you're using an older version of PaintShop Pro and you want to know what you're missing, turn to page 16. In addition to the brand new stuff, we will also take a look at features that were introduced in earlier versions.
- The four step-by-step projects—Exploring the Learning Center, Straightening an Image, Perspective Correction, and Cropping Pictures—can each be completed in just a few minutes with little or no previous knowledge of the program—a nice easy start!

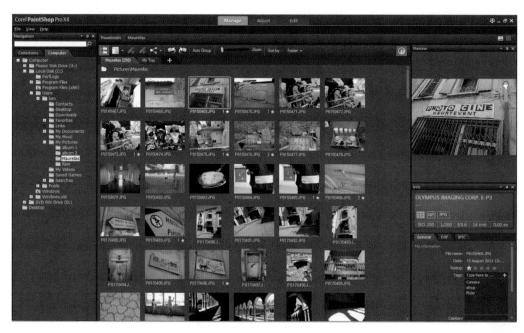

FIG 1.1 PaintShop Pro X4's new-look interface with three workspaces: Manage, Adjust, and Edit. This is the Manage workspace in Thumbnail mode. The thumbnails shown are of photos in a folder called Maurellas, which is in the My Pictures folder and is highlighted in the Navigation palette on the left. Below the preview on the right, information about the currently selected thumbnail is displayed.

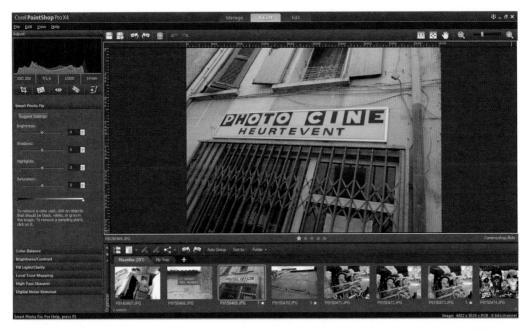

FIG 1.2 This is the Adjust workspace, which is used to make quick adjustments using Smart Photo Fix (shown in the Adjust palette on the left) and other quick fix tools. Notice the Organizer palette containing thumbnails is now displayed at the bottom of the screen.

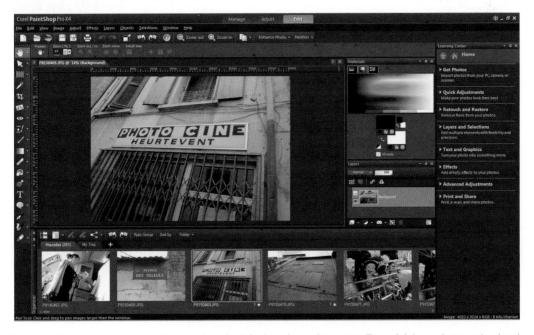

FIG 1.3 The Edit workspace, shown here, provides more advanced tools for photo editing and composition. These include layers, selections, and masks and an extensive range of retouching tools. The Learning Center, shown on the right, can help you find your way around and walk you through editing tasks.

- Whether you're a novice PaintShop Pro user or an old hand, there's one
 fundamental aspect of the interface that you need to be aware of, as
 everything you do revolves around it. PaintShop Pro X4 has three
 workspaces, which you enter by selecting one of the tabs in the middle of
 the top edge of the screen.
- The Manage workspace is where you organize your photos into collections, assign star ratings, caption them, and add keyword tags.
 There are lots of other things you can do in the Manage workspace. I'll describe them in a little more detail later in this chapter, and Chapter 2 is devoted entirely to organizing your photos using the Manage workspace.
- The Adjust workspace is where you go to make quick, everyday edits such
 as rotating and cropping photos. It also has some clever one-step filters
 designed to improve image quality and other easy-to-use tools for making
 tonal adjustments. I look at the Adjust workspace in more detail in
 Chapter 3.
- Finally, the Edit workspace is for full-on image editing, the only limits to
 which are your skill and imagination. The Edit workspace offers a huge array
 of tools that provide massive scope for control over image adjustment and
 editing. I'll look at some of them later in this chapter, and from Chapter 4
 onward most of what we'll be doing involves working in the Edit
 workspace.

Introduction: Basic Tools and Functions

Over the next few pages, I'll explain the various features of the PaintShop Pro X4 workspace and how to use them to carry out basic photo editing tasks. This part of the book is aimed squarely at beginners, so more experienced readers might want to skip to the overview of the Edit workspace on page 9 or to the New and Enhanced Features section on page 16. For those starting out, I'd recommend you read through the following section while in front of your PC, so that you can try things out and familiarize yourself with the basics of uploading, organizing, and editing your photos.

Earlier versions of PaintShop Pro included an application called Corel Photo Downloader, which ran in the background and helped download images when you plugged your camera or a card into a universal serial bus (USB) port on your PC. This was largely superfluous, as you can easily drag and drop a folder of images from your camera or card reader into the Pictures folder on your hard drive (or wherever else you want to keep them) using Windows Explorer. Some people prefer to use software supplied with their camera; however you decide to do it, once the images are on your hard drive, they're ready for you to work with in PaintShop Pro.

The Manage Workspace

More likely than not, you already have some photos stored on your hard disk and you'll want to open these in PaintShop Pro X4. There are a number of ways you can do this, but try to get into the habit of using the Manage workspace from the start. Figure 1.1 shows what the Manage workspace looks like. If yours doesn't look like this, you need to click the Manage tab in the middle of the top edge of the screen.

Chapter 2 explains in more detail how the Manage workspace works. For now it will help you to know that it makes finding and opening photos much easier than selecting File > Open, though you're welcome to do it that way if you prefer.

The Manage workspace has four elements: the Navigation palette on the left, which shows files and folders on your hard drive; a large preview area in the middle of the screen, which shows a preview of the thumbnail selected in the Organizer palette at the bottom; and, finally, the Info palette on the right, which displays metadata for the selected image including the exposure details, time and date, and IPTC metadata such as captions, keyword tags, and ratings.

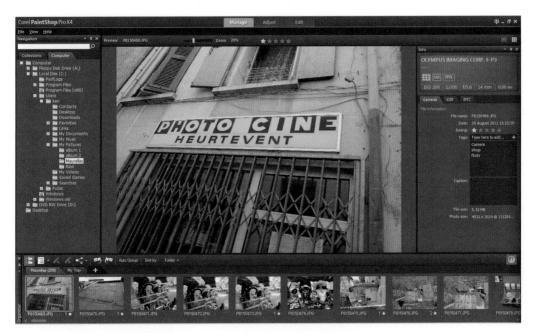

FIG 1.4 This is what the Manage workspace looks like in Preview mode. The Organizer palette moves to the bottom of the screen to be replaced by a big preview. This is useful if you want a good look at your photos, but for organizing them the thumbnail mode (shown in Figure 2.1) is best.

There are a few important things about the way the Manage workspace functions that you might find it helpful to know at this stage. The first is that there are two viewing modes: the one we've been looking at is called Preview mode; the other is called Thumbnail mode. To change between the two, click one of the two mode buttons at the top right of the Manage workspace. When you enter Thumbnail mode, a smaller preview is displayed above the Info palette and the Organizer palette moves to the middle of the screen, providing a larger area for viewing and working with thumbnails.

The Navigation palette has two tabs labeled Collections and Computer. The Computer tab shows the files and folders on your hard drive. This is quite useful to begin with, as you can locate a folder of images anywhere on your PC, but there's a lot of clutter—folders that have nothing to do with your photos—getting in the way. Click the Collections tab at the top of the Navigation palette and you'll see a list that includes your Pictures folder, some Smart Collections, which are collections of photos selected using saved search criteria, and the option to display thumbnails based on their star rating. The Collections tab provides a far more useful way to organize and find your photos because you can decide exactly what appears on it and which images are displayed in the Organizer palette. More about that in the next chapter.

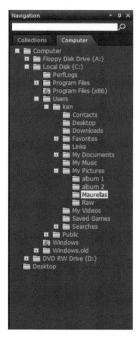

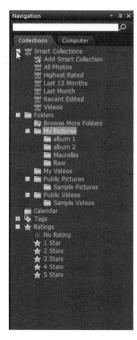

FIG 1.5 The Navigation palette tabs. The Computer tab (*left*) displays the files and folders on your PC, useful for finding photos if you know where you put them, but there's a lot of clutter. The Collections tab (*right*) shows only those folders you choose.

For now, let's take a quick look at some of the functions of the Navigator palette and how you can use it to browse for photos on your PC. Start by clicking the Computer tab at the top of the Navigator palette, then click the + sign next to the hard drive on which Windows is installed; it's probably called Local Disk (C:). Click the + sign next to the Users folder, followed by the + sign next to your username (in my case, ken). You should now be able to see the My Pictures folder. Mine has subfolders in it, so I need to select one of these to display the thumbnails of the photos it contains in the Organizer palette. When I do that, the first image is automatically selected and its info is displayed in the Info palette on the right, below the preview.

Now click the Collections tab, then click the + sign next to Folders, and you'll see your My Pictures folder right there. It's automatically added to the Folders collection and it's much easier to get to without all that other stuff in the way. You can easily add other folders by clicking "Browse more folders" at the top of the folders list.

Notice there are three tabs on the Info palette labeled General Info, EXIF, and IPTC. The first of these tells you the file name, the date the photo was taken, the rating (which you can change by clicking on the stars), what keyword tags have been applied, and, if you scroll down, the caption and some other information. EXIF stands for Exchangeable Image File format and it contains noneditable information recorded by the camera at the time of exposure. Click the EXIF tab and you'll see the exposure details, date and time, camera make and model, resolution, and a lot of other stuff. EXIF information can include all kinds of things down to the kind of metering mode you used, whether the flash was fired, and the focal length of the lens.

IPTC stands for International Press Telecommunications Council (these acronyms, usually named from the organizations and committees that define these standards, aren't particularly useful to know, but there you are) and is a standard for adding metadata to digital photos after they've been taken. IPTC metadata can include things like your name and address, a copyright statement, and a caption. The distinction between EXIF and IPTC metadata is that the former is recorded by the camera at the time of exposure and is usually noneditable and the latter is subsequently added by people and can be edited. The Info palette and the information it displays are described in more detail in Chapter 2.

The Organizer palette appears in all three workspaces, which makes it easy to select any photo from the currently selected folder or from a tray to adjust or edit. The Navigator palette appears in the Manage workspace. To display it in the Adjust and Edit workspaces click the Show/Hide Navigator button on the Organizer tray. If you select an image in the Organizer palette in the Manage workspace, when you switch to the Adjust or Edit workspaces that image is open and ready to work on. Alternatively, you can right-click the thumbnail in the Manage workspace and select Adjust Photo or Edit Photo from the menu.

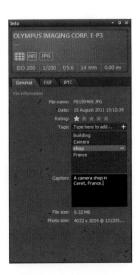

FIG 1.6 The General tab of the Info palette tells you the file name, date taken, rating, tags, and caption as well as file size and pixel dimensions. More information is available on the EXIF and IPTC tabs.

The Adjust Workspace

The Adjust workspace is new to PaintShop Pro X4. If you're working with PaintShop Photo Pro X3 or PaintShop Pro Photo X2 (consistency hasn't been a strong point of Corel's branding strategy), you'll have something called Express Lab, which is similar, though less well-integrated.

As I've said, the Adjust workspace is where you carry out routine adjustments such as cropping and straightening, correcting color and exposure problems, fixing red-eye caused by on-camera flash, and touching up spots and blemishes. I'm going to go into more detail here than I did for the Manage workspace because if you only read this chapter and the next you'll be well equipped to carry out the most important tasks—organizing and basic photo editing.

The Adjust workspace is shown in Figure 1.2. As you can see, it's divided into three areas; there's the Organizer palette (familiar from the Manage workspace) at the bottom of the screen, the Adjust palette on the left, and a large preview area occupying most of the screen on the top right.

Most of what goes on in the Adjust workspace happens, appropriately enough, in the Adjust palette, but before we look in detail at that I'll explain what some of the other controls are for. Above the Preview area there's a toolbar with rows of buttons top left and top right. The buttons on the left are for saving your work, rotating photos left and right, deleting, and undoing and redoing. On the right are view buttons for zooming to 100% view, fitting in window, a Pan tool for grabbing the image and moving it around in the preview window when you're zoomed in, and, on the extreme right, a zoom slider with + and - magnifiers. Incidentally, if you get to the Adjust workspace and find the image you want to adjust is located in a different folder, you can display the Navigation palette by clicking the Show/Hide Navigation button on the top left corner of the Organizer palette.

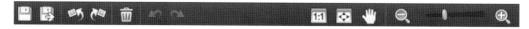

FIG 1.7 The Adjust workspace toolbar buttons are divided into two groups. On the left: save, save as, rotate left, rotate right, delete, undo, and redo. On the right: zoom to 100%, fit image to window, pan, and zoom.

At the top of the Adjust palette, there's a histogram display. I look at histograms and how to interpret and work with them in Chapter 3. Below the histogram the EXIF exposure information is displayed, and below that is a toolbar containing four tools—Crop, Straighten, Red-eye, and Makeover—and a Clone brush. If you want to know how to use some of these tools, take a look at the step-by-step projects at the end of this chapter.

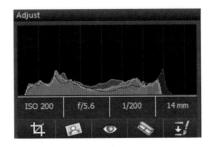

FIG 1.8 The Adjust palette toolbar (*left to right*): Crop tool, Straighten tool, Red-eye tool, Makeover tool, and Clone brush.

Below the Adjust palette toolbar is the Smart Photo Fix panel. Unless you've clicked on one of the tools above the Smart Photo Fix panel (in which case just click the Smart Photo Fix header to expand the panel), the control sliders will be displayed. You can experiment with these to try and improve image quality, but it's called "Smart" photo fix for a reason; click the Suggest Settings button, and it will do the hard work for you by analyzing the image and deciding what settings to apply to get the best results.

Below the Smart Photo Fix panel you'll find a range of other tools designed to improve your photos quickly and easily. These include Color Balance, Fill Light/Clarity, High Pass Sharpen, and Digital Noise removal. These are "simplified" versions of tools that are available in the Edit workspace and described briefly later in this chapter and demonstrated throughout the book. They're included in the Adjust workspace so that you can quickly access and apply them without having to think too much about the process. The point of the Adjust workspace is to provide a place where you can scan through all of your images from an event and apply adjustments to those that need it.

Of course, no matter how quick and simple the adjustments you make, if you have to apply them individually to hundreds of photos they're going to add up. Thankfully, PaintShop Pro X4 allows you to "capture" the changes you make to a photo in the Adjust or Edit workspaces and apply them to others. This feature is described more fully in the Nearly New Features section of this chapter, and there's a step-by-step project at the end of the chapter.

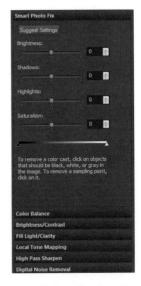

FIG 1.9 The Smart Photo Fix panel has sliders for Brightness, Shadows, Highlights, and Saturation, but a click on the Suggest Settings button is often all that's required.

The Edit Workspace

The Edit workspace is where you go for serious photo editing work. The Adjust workspace is fine for quick edits, but the Edit workspace has the tools you'll need to carry out more substantial work. In the Edit workspace

you can create layers, superimposing photos on top of each other, and you can add masks to layers that work like stencils by hiding some areas of the layers below and revealing others. Sophisticated selection tools allow you restrict edits and adjustments to parts of an image, and these selections can form the basis for masks, which do the same thing only more flexibly.

As well as including a wide range of editing tools, the Edit workspace has a raft of special effects filters as well as controls for adjusting tone, color, and just about every other factor that affects how a digital photo appears. Using these tools, you can fix exposure problems; remove color casts; change the color of individual objects in photos; sharpen or blur photos; remove scratches and digital noise; remove people, cats, lampposts, or anything else; make old photos look like new and new ones look old; produce one good photo from several not-so-good ones; and a lot more besides.

Figure 1.3 shows the Edit workspace. The main components of this workspace are the menu bar and Standard toolbar at the top of the screen; below that is the Tool Options palette, then the image window, and at the bottom of the screen the by-now-familiar Organizer palette. The Tools toolbar is the long, narrow strip on the left that contains all of the Edit workspace tools. When you hover over a tool, its name is displayed in a tool tip and its function is explained in the status bar at the very bottom of the screen. Finally, on the right of the screen is the Learning Center palette.

The Learning Center

The Learning Center appears on the right of the screen in the Edit workspace and shows you how to get things done. If you can't see the Learning Center, select View > Palettes > Learning Center, or press the F10 key on your keyboard.

For simple tasks, such as rotating photos, the Learning Center just does it for you. For more complex tasks involving several steps, the Learning Center walks you through, step-by-step, selecting the tools for the job at the appropriate moment.

Because the Learning Center selects the tools for you and tells you how to use them, after a while, you'll find you no longer need it for common tasks like cropping, straightening, and rotating photos—when you know how, it's quicker and easier to do it yourself. When the time comes you can close the Learning Center palette (press F10 again) to make more room for your photos and other palettes.

The Learning Center works like a website. The Home page has eight categories: Get Photos, Quick Adjustments, Retouch and Restore, Layers and

Selections, Text and Graphics, Effects, Advanced Adjustments, and Print and Share. You can return to this page at any time by clicking the Home button at the top of the palette.

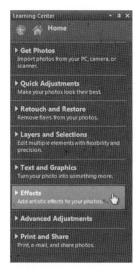

FIG 1.11 The Effects tab.

Each topic has a number of projects. Click Effects and you'll find seven projects that demonstrate, among other things, how to use the Time Machine to create vintage-style photos, converting photos to black and white, and distorting photos. Click either the Home or Back buttons at the top of the palette to return to the home page. I'm not going to go through each of the projects in the Learning Center because they don't need any explanation. Why not try them out for yourself?

The Menu Bar

PaintShop Pro X4's menu system gives you access to most of the program's tools, commands, and features. There are other ways to access them, but the menu bar lays them all out for you in a logical, organized fashion. If you're not sure where something is, a quick skim through the menus will usually reveal it. For example, if you want to apply a special effects filter, there's a good chance you'll find what you're looking for somewhere in the Effects menu. Anything to do with making tonal and color adjustments is on the Adjust menu, and stuff having to do with displaying toolbars, palettes, grids, guides, and organizing the workspace is on the View menu (except workspace presets, which, for some reason, are on the File menu).

Some menu items are nested in submenus. When I refer to these in the book they are denoted using the > character. For example, the Levels command on the Brightness and Contrast submenu of the Adjust menu is shown as Adjust > Brightness and Contrast > Levels.

Another useful piece of information you'll find on menus is keyboard shortcuts. After a while it will become second nature to you to press $\mathsf{Ctrl} + \mathsf{O}$ to open a photo rather than selecting $\mathsf{File} > \mathsf{Open}$.

FIG 1.12 The Adjust menu with the Brightness and Contrast submenu selected.

Toolbars

Now that you know how to use the Organizer to find and open photos into PaintShop Pro X4 and you can carry out simple guided projects using the Learning Center, it's time to take a look at some of the other parts of the PaintShop Pro X4 Edit workspace.

The narrow strip of buttons running down the left side of the screen, between the Learning Center and the main picture window, is the Tools toolbar. If you need to select part of a photo, crop it, straighten it, retouch it, add text, or fix problems like red-eye, this is where you'll find the tools for the job.

PaintShop Pro X4 displays tool tips when you hover with your mouse pointer over each of the tools, and this is a good way to familiarize yourself with each tool's function. As well as the tool tips, the Status bar at the very bottom of the screen provides some guidance on how to use each tool.

There are several other toolbars; some of them, like the Standard toolbar, are visible in the default workspace, and some need to be activated by selecting them from the Toolbars submenu of the View menu.

The different toolbars group together similar tools and functions that you're likely to need for a specific photo editing task or that it seems logical to keep in the same place. On the Standard toolbar at the top of the screen you'll find tools for creating, opening, and saving; scanning and printing; resizing; rotating; and displaying photo information.

Other toolbars include the Effects, Photo, Script, and Web toolbars. Some of these you'll use rarely, or possibly not at all, which is one of the reasons they're tucked away, so as not to clutter up the workspace. I've already mentioned that you can toggle the toolbars on and off by selecting them from the View > Toolbars menu (you can also hide toolbars and palettes by clicking their close box) and you can float or dock any of the toolbars by dragging the title bar. To dock a toolbar, drag it to one of the top, bottom, or side edges of the main picture window, where it will snap into place. To float a toolbar, drop it anywhere away from one of the docking edges.

FIG 1.13 The Tools toolbar sits on the left of the main picture window. Hover over the tools to display a tool tip naming the tool and a brief explanation of its function in the Status bar at the bottom of the screen. From the top: Pan + Zoom tool, Pick + Move, Selection + Freehand Selection + Magic Wand, Dropper, Crop, Straighten + Perspective Correction, Red-Eye + Makeover, Clone Brush + Scratch Remover + Object Remover, Paint Brush + Airbrush, Lighten/Darken + Dodge + Burn + Smudge + Push + Soften + Sharpen + Emboss + Saturation Up/Down + Hue Up/Down + Change to target + Color Replacer, Eraser + Background Eraser, Flood Fill + Color Changer, Picture Tube, Text tool, Preset Shape tool + Rectangle + Ellipse + Symmetric Shape, Pen tool, Warp Brush + Mesh Warp, and Oil Brush + Chalk + Pastel + Crayon + Colored Pencil + Marker + Palette Knife + Smear + Art Eraser.

FIG 1.14 To activate toolbars, select them from the View > Toolbars menu. The Standard toolbar appears in the default workspace and contains, among other things, filing commands, rotate buttons, undo and redo commands, zoom buttons, and the Palettes menu.

Tip

To reset Preferences including the default workspace layouts, hold down the Shift key when you launch PaintShop Pro X4. You can also go to File > Preferences and check the items you want to reset.

Play around with showing, hiding, and rearranging the PaintShop Pro X4 workspace elements. Before you do, though, first select File > Workspace > Save and save your existing setup as "default_workspace" or something similar. When you've everything set up the way you want, save this new arrangement as "favorite_workspace." Now, to return the workspace to either of these arrangements, you just need to select Workspace and then Load and choose the one you want.

Photo Toolbar

If you deal with scanned or digital photos, this is the toolbar to get friendly with. The Backlighting and Fill Flash tools help to correct exposure problems caused by problematic lighting conditions, and the Chromatic Aberration and Digital Camera Noise Removal filters help reduce colored fringing and noise problems that can occur in digital photos. You can add tools for common photo-enhanced operations like levels, for example, by right-clicking any of the toolbar buttons and selecting Customize from the contextual menu.

Effects Toolbar

If you have had no experience using PaintShop Pro X4 but are curious how its effects might look when applied to a picture, click the first button on the Effects toolbar—the Browse Presets button. This loads and displays the Effects Browser, displaying all of the available adjustment and effect filter presets. Click on a folder to see the entire contents—all of the artistic effects, for example—or choose an individual preset from within one of the folders. Double-click the effect you like the look of in the Browser, and PaintShop Pro X4 transfers it to the photo in the work area. In this way you can preview the filter effect and save time by only trying effects that you like the look of.

What else is on the Effects toolbar? Buttonize, Drop Shadow, Inner Bevel, Gaussian Blur, Hot Wax, Brush Strokes, Colored Foil, Emboss, Fur, Lights, Polished Stone, Sunburst, and Topography—all are preset filter effects that can be applied to a selection, or globally, depending on application. All can be customized through the displayed options window. Customized filter sets can also be saved in the same way as customized tools.

Script Toolbar

Although strictly not a tool as such, scripting offers incredible power to anyone with a bit more than the most basic of photo editing requirements. What's scripting all about? As the name might suggest, a script is a file of instructions that produce a series of actions or effects—much in the same

way that a play's script, when followed by a group of actors, produces actions that result in a play.

PaintShop Pro ships with a wide range of prerecorded scripts, but the fun really begins when you start to record your own. The Script toolbar is set up just like a video recorder. Press "Record," then perform the actions you want on the selected picture (i.e., rotate + change contrast + save). It's that easy. Once saved, the script can be run on other pictures in the work area. It's a great way to automate jobs that require repetitive actions applied to multiple pictures (for example, in website design).

Web Toolbar

Put together specifically for web designers, this small toolbar contains an Image Slicer tool, an Image Mapper tool, "JPEG," "GIF," and "PNG" image optimizers, plus a Web Browser Preview feature, a Seamless Tiling feature, and a Buttonize feature—most of the tools, in fact, needed to prepare images for your own website. Chapter 10 The Web—Optimizing Images contains more details about some of these tools and how to use them.

Tool Options and Other Palettes

A tool wouldn't be very useful if it did only one thing, and PaintShop Pro X4's tools are nothing if not versatile. The Tool Options palette is what gives tools their versatility, allowing you to change settings that modify the selected tool's behavior.

FIG 1.15 Tool options for the Paint Brush.

The Tool Options palette automatically displays the available settings for the selected tool. So, when you select the Paint Brush tool, the Tool Options palette displays size, shape, opacity, and other options. Switch to the Selection tool and the Tool Options palette displays selection type, mode, feathered edge, and other selection options.

Try selecting a few different tools and looking at what aspects of their behavior can be modified using the Tool Options palette. Don't worry if it's not clear at this stage what they do or how they work. As you progress through the book, you'll discover how to use them in practice. Right now it's enough to know that, along with the Tools toolbar, the Tool Options palette is one of PaintShop Pro X4's most useful assets.

Tip

For lackluster digital photos, start with the One Step Photo Fix. This versatile command applies six different processes to the image: Automatic Color Balance, Automatic Contrast Enhancement, Clarify, Automatic Saturation Enhancement, Edge Preserving Smooth, and Sharpen.

We've already talked about two other palettes—the Learning Center and Organizer. PaintShop Pro X4's other palettes include the Layers, Materials, Histogram, and History palettes. The Materials palette is used to select colors, gradients, and patterns for all of the painting and drawing tools.

FIG 1.16 The Materials palette (left) is used for selecting foreground and background colors, gradients, and patterns for all the painting and drawing tools. The Material Properties dialog (center) (click the foreground or background swatch) is used to fine-tune color selection, create gradients, and choose pattern and texture swatches (right).

New and Enhanced Features

Here's a brief overview of the new features that Corel has added to PaintShop Pro X4. If you're an old hand with PaintShop Pro, this is where to look to find out what's new and what's changed. You'll find more detailed descriptions of the new features, as well as practical examples of how to use them, throughout the book.

HDR Tools

HDR stands for high dynamic range. The dynamic range in a photo is the range of tones that are represented, from pure white to solid black. Paint-Shop Pro X4's HDR tools combine several bracketed exposures to better represent the wide tonal range in some subjects and avoid blown-out

highlights and filled-in shadows. Earlier versions of PaintShop Pro had HDR Photo Merge, but PaintShop Pro X4 improves the merge algorithm and introduces a new batch merge feature.

Photo Blend

Photo Blend lets you combine two or more photos of the same scene so that you can swap or remove unwanted details. This is perfect for a group shot where, for example, one person has his or her eyes closed. You can combine the best bits from several photos to make one really good one.

Selective Focus

Selective Focus simulates the shallow depth of field that's typical of a specialist tilt-shift lens and often makes real-life subjects look like miniaturized models. It's an effect that has become very popular—if you haven't seen it before (where have you been?), go to flickr.com and search "tilt-shift."

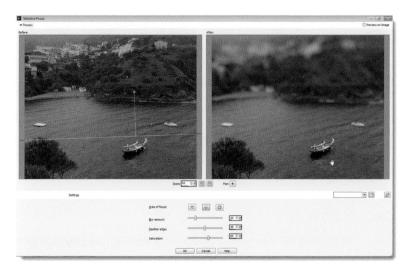

FIG 1.17 PaintShop Pro X4's new selective focus feature simulates the shallow depth of field produced by specialist tilt-shift lenses.

Vignette

Another classic effect, a vignette is simply a soft focus fade to black or white at the edges of a photo. In the old days, vignetting was a common problem with lenses, so the vignette filter can be used on its own or as part of a process to produce an aged or vintage look.

Fill Light/Clarity

Fill Light/Clarity is a new adjustment that comes in two parts. Fill Light works a bit like the existing Fill Flash, only is more effective at brightening shadows without affecting other areas. According to Corel, the Clarity filter "enhances subtle yet important details." The overall effect is to make lifeless detail "pop."

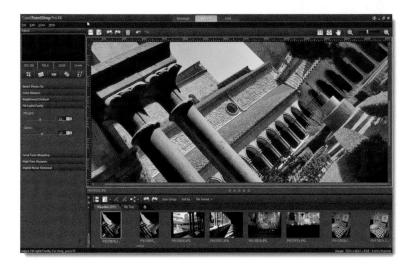

FIG 1.18 The new Fill Light/Clarity filter in action.

Facebook and Flickr Sharing

You can now share your photos on Flickr and Facebook directly from PaintShop Pro X4.

Camera RAW Lab

Camera RAW Lab is PaintShop Pro X4's module for processing camera RAW files. In this version it's been enhanced with an improved histogram and new highlight recovery options.

Quick Review

The Quick Review feature isn't new, but it's been updated and is now much more useful than its slideshow-based predecessor. It's an Organizer feature that displays a full-screen preview of the Organizer palette. Quick Review can be used to scan through a folder of images, delete the ones you don't want, and rate and rotate the rest. It's full screen, so you get a good look at the images, and you can use the keyboard to navigate.

FIG 1.19 The Quick Review space is great for quickly rating your photos.

Tabbed Workspaces

The biggest change to this version of PaintShop Pro is not a new killer feature or tool, but the redesign of the user interface. The introduction of a tabbed interface accessing three linked workspaces for managing, adjusting, and editing photos makes everything more straightforward and provides a structured workflow. First, manage your images, rate them, add captions, and add keyword metadata that will make them easier to locate and view later. Then, apply quick adjustments where necessary. Finally, go to the full editing workspace for more complex editing and project-based work.

Nearly New Features

These features were all added in previous versions: PaintShop Photo Pro XI, X2, and X3. I've included them because they are among the most useful features of the program and, like the new features, you'll find them used throughout the book.

Multiphoto Editing

PaintShop Pro provides an easy way to apply all of the edits you make to a photo to other photos in the Organizer. This is an extremely useful thing to be able to do and has the potential to drastically reduce the amount of time you spend editing. Let's say you've downloaded a card full of images from your camera and want to prepare them for a slideshow presentation.

You select the first image, open it in the Adjust workspace, apply the Smart Photo Fix, adjust the color using Color Balance, then sharpen it before saving the image.

These are general edits that you'd like to apply to every image, so back in the Organizer you select the image and click the Capture Editing button on the toolbar. Now you just need to select the photos you want to apply the same editing process to, click the Apply Editing button, and you're done. There are other ways to apply a sequence of editing steps to multiple photos, but none are as quick and easy as this.

Smart Carver

The Smart Carver is like an intelligent crop tool. It changes the dimensions of a photo without distorting the content by removing parts of the image that have little structural detail. You can also use the Smart Carver to target specific parts of the image that you want to remove. Used in this way, it's great for removing unwanted and distracting bits of photos like lampposts, cars, trees, or even people.

Object Extractor

The Object Extractor is a new tool that makes it easy to isolate and cut out part of an image from its background. Whereas the conventional selection tools require some skill and patience to get a good result, using the Object extractor is a much simpler process. You just paint an outline around the thing you want to extract, fill the area inside, then click Process to preview the result. You can then refine the result using Edit Mask.

Vibrancy

To adjust the saturation of colors in a photo, you can use the Hue/Saturation/Lightness controls. The problem with increasing saturation, though, is that some colors can become oversaturated and unnatural-looking. Vibrancy is a more subtle saturation controller—it increases saturation, but, rather than a blanket increase, only those colors that lack saturation are boosted. This makes it ideal for giving a boost to skin tones in portraits and in other images that have a mix of strongly saturated and more muted hues.

On-Image Text Editing

In early versions of PaintShop Pro, when you clicked on a photo with the text tool, a text dialog box opened into which you entered and edited your text. When you were done, you clicked OK and a text layer was added to the document. Now you can add and edit text directly on the image. It's a lot

easier this way; with the text selected you can change the font, size, alignment, and other attributes from the Tool Options palette.

Raw Format Support

PaintShop Pro X4 can open and edit images shot in your camera's proprietary camera RAW format. For advanced photographers, there are many advantages to doing this, not the least of which is the potential to produce better-quality images than if you shoot using the JPEG file format to capture images.

The Organizer can display thumbnails for RAW images, and when you open them they are initially processed using Camera Raw Lab. PaintShop Pro X4 extends the range of camera RAW formats supported; you can find a list of supported camera RAW formats on the Corel website at www.corel.com. You can find out more about processing RAW files in Chapter 10.

Auto-Preserve Originals

It's always a good idea to back up your photos onto a CD or DVD so that, should the worst happen, you've always got the originals somewhere safe. Likewise, before you begin work on a photo in PaintShop Pro X4, it's always a good idea to leave the original untouched and work on a copy. One way of doing this is to select "Save As" from the File menu and save the photo with a different name or in a different location (I sometimes create a folder inside the folder containing the downloaded photos and call it "edited")

PaintShop Pro X4's Auto-Preserve Originals feature takes care of this for you by saving the original in a subfolder of the current folder. You can use this either in addition to the backup steps I've already suggested or instead of using "Save As" to create a copy. Auto-Preserve Originals is on by default; to turn it off, select File > Preferences > General Program Preferences, select Auto-Preserve from the list on the left, then uncheck the box and click OK.

Layer Styles

Layer styles are live editable effects that can be applied to raster and vector layers. There are six layer styles: Reflection, Outer Glow, Bevel, Emboss, Inner Glow, and Drop Shadow. To apply layer styles, double-click a layer in the Layers palette and select the Layer Styles tab in the Layer Properties dialog box. Most of the layer styles have basic controls—to adjust the size, position, and opacity of a drop shadow, for example. You can edit layer styles at any time by reopening the Layer Properties dialog box and adjusting the settings. And, when you edit a layer that has a Layer style applied, the style automatically updates.

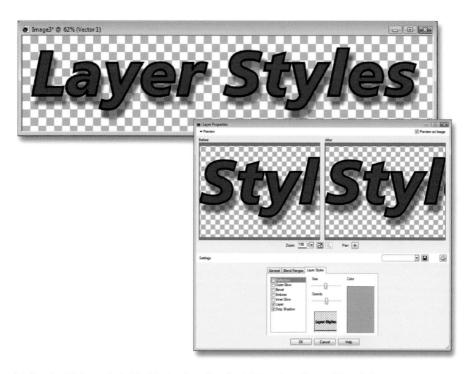

FIG 1.20 PaintShop Pro X4's layer styles include Reflection, Outer Glow, Bevel, Emboss, Inner Glow, and Drop Shadow.

Visible Watermarks

Watermarking your images is one way to prevent copyright theft. PaintShop Pro X4's visible watermarks make it easy for you to add a logo or other text or graphic to your photos.

Save for Office and Copy Special

The Save for Office and Copy Special features automatically resize large photos that are intended for things like PowerPoint presentations or Word documents. You don't need megapixels of image data for photos embedded in these applications. Placing digital images at their original size in such documents has no advantages and creates big files that are difficult to email and take a long time to open. The Save for Office and Copy Special features create files at the right size for these applications without you needing to think about it.

Color Changer Tool

The Color Changer tool lets you change pixel colors at a stroke and provides sophisticated, but easy-to-use, selection methods so that only those pixels you want to recolor are affected. You can use the Color Changer tool to change the color of clothing, paintwork, or pretty much anything at a stroke. There's a step-by-step project using the Color Changer tool on page 244.

Skin Smoothing

Removing wrinkles and blemishes is one of the most difficult retouching tasks there is; even professional retouchers find it a challenge. PaintShop Pro X4's Skin Smoothing feature makes it easy to remove wrinkles and skin blemishes, taking years off your portrait subjects.

Riff File Format Support

You can save PaintShop Pro X4 files in the Riff file format used by Corel Painter and Corel Painter Essentials. These programs provide natural media painting effects and tools, which can be used to simulate traditional media.

Time Machine

Some photo applications have an "antique" effect; PaintShop's Time Machine filter goes much further, providing a range of effects that simulate historical photographic processes such as the daguerreotype and platinotype.

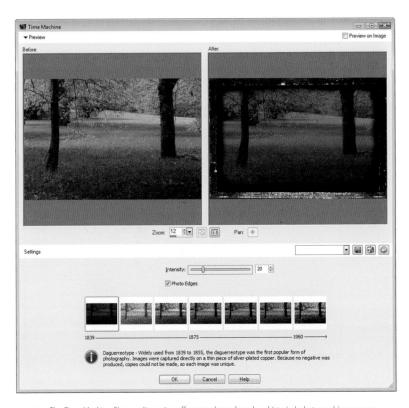

FIG 1.21 The Time Machine filter applies aging effects to photos based on historical photographic processes—this one simulates the daguerreotype; also available, in chronological order, are Albumen, Cyanotype, Platinum, Autochrome, Box camera and Cross process—a more recent photo lab technique.

Film and Filters

The Film and Filters feature does two things. First, it allows you to simulate the particular look of some color film stock. In the days of film, photographers would choose a particular emulsion for the look. Portrait photographers would choose a film for the way it rendered skin tones; for landscapes, an emulsion that rendered rich earth tones and natural-looking blue skies was appropriate. Photo Paint Photo has seven film looks to choose from, including Muted Reds, Vibrant Foliage, and Glamour. Additionally, you can apply creative filters from a range of six, including Night Effect, Warming, Orange, Champagne, and Sunset. You can also create your own custom filters.

Depth of Field

Creating artificial depth of field effects to simulate using a wide aperture and throwing the background out of focus isn't difficult, but it takes time and a little skill. To find out how you can do it manually, see page 149. Alternatively, Corel PaintShop Pro's Depth of Field effect makes it a lot simpler.

FIG 1.22 The Depth of Field effect simulates the narrow depth of field achieved in camera by shooting with a wide-open lens aperture.

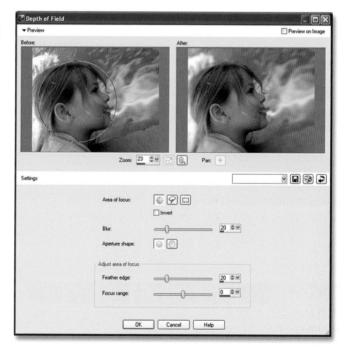

Other Features

Numerous other innovative features were introduced in previous versions of the program. Brief details of their functions are given here. You'll find more detailed descriptions of how they work, as well as practical examples, throughout the book.

Smart Photo Fix

The Smart Photo Fix feature provides a one-click method of "toning up" lackluster images, but it also provides a degree of control over the process. Sliders provide control over tonal adjustments, saturation, sharpening, and color balance, all in an easy-to-use panel with big before and after thumbnail previews.

Makeover Tools

The Blemish Fixer, Toothbrush, and Suntan brush can give your portraits an instant lift with very little effort. The Blemish Fixer can also be used for where a more subtle effect than can be achieved with the Clone brush is needed.

Red-Eye Tool

The Red-Eye tool is a much more straightforward tool than PaintShop Pro's previous red-eye removal tool; just set the tool size and click on the eyes.

Object Remover

Like the Clone brush but easier to use, the Object Remover seamlessly replaces unwanted detail in a photo, such as a lamppost, tree, or other distracting background detail, with another part of the image.

One Step Purple Fringe Fix

A common problem with digital cameras, purple fringing is caused by lens aberrations and the limitations of digital camera sensors. Purple fringing usually shows up as a thick purple fringe around high-contrast edges, like tree branches against a bright sky. The One Step Purple Fringe Fix does exactly what it says.

High Pass Sharpen

High pass sharpening is a professional sharpening technique that has some advantages over conventional unsharp masking—mainly, it's less likely to exaggerate noise and produce haloing.

Color Balance

If you don't know your additive from your subtractive primaries, then PaintShop Pro's new Color Balance tool is the one for you. It automatically

adjusts the white balance to remove color casts; then all you need to decide is whether you want to warm the colors up or cool them down. There's also an advanced mode.

Black and White and Infrared Conversion Filters

These effects allow you to easily convert your images to black and white and to simulate shooting with infrared and black-and-white film with colored filters for enhanced tonal reproduction.

One Step Noise Removal

PaintShop Pro's existing Digital Noise Removal feature provides powerful tools for cleaning up noisy images, providing you have the time and knowhow to use it effectively. For everyone else, there's One Step Noise Removal.

16-bit Support

You can open, edit, and save 16-bit images in PaintShop Pro X onward. The advantage is that you have more tonal and color information, so images have a higher dynamic range and are less prone to degradation, like highlight and shadow clipping and posterization, when you make color and tonal adjustments. Some PaintShop Pro features require you to convert 16-bit images to 8-bit images before you can use them. These adjustments are best left until last in your editing workflow.

Color Management

PaintShop Pro's new color management engine lets you work with embedded image color profiles to improve screen-to-print color matching.

IPTC Metadata Support

Most metadata that's saved with images when you shoot them—the camera model and exposure settings, for example—isn't editable. But IPTC fields are designed to allow you to record information about the photographer, the location of the scene, and searchable keywords. You can add and edit IPTC metadata in PaintShop Pro.

File Open Pre-Processing

This feature allows you to run a script on files as they are opened. It's a time-saver if you want to automatically apply the same process to all images you open, such as the One Step Photo Fix. Or you might use it to automatically down-sample 16-bit images to 8-bit images, or anything else you have or can write a script for.

Step-by-Step Projects

Exploring the Learning Center

Whether you're new to PaintShop Pro or an old hand, it's worth taking a little time to explore the Learning Center and see what it has to offer. As well as taking you step-by-step through basic editing techniques, like cropping and rotating images, the Learning Center can help you with more ambitious projects like producing a photomontage and advanced editing techniques like digital camera noise removal.

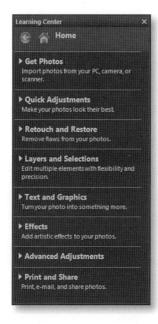

STEP 1 If the Learning Center isn't on the home page, click the Home button. Topics are divided into eight categories: Get Photos, Quick Adjustments, Retouch and Restore, Layers and Selections, Text and Graphics, Effects, Advanced Adjustments, and Print and Share. Click on any of these to view the list of available projects. You can get back to the home page by clicking either the Home button or the Back button at the top of the Learning Center palette, just like you would in a web browser.

STEP 2 Click the second option on the Learning Center home page, Quick Adjustments, and on the next page click the last option on the list, Resize. The Resize dialog box is automatically opened for you and the Learning Center explains what the various fields are for and how to use them. We don't want to resize this image just now, so click the close box to get of the Resize dialog and click the Home button at the top of the Learning Center palette.

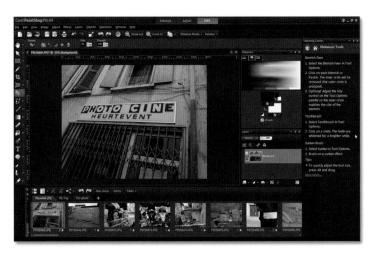

STEP 3 Now select Retouch and Restore from the Learning Center home page and choose Makeover from the Retouch and Restore menu. This time the Learning Center selects the Makeover tool from the Tools toolbar and tells you what to do with it. The Learning Center provides step-by-step instructions for a wide variety of tasks and selects the tools you need or opens the appropriate dialogs to help get you going. In the next two step-by-step projects, we'll look at how to straighten a photo and how to correct perspective with the help of the Learning Center.

Straightening an Image

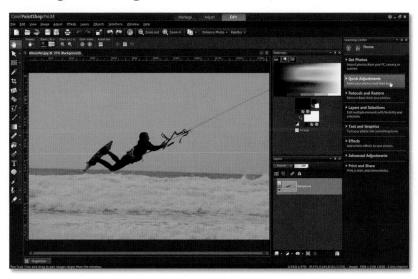

STEP 1 It's often not until you get to look at your photos onscreen that you realize the horizon isn't level. Deliberate tilting of the camera to create a dynamic angle is one thing; a horizon that runs downhill, whether because of a tilted camera or skewed scanning, is generally to be avoided and can easily be fixed. Use the Organizer to open the offending image, and click the Adjust button on the home page of the Learning Center.

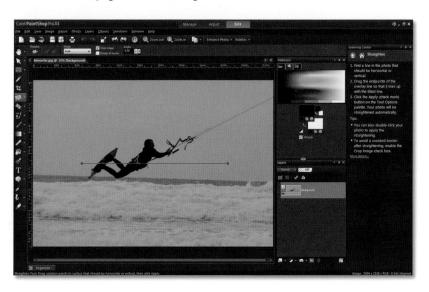

STEP 2 Select Straighten from the Adjust page in the Learning Center. The Straighten tool is automatically selected for you (it's the sixth tool from the top of the Tools toolbar), and a line appears in the center of your image.

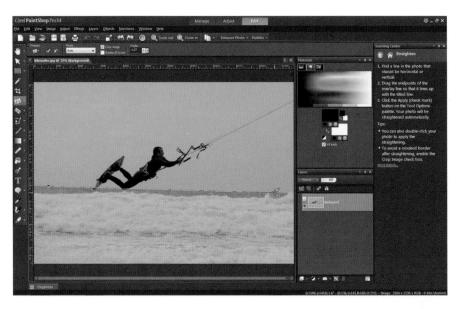

STEP 3 The panel in the Learning Center tells you exactly what you need to do to straighten the image. Move the end points of the line until it lines up with a horizontal or vertical line in the image—in this case the horizon.

STEP 4 Then click the Apply button, or double-click the photo, to apply the straightening. Bear in mind that when you straighten a photo like this the edges are cropped, and the more straightening you require, the more of the edges you'll lose.

Perspective Correction

STEP 1 As well as straightforward editing tasks like opening and straightening images, the Learning Center can help you with more advanced techniques. The Perspective Correction tool can be used to straighten "converging verticals"—the tendency for tall buildings to appear to be falling backward when you tilt the camera upward. Start by opening the problem photo and selecting the Adjust button on the Learning Center home page.

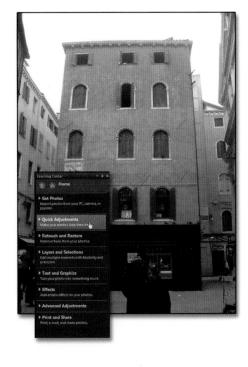

STEP 2 Click the Advanced Adjustments page on the Learning Center home page, followed by the Perspective Correction button. The Perspective Correction tool is selected, and a rectangular box appears in the center of the image window.

STEP 3 Follow the instructions in the Learning Center to align the box with the edges of the building. If the building shape is irregular and you find alignment difficult, enter a number of around 4 to 8 in the Grid Lines box in the Tool Options palette. This applies a grid to the perspective rectangle, making it easier to align it with what should be vertical features on the building.

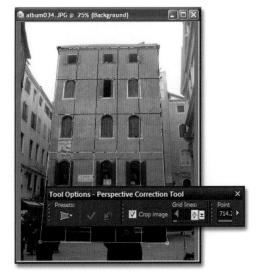

STEP 4 Click the Apply button to correct the perspective distortion. If you check the Crop Image box, the edges of the photo will be cropped to remove the white space that appears as a result.

Cropping Pictures

After a while you'll find you can do without the Learning Center for simple and even more advanced editing tasks. Most pictures need cropping for aesthetic reasons, and there are few pictures that can't be improved by removing some of the detail around the outside to focus attention on the central subject. You might also want to crop a picture to change its proportions for printing—for example, so that it will fit a 4 \times 6 inch or 5 \times 7 inch frame or a space on a web page.

Tip

Select the Crop tool, click the Presets button on the Options palette, and select one of the preset crop sizes from the pull-down menu. You can save your own crop settings to this list, enabling you to quickly apply custom crop settings to any number of images.

STEP 1 Open a picture, and choose the Crop tool from the Tools toolbar. The image area outside the crop rectangle is shaded. Adjust the crop area size or position.

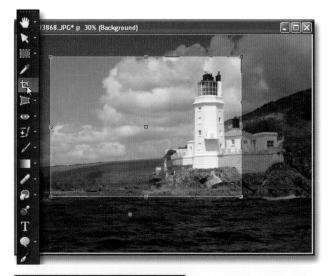

STEP 2 Click inside the crop area, and drag to reposition it. You can constrain the crop area to its existing proportions by holding down the Shift key. If you're cropping for a standard-sized photo frame, choose a preset from the Options palette.

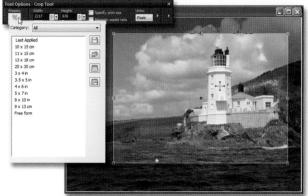

STEP 3 When you're satisfied with the area you've chosen, double-click in the crop area or click the Apply button (the green checkmark) on the Tool Options palette to crop the image. The inside section of the marquee remains, whereas the image contents outside the crop area are discarded. Care must be taken so as not to crop off too much! If it is not right, choose Edit > Undo or Ctrl + Z.

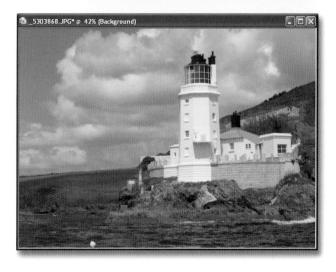

PaintShop Pro X4 for Photographers

If you know the dimensions that the picture is to be cropped to, click the Specify Print Size check box and enter the dimensions in the Width/Height and Units fields provided. The crop area automatically appears in the correct proportions for the desired crop. If you have many photos to be cropped for, say, a web gallery, this is a very productive tool. Click-drag any of the corner "handles" or edges to expand or contract the crop dimensions while maintaining proportions.

You can also snap the Crop tool to a previously made selection in the image, its layer opaqueness, or a layer's merged opaqueness. Once the cropped image is saved, the discarded area cannot be recovered. As a general rule, you should click File > Save As to save a copy and make sure you have the originals safely backed up on a CD!

The Manage Workspace

Organizing Your Photos

What's Covered in this Chapter

This chapter explains what the Manage workspace is and how you can use it to organize and manage your photos. As well as the image itself, a photo file contains text metadata, some metadata is recorded by the camera, other details can be added in PaintShop Pro X4.

- In this chapter I'll show you how to use the existing metadata in your photos and how to add captions, ratings and keyword tags.
- You'll learn how to search for images using this information and how to turn searches into Smart Collections.
- The Manage workspace can be used to organize and edit camera RAW files and I'll show you how that's done.
- Finally the Step-by-step projects demonstrate how to caption, rate and tag photos and how to apply a series of edits to several images at once.

PaintShop Pro X4's Manage workspace is where you keep track of all your photos, organize them into collections, rate them, and apply captions, keywords, and other metadata. You can open images from the Manage

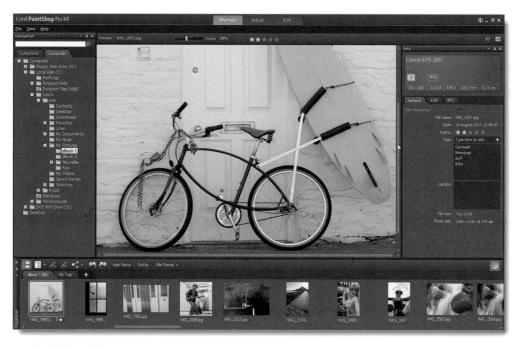

FIG 2.1 The default view of the Manage workspace is Preview mode, which arranges the Navigation palette, Info palette, and Organizer palette around a central Preview area.

workspace into the Adjust or Edit workspaces and you can view and prepare camera RAW images.

When you first open the Manage workspace, what you see will most likely look like Figure 2.1. The default view is arranged over four areas. On the left is the Navigation palette, which shows the structure of folders and files on your computer; use it to navigate to where you keep your photos, and the contents of any folder will be displayed in the Organizer palette at the bottom. A preview of any thumbnail you select is displayed in the Preview area, and information about the selected image—including the exposure data, file name, file size, caption, and associated keyword data—is displayed in the Info panel on the right of the screen.

The Manage workspace is customizable, and you can change the layout to better suit the way you like to work. It's currently in Preview mode, which is good if you want to get a look at each of your photos. For more of an overview, switch to Thumbnail mode by clicking the Thumbnail mode button at the top right next to the grayed Preview mode button. You can switch back to Preview mode at any time by pressing the Preview mode button.

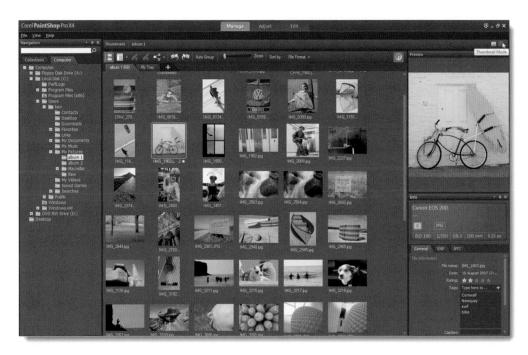

FIG 2.2 Use Thumbnail mode to get an overview of the contents of a folder, and for searching and sorting folders of images.

In Thumbnail mode, the Preview window shrinks to a small panel on top of the Info palette, and the Organizer palette expands to fill the central space. Atop it the Organizer toolbar has controls for, among other things, grouping similar thumbnails, sharing photos, sorting thumbnails, rotating photos, changing the photos' size, and printing a contact sheet. If you've upgraded from PaintShop Photo Pro X3 and are looking for the Search field, it has been moved from the Organizer palette to the top of the Navigation palette. Its function is the same though; you can use it to search image metadata—for example, to locate an image from its caption or keyword tags.

You can further customize the workspace in both Preview and Thumbnail views by changing the size of the panels and windows by dragging the boundaries between them. Hover over the line dividing two panels until the cursor changes to a double bar with a double-headed arrow and drag to expand one panel and contract the other.

The Navigation Palette

Take a closer look at the Navigation palette, and you'll see that it has two tabs. The default view—the Computer tab—shows the structure of folders on your computer, but this isn't always the best or easiest way to organize your photos. The Collections tab allows you to arrange your images in a way that

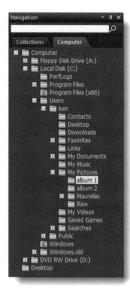

FIG 2.3 The Computer tab on the Navigation palette shows the contents of the hard drives and folders on your PC. It shows you everything and, if you're used to navigating folders in Windows, you'll quickly find what you're looking for, but all that other stuff mostly just gets in the way.

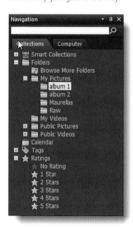

FIG 2.4 The Collections tab provides a much less cluttered way to view and organize your photos because it shows only those folders you choose—in other words, only those containing photos and video.

isn't tied to how you keep them on your hard drive—it's not bound by the folder and file name conventions used by Windows.

Using the Computer Tab

If it isn't already selected, click the Computer tab at the top of the Navigation palette to display a Windows Explorer-style list of all of the disk drives and folders on your PC. Click the plus symbol next to a drive or folder to expand the list and reveal its contents. The thumbnail panel remains empty until you click on a folder that contains images or video.

You can organize your images using only the Computer tab of the Navigation palette, locating folders of pictures on your computer and carrying out all of the manage functions, such as captioning and rating, described later, but then you'd be missing out on one of the Manage workspace's best features. The problem with the Computer tab is that it shows you all of the disks and folders on your PC, whether they contain photos or not. Most people keep all of their photos in one place and all that other stuff—folders containing applications, text documents, spreadsheets, stuff downloaded from websites, your personal finances—just gets in the way. The Collections tab lets you concentrate only on the folders containing your photos and videos.

The other really useful thing the Collections tab can do is to group photos on the basis of their content, rather than where they happen to be on your hard drive.

Using the Collections Tab

Click the collections tab at the top of the Navigation palette and you'll see a list that contains five items, each of which can be expanded by clicking the plus icon next to it. For now, click the plus icon to expand the folders list. What you see here will depend to an extent on your version of Windows. Windows 7 users will see four folders: My Pictures, My Videos, Public Pictures, and Public Videos.

There's one other item in the list, which looks like a folder but isn't. Click the Browse More Folders button and a dialog box opens that you can use to search for folders on your hard disk and add them to the Folders list. If you select a folder containing subfolders, all the subfolders are added too. So, if you keep all of your photos in a folder on your hard drive called "Pictures," which contains subfolders like "summer holiday 2010" and "Joe and Anna's wedding," just select the Pictures folder and everything else will be added automatically, neatly arranged in subfolders just like on your hard drive.

We'll come back to the Collections tab of the Navigation palette after we've taken a look at some other aspects of the Manage workspace, including how to add captions, keywords, and other metadata to your photos.

Using the Info Palette

The Info palette displays metadata—information about your photos—which you can edit and add to. Adding metadata like caption information and keywords tells you and others more about your images than the picture data alone can. It also helps when it comes to finding particular photos, computers being much more adept at recognizing words than pictures.

As we saw in the previous chapter, the Info Palette has three tabs—General, EXIF, and IPTC. First, let's take a look at what you can do on the General tab.

Adding a Rating

Below the image preview in the Info palette you'll see a Rating section with five stars. If you haven't rated any of your images, the stars will appear grayed. Hover over them with your mouse and they turn gold. Click on one of the stars to apply that rating to the selected image. That's all there is to it. If you change your mind, just click on the same star to remove the rating or one of the others to change it.

As you'll discover in the section about searching and Smart Collections, rating your images is one of the best ways to sort them, allowing you to quickly locate your best shots.

OLYMPUS IMAGING CORP. E-P3 TO DIFF IPG TO DIFF IPTC File information File name: P8200702.IPG Date: 20 August 2011 10:.... Rating: 常意意意

FIG 2.6 To add a tag to a photo, select the thumbnail, type the keyword into the Tag field, then press Enter or click the Add Tag button to the right.

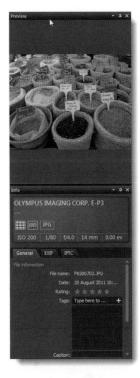

FIG 2.5 In Thumbnails mode, the Info palette sits underneath the Preview panel.

Adding Keyword Tags

Underneath the Ratings section is the Tags section, which is where you assign keywords to your images. To add a new tag to an image, type the tag in the top field, then click the Add Tag button to the right and it will appear in the tag list below. To add further tags, just keep typing them in and adding them to the list.

Is there an easier way to add keywords than typing them individually for every image? Yes, there is. Each time you add a keyword to a photo, it is added to the tag list in the collections tab of the Navigation palette. Once you've added a few keywords, click the plus sign next to tags in the Collections tab of the Navigation palette to expand the keyword list. You'll see all of the keywords you just added, in addition to every keyword tag you've ever previously added to a photo.

Tip

The best way to apply ratings is to use Quick Review. Double-click the first thumbnail in a tray to launch Quick Review, click to set the rating, click the next button, and continue. You can speed the process up even more using keyboard shortcuts—press Ctrl plus the number of stars you want to assign.

FIG 2.7 Every image tag is added to the Tag list in the Collections tab of the Navigation palette. Click the plus icon next to Tags to expand it and see them all.

Tip

You can add keyword tags and captions to multiple images by selecting their thumbnails in the Organizer palette and typing in the Tags and Caption fields of the General tab on the info palette.

To add these tags to other images, first select the images in the Thumbnail pane, then drag and drop them onto the keyword you want to apply.

The way to get all your keywording done quickly without it turning into a tedious chore is to start with the most generic keywords and work your way down to more specific ones. For example, let's say you've spent a day at the beach with your family. You'll want to add the tag "beach" to most, if not all , of those shots, so select the first thumbnail, then press Ctr + A to select them all and drag them onto the word "beach" in the tags list.

A lot of your photos are of the sandcastle competition, so Ctrl-click to select those thumbnails and drag them onto the Sandcastle tag, then onto the competition tag. Remember, to get these words into the Tag list you'll first need to apply them to a single image by adding them in the Tags section of the General Info panel.

Keep on going in this fashion, selecting and tagging batches of images with common keywords—"family members," and so on. Eventually, you'll be dealing with small groups and eventually single images that you can keyword tag from the Info palette.

Once all your photos are tagged, finding photos that contain a particular tag is easy. Just select the tag from the list in the Navigation palette and all of the photos tagged with that word will be displayed in the Thumbnails panel.

Adding a Caption

Like keyword tagging, captions can be applied to batches of photos. Shift or Ctrl-click to select the photos you want to caption, then type the text into the Caption field in the General Info panel. If you can't be bothered to individually caption your images, give them all a more general caption—"Beach trip, Cornwall, UK, August 2011," for example. You can always go back and edit them later if you have time.

The EXIF Tab

The Info palette's EXIF tab is divided into two sections. The top section displays the file info and below it is the camera data recorded at the time the shot was taken. There's quite a lot of information on this tab, and you won't be able to see all or even most of it because in Thumbnail mode the Preview takes up the top part of the right side of the screen, and in Thumbnail mode the Organizer palette runs across the bottom. You could close either the Preview pane or the Organizer by clicking their close buttons, but there's a better way to manage your screen space.

If you're not already in Preview mode, click the Preview button at the top right of the screen. Now go to the title bar of the Organizer palette on the

left and click the pushpin just below the close icon. When you do this, the Organizer palette will disappear, but only temporarily. Look closely and you'll see the Organizer palette title tab is still there, and if you roll over it, it will reappear.

You can autohide or "roll up" other palettes in the same way, either by clicking the pushpin icon (click it again to turn off the feature) or clicking the button below the pushpin and selecting Auto Hide from the palette menu.

Now you have a better view of the Info palette, but you'll still need to scroll to see all of the camera data.

EXIF data can tell you a lot of things, including the date and time the image was taken, the camera model, exposure settings, the lens focal length, the exposure mode, and whether a flash was used. Generally, EXIF data are not editable—there's no reason you'd want to change it.

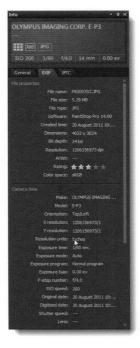

FIG 2.8 The EXIF section of the Info palette is divided into two subsections: File properties and Camera data. The EXIF section shown here displays the camera make and model, exposure details, and other metadata recorded by the camera at exposure time.

IPTC

Unlike EXIF, the IPTC section of the advanced Info panel contains information that is added after the event, by the photographer or others. IPTC stands for International Press Telecommunications Council, the body that defined the standard. The IPTC standard for this kind of information was developed so that newspaper picture desks, stock photo libraries, and other organizations dealing with lots of photos from lots of different sources would find it easier to manage them. But that doesn't mean IPTC data aren't useful to everyone else.

If you've added captions to your photos, you'll notice that they appear in the Description IPTC field, where you can edit them. Your changes will be updated in the Caption field of the General Info panel—it's the same information; it just appears in two different places with a different label.

Other IPTC fields that are useful include Author and Credit, which you can use to state your ownership as the photographer and to add a copyright notice—useful if you apply to competitions or send your images for potential use in publications.

Earlier we looked at how to add folders of photos to the Collections tab of the Navigation palette. Then we saw how you can add keywords and other metadata to the existing metadata recorded by your camera and stored with

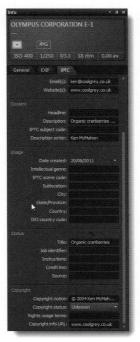

FIG 2.9 Use the IPTC subsection of Advanced info to add and edit caption (description), title, and author credits.

each individual image file. Now we'll see how all this organization pays off by making it easy to quickly locate your photos and organize them into meaningful collections.

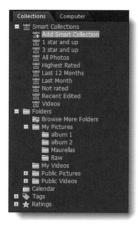

FIG 2.10 Smart Collections are saved searches. The Organizer has a few preset ones including "Last 12 months," which displays all the photos you've taken in—that's right—the last year.

Searching and Smart Collections

Click the plus icon next to the Smart Collections item at the top of the Collections tab on the Navigation palette to reveal the list of existing Smart Collections. Click the Smart Selection called "Last 12 Months" and, provided you've cataloged a folder of recent images (see Using the Collections tab earlier), the Thumbnails panel will display all of the shots taken during the last 12 months.

Using Search and Advanced Searching

We'll come back to Smart Collections in a minute. There's another way to search for photos using the metadata they contain. As I mentioned earlier in this chapter, the Navigation palette has a text search field. Type anything in here and the Organizer will show you thumbnails of all the images that contain what you type in any of the metadata fields or the file names of your images. Before using search, select All Photos from the Collections tab to search all of your cataloged images. Alternatively, you can search within a folder—either in the Collections tab or the Computer tab.

For more advanced search options, select "Add Smart Collection"—the first item under Smart Collections on the Collections tab—to open the Smart Collection dialog. Use the left pull-down menu to select the search criteria; you can search by image name, caption, date, size, file type, keyword tag, edited date, or rating. The next pull-down menu defines how the search engine matches the search term. Normally you'll set this to "contains," but "starts with" and "ends with" can be useful, or you might want to search for images that don't contain a particular search term. Next, type your search term into the field on the right.

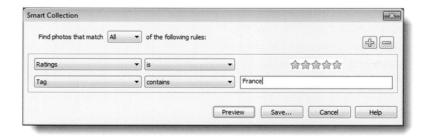

FIG 2.11 Using the Smart Collection dialog, you can search for images that match all or any of multiple search criteria.

If you want to search for more than one term, click the plus icon to add another line. For example, you might want to search for images that contain the keyword "beach" and were taken after January 1, 2011. In this case, the first line of your advanced search would read, "Tag contains beach" and the second line would read, "Image date is after 01/01/2011."

There's one final thing you need to consider before applying the search criteria. The pull-down menu at the top of the Smart Collection dialog has two settings. The default position is "Find photos that match All of the following rules." This means that if you select multiple criteria, like our beach example, only photos that comply with all of them will be displayed (i.e., they must contain the tag "beach" and be taken after January 1, 2011). Changing this to "Find photos that match Any of the following rules" means that only one of your criteria need be matched for images to be displayed. With "Any" selected, all photos tagged with the keyword "beach" will be displayed, regardless of when they were taken. Likewise, all photos taken after January 1, 2011 will be displayed, even if they aren't tagged with the "beach" keyword.

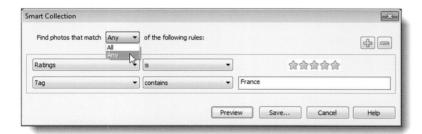

FIG 2.12 Searching multiple criteria using "find any" results in a wider range of images that match any of the search criteria.

Saving Searches as Smart Collections

When you've entered your search criteria and rules, click the Preview button to see all of the images that match. Click the Save button, and enter a name to save your advanced search to the Smart Collections list in the Collections tab of the Navigation palette. Now you can access the same search simply by clicking its name in the Smart Collections list. You can also duplicate and edit existing Smart Collections.

First, click Add Smart Collection, then choose Ratings from the left pull-down menu in the Smart Collection dialog. Leave the middle menu set to "is" and click the fifth star to set the rating to 5. Click the Save button and call the Smart Collection "Highest Rated" or "5 Star photos" and click Save. That's it!

I find these ratings-based Smart Collections really useful. Here's how to make another one, using a duplicate of the 5-star Smart Collection, that shows all your 3-star and higher rated shots.

First, right-click the "Highest Rated" (or whatever you decided to call it) Smart Collection in the Collections tab, select Duplicate from the contextual menu, and enter "3 star and up" in the Save as a Smart Collection dialog. Click OK to add the new Smart Collection to the list.

FIG 2.13 You can duplicate and edit Smart Collections to create new ones. In this case, the Highest Rated Smart Collection has been edited to produce a more useful "Rated 3 stars and above" one.

Now right-click your new "Rated 3 star and above" Smart Collection and select Edit from the contextual menu. The Smart Collection dialog shows "Rating is 5 stars"—the setup for the Highest Rated Smart Collection, which we duplicated. Change it to "Rating is greater than 3 stars" and click the Save button—you'll be prompted with another dialog containing the name of the Smart Collection; as you've already renamed it, just click save. Now when you select the "Rated 3 star and above" Smart Selection you'll see all images that have a 3-star or higher rating.

Smart Selections are live—whenever you catalog new folders of images by adding them to the Collections tab, your Smart Collections will automatically update to include them. So from now on any new images that you assign a 3-star or higher rating to will appear when you choose the "Rated 3 star and above" Smart Selection.

Working with Camera RAW Images

PaintShop Pro X4 supports camera RAW image file formats for a wide range of camera manufacturers and models. As new models are released, Corel updates the application to provide support for them, so, even if your camera is a recent model, the chances are it will be supported. To check, go to www.corel.com and select Knowledgebase from the Support menu; then type "PaintShop raw support list" in the search box and click the search button.

What are camera RAW files and why should you use them? Camera RAW is a proprietary format that's available on most digital single lens reflex (SLR) cameras and some advanced compacts. If you're not using RAW, your camera processes the information collected by the sensor and saves it as an RGB image file with JPEG compression (see Chapter 9 for more detail about how JPEG compression works). As well as compressing the file, in the process of converting the RAW file to a JPEG a lot of the original image data are discarded. By shooting and recording the RAW data, then doing the conversion yourself in PaintShop Pro X4, you can make your own decisions about how best to perform the conversion and get a better quality image than if you'd left it to your camera.

One of the main advantages of shooting and processing RAW files is that you can import them into PaintShop Pro X4 for editing as 16-bit RGB files—retaining all of the bit data for each pixel that the camera was capable of recording. When you shoot JPEG images, the files are automatically down-sampled to 8 bits per pixel, giving you much less scope when it comes to making tonal and color corrections and other edits.

The downside to this is that, with more bits per pixel and no JPEG compression applied, RAW files are much larger than JPEGs and eat up your memory card and hard disk space more quickly. With the falling cost of storage, this isn't the big issue it used to be though. And, when you've finished editing, you can always down-sample files to 8 bits per pixel (select Image > Decrease Color Depth > RGB—8 bits/channel). Just remember to keep a backup of your original RAW files.

The Organizer displays thumbnails for supported RAW files. Camera RAW files are processed by PaintShop Pro X4 in the Camera RAW Lab. To open a file into the Camera RAW Lab, double-click its thumbnail. To process more than one image at a time, Shift- or Ctrl-click to select several thumbnails and then right-click and select "Edit photo" from the contextual menu.

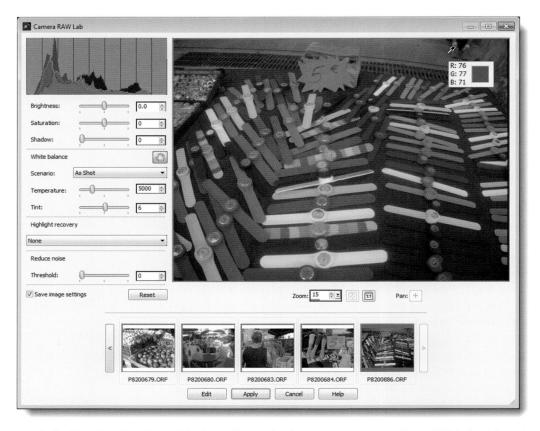

FIG 2.14 Double-click RAW thumbnails (or right-click and select "Edit photo") in the Organizer to open them into Camera RAW Lab. Several files can be opened into the lab for editing at the same time.

The Camera RAW Lab window displays a preview image at the top. To get a better look, maximize the window. It's important to understand that what you're looking at is an RGB interpretation of the RAW data. By adjusting the controls in Camera RAW Lab, you can interpret the data differently to produce different results, finally outputting an RGB file for editing in the Full Editor or saving the settings to a "sidecar" file that's associated with the original RAW file.

Two things about this approach are radically different from the way you might be used to working with image files. First, you can't make changes to and save RAW files; RAW files are, in effect, locked. Because the data in a RAW file aren't in RGB format, they can't be edited in the conventional way. Instead, any changes you apply in the Camera RAW Lab are saved in the database and applied when you next open the RAW file in the Camera RAW Lab.

The second thing is that these changes in interpretation aren't destructive in the same way that editing an RGB file can be. You're not manipulating pixels, but reinterpreting the information in the RAW file to produce a different outcome. When you're happy with that interpretation, you can output the file in RGB format for further editing in PaintShop Pro X4 or simply save it in any RGB format, such as TIFF, JPEG, or PSPIMAGE once you've clicked the Edit button to open it in the Edit workspace.

So let's take a look at the controls in the Camera RAW Lab. Below the histogram on the right you'll find four panels with controls for adjusting tonality and saturation, white balance, highlight recovery, and noise reduction.

The Brightness slider is used to rescue under- or overexposed photos. It will be obvious from the preview if your photo is under- or overexposed, but the histogram can help you make a diagnosis as well as tell you how much correction is needed (see page 66). Drag the Brightness slider to the right to fix underexposed shots and to the left to correct overexposure.

Remember what I said earlier about Camera RAW Lab interpreting the data in you RAW files and how that's not the same thing as applying similar adjustments in the Edit workspace? Not only will these changes in the Camera RAW Lab produce better results, you have a lot more scope for correction. The Brightness slider extends to plus or minus 3, which means you can effectively correct up to three stops of under- or over-exposure—more than you could hope to achieve working on an 8-bit JPEG file in the Edit workspace.

The Saturation slider works in much the same way for RGB files. It's good for making small changes to saturation, but you don't want to go too far with it. The Shadow slider can be used to add contrast to slightly overexposed or flat shots that are lacking solid blacks

Next are the white balance controls. Ordinarily white balance is applied in the camera—all you need to do is set the white balance to automatic or one of the available presets. But, as we've seen, none of this in-camera processing occurs when you shoot RAW and the white balance can be applied later. This is hugely advantageous, as it allows you to easily remove color casts caused by incorrectly setting the white balance or by the camera's auto white balance getting it wrong—it happens.

There are three white balance controls. A drop-down menu provides presets, one of which is the camera's "As shot" white balance setting. Others include common lighting setups like daylight, tungsten, flash, and fluorescent lighting. More control is provided via two sliders below. The main one sets the color temperature—you can enter it numerically in the adjoining field. Dragging it to the left, or entering a lower value, makes the image cooler or more blue; dragging the control in the opposite direction makes the image become warmer or more yellow.

If you know anything about color temperature, this may seem a little counterintuitive. On the Kelvin scale used to represent color temperature,

the higher the color temperature, the bluer the light; so how come setting a higher color temperature makes the image warmer? The answer is that the setting represents the color temperature of the prevailing lighting conditions when the photo was taken. By dragging the slider to a higher color temperature, you're telling Camera RAW Lab the light used to create the image was cooler (more blue) than the currently specified setting and therefore the result is a warmer (more yellow) image.

FIG 2.15 These two images show the same RAW file saved to RGB using different white balance settings in Camera RAW Lab. The one on top was saved with the "as shot" white balance of 7770; the one below was saved with the white balance adjusted to 12500.

The Tint slider below the Temperature sliders is used to eliminate green/magenta casts. Drag it to the right to add green (remove magenta) and to the left to add magenta (remove green).

The next panel down provides noise reduction controls. This has been simplified from the two-slider setup in PaintShop Photo Pro X3. Now there's just one slider labeled Threshold, which goes from 0 to 100. The higher the setting, the more noise filtering is applied. But beware. Beyond a certain point you'll start to lose fine detail in your image because the noise filter softens and smooths image detail to suppress the noise. Used sensibly, though, these controls in the Camera RAW Lab can give you a head start by removing some of the digital noise from high ISO shots.

When you're happy with your adjustments, you can either click Apply to save them to the database (they'll be there the next time you open the RAW file in Camera RAW Lab) or click Edit to open the image as an RGB file in the Edit workspace.

Step-by-Step Projects

Managing Metadata Captioning, Rating, and Tagging Photos

Whenever you download a card of photos to your PC, it's always a good idea to rate them and add keyword tags and a caption. Don't put this off! If you do, you'll probably never get around to it and you'll be missing out on one of PaintShop Pro X4's most useful features. Tagging and captioning your photos will make them much easier to find in the future.

STEP 1 If you're not already in the Manage workspace, click the Manage tab at the top of the screen and use the Navigation palette to locate the folder containing your photos. If you're in Preview mode, click the Thumbnail mode button at the top right. Double-click the first thumbnail to enter Quick Review mode.

STEP 2 This is the Quick Review workspace. If you can't see the tool panel at the bottom, move your mouse around and it will appear (it disappears after a few seconds of activity to give you a clear view of the photo). Apply a star rating to the photo by clicking one of the star buttons in the center of the tool panel, then advance to the next photo either by clicking the next button under the

star rating or by pressing the right arrow on your keyboard. I find it's easiest to have one hand on the keyboard navigating back and forth through the photos and the other on the mouse (or trackpad) to apply ratings.

STEP 3 Keep on going until you've rated every photo. Use the rotate buttons on the left to rotate photos and, if they're really awful, click the trash button to delete them. This will remove them from the folder and put the image file in the Windows Recycle bin. There are buttons on the right to zoom in to 100% view and back out to fit in the window, but if you want a closer look—for example, to check the focus—just click once to zoom in. While zoomed in you can move around by clicking and dragging, then zoom out again with a single click.

STEP 4 Every time you hit the Delete button, a warning appears asking you if you really want to delete the photo, which can get a bit tedious, particularly if you want to delete a lot of shots. You can turn this warning off, which makes deleting photos a lot easier but clearly carries its own dangers. Once you've done this you don't get any second chances (though you can fish

accidentally deleted images out of the Recycle Bin in an emergency). From the File menu select Preferences > General Program Preferences and select Warnings from the list on the left. Now uncheck the box that says "WARNING—Confirm before deleting a file."

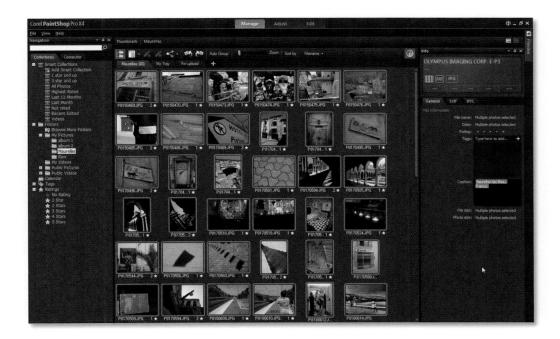

STEP 5 When you've rated the last image, hit escape, or click the close icon top right to exit Quick Review. Now it's time to caption every shot. You could go through captioning every shot individually, but that would take time and, in any case, many of your shots will probably share the same caption, or at least part of it. This folder of photos was mostly shot in and around the village of Maureillas las Illas in Southern France, so that's what we'll add as a caption. Back in the Manage workspace, click on any thumbnail, then press Ctrl + A to select all. In the Caption field of the General tab on the Info palette, type your caption, in this case "Maureillas las Illas, France," and hit return. It may take a short while to caption an entire folder of photos.

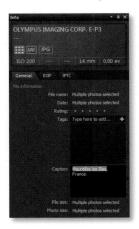

STEP 6 Click in between two thumbnails to deselect them. Some of these shots were taken in the nearby town of Ceret, so we're going to recaption them. Click the first thumbnail and Ctrl-click subsequent thumbnails to add them to the selection. Then simply overwrite the Caption field with the new caption (in this case "Ceret, France."). Likewise, make group selections of other images you want to recaption. It's often a case of just adding to the caption to make it more specific (e.g., "Shop, Maureillas las Illas, France" or "Street market, Ceret, France"). Eventually, you'll get to amending captions for individual images—"Harry buying sunflowers in the street market, Ceret, France." Even if you don't have patience for these individual captions, you'll have no problem locating the photos (or all your photos of street markets or Harry) by typing the relevant search term into the Search field at the top of the Navigation palette.

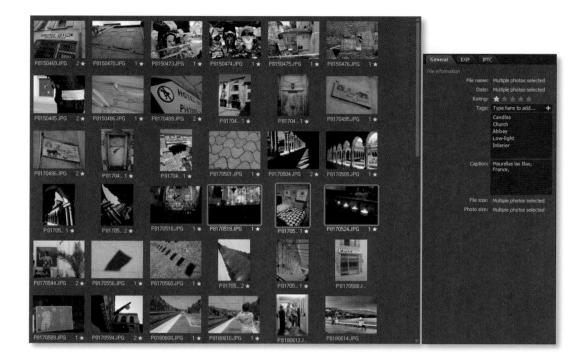

STEP 7 The final step in the process is to add some tags to your folder of images. As with captioning, there are some tags that you'll want to add to lots of photos. There are two ways you can do this. The first is by selecting multiple thumbnails, as we did for the captioning, and typing the keyword into the Tag field in the General tab of the Info palette (above the Caption field). Here, I've selected three thumbnails and added the word "candles." Click the plus sign (or press Enter) at the right of the Tag field to add the tag, then enter any other tags you want and add them in the same way. Here I've added "Church," "Abbey," "Interior," and "Low-light."

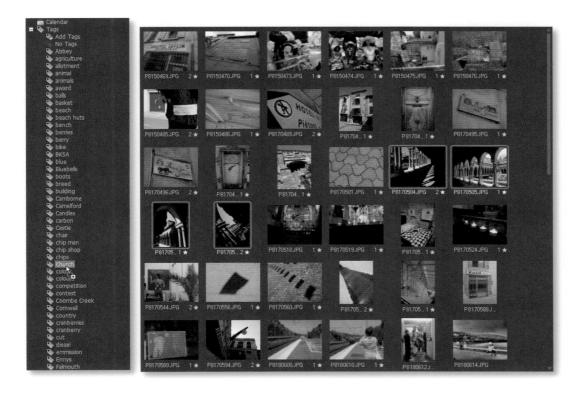

STEP 8 I've got several other photos of churches I took on this trip, some in the same location, but they don't have candles and they're not all low-light interior shots. I could just select these and add the "Church" or "Abbey" keyword in the same way, but there's an easier way that ensures I use the exact same keyword as before and don't mistype it or change the capitalization. Click the + button next to Tags in the Navigation palette to expand the list of tags. Here you'll see all the keywords you've ever added to photos including the ones we added in the previous step. To add the "Church" keyword to several new thumbnails, Ctrl-click to select them then drag them onto the "Church" keyword in the Tag list in the Navigation palette.

STEP 9 Continue to add keyword tags to images as described in the previous two steps. If you want to see all the shots tagged with a particular keyword, just select it from the Tag list. And, to check for any photos that haven't been tagged, click No tags at the top of the Tag list. With your images rated, captioned, and keyword tagged, you now have several ways to organize, select, and search for them.

Using the Organizer Applying a Series of Image Edits to Multiple Photos

One of PaintShop Pro's really useful features, introduced in the previous version, is the ability to capture a whole editing session from one image and apply it to many others. This feature is particularly useful for applying edits to Camera RAW files, but can be applied to any image that you've already edited in PaintShop Pro.

When dealing with RGB files, you can only capture and apply an edit list from photos that have been edited during your current session (the changes don't need to have been saved though). PaintShop Pro X4 keeps lists of all the edits you make to images (it uses these lists for the Undo command), but, once you exit the program, the lists are deleted.

If you recall, when you make changes to a camera RAW file, they're not saved to the RAW file itself but as a list of edits in the database. This means that those lists are always available to PaintShop Pro (it applies them each time you open the program and view thumbnails for RAW files in the Organizer). And that means the current session limitation doesn't apply to RAW files; you can capture the settings you applied to them in Camera RAW Lab at any time and apply them to as many other RAW files as you like.

STEP 1 Select a RAW thumbnail in the Organizer in the Manage workspace that you've previously edited in Camera RAW Lab and click the Capture Editing button on the Organizer toolbar.

STEP 2 Now select all the other RAW image thumbnails that you want to apply the same settings to and click the Apply Editing button. If you selected more than a handful of images, it may take a short while for them all to be processed. You can undo these changes by right-clicking and choosing revert, but only during the current editing session, so make sure you have backups! For RAW files though, all you're doing is changing the settings that determine how the RAW data in the original file are interpreted. And you could always open up one of the changed files, reset everything back to the way it was, then capture that file's editing and reapply it to the others to get back to where you started.

STEP 3 That's it! It really is that simple. I probably don't need to reiterate that all you've done is changed the RAW settings that are applied when you create an RGB file. To do that, you'll need to right-click and select Convert Raw from the menu.

Improving Your Photos Basic Editing

What's Covered in this Chapter

• This chapter explains how to use PaintShop Pro X4's tools to improve digital photos that suffer from common problems like incorrect exposure or are simply a bit dull and lifeless and need polishing up. PaintShop Pro X4 has a selection of tools, like Smart Photo Fix and Color Balance, that do most of the work for you and make it easy to get good results with very little effort. You'll have read in Chapter 1 that there are two workspaces designed for this kind of work. We'll begin by looking at practical things you can do to improve your photos using the Adjust workspace before moving on to explain in detail what kinds of tools are available in the Edit workspace and how to make the best use of them. Later in the chapter, we'll look at some of the more advanced tools for enhancing image quality, like Hue/ Saturation/Lightness, Levels, Histogram Adjustment, the Unsharp Mask filter, and the High Pass Sharpen filter.

- There are so many tools in PaintShop Pro X4 that it's sometimes difficult to know where to start, but if you work through this chapter you'll discover one of its biggest strengths; you can start with the simple tools like Smart Photo Fix and, if you can't get good results, move on to the more advanced tools that target specific exposure and color problems.
- It's not all about fixing pictures. Tools like Hue/Saturation/Lightness, Curves, and the Hue Map can be used creatively to replace colors, and this chapter also touches briefly on how to do this.
- Sharpening digital photos is something that can hugely improve picture quality, but there's more to it than simply whacking on the Unsharp Mask filter. Toward the end of the chapter I'll show you how to do it properly, and, for those who want to squeeze every last drop of sharpness out of their photos without introducing other problems like noise and haloing, there's a step-by-step project that covers advanced sharpening using the High Pass Sharpen filter.
- Another step-by-step project goes into detail on how to use Smart Photo
 Fix. Though this is covered comprehensively in the text, it's such a useful
 tool that I thought a hands-on walk-through would be a big help if you
 haven't used this tool before. The third project explores how to use Camera
 RAW Lab to restore detail in overexposed photos.

Adjust or Edit?

PaintShop Pro X4 has a bewilderingly large array of tools for fixing up photos, so many, in fact, that knowing where to start can be a problem. If that's the case, then the short answer is probably to begin with the Adjust workspace. It contains all the tools you need to sort out most of the common problems that affect digital photos, from bad exposure to red-eye removal.

Using the Adjust Workspace

To get started, if you're not already in the Adjust workspace enter it by selecting the Adjust tab at the top of the screen, then select an image to adjust from the Organizer palette. The Smart Photo Fix panel appears in the Adjust palette on the left with four sliders to control brightness, shadows, highlights, and saturation.

Smart Photo Fix

The first thing to do is ignore the sliders and click the Suggest Settings button at the top of the Smart Photo Fix panel. This almost always improves the image, but there may be more that you can do. You'll notice that the sliders have moved with the suggested settings. Now is your chance to tweak them to see if you can improve on the suggested settings.

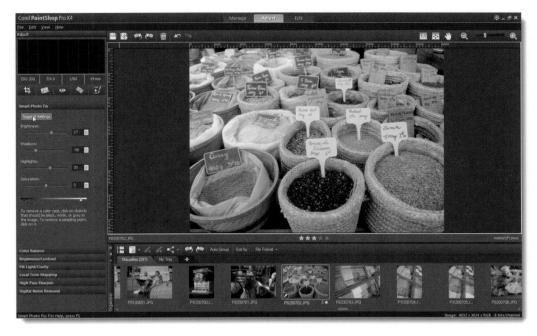

FIG 3.1 With Smart Photo Fix, start by clicking the Suggest Settings button. More often than not it will result in a marked improvement, and at the very least it will provide you with a result you can improve on using the sliders.

With all these adjustments you need to be careful not to overdo it, particularly when you're altering the tonal qualities of an image, as we are here. The Brightness slider, for example, can be used to compensate for a small degree of over- or underexposure, but nothing like the degree to which you can adjust camera RAW files as discussed in Chapter 2. Keep an eye on the histogram when you're making these changes. Generally you're looking for a graph that just extends to both ends of the x-axis. For more help on understanding the histogram and using it to guide your adjustments, see page 65 later in the chapter.

When you use the Brightness slider you affect the value of every pixel in the image—from the darkest shadows to the brightest highlights. The Shadows and Highlights sliders only affect pixels in their respective tonal ranges. These sliders can be used to make further changes to an incorrectly exposed photo or to add contrast to a flat one. Dragging either slider to the left darkens pixels and dragging to the right lightens them. So, to make the shadows a bit deeper, you'd drag the Shadows slider to the left, and you'd do the same thing with the Highlights slider to recover blown highlights.

The Saturation slider controls the vibrancy of the colors. If the color is looking a bit dull and washed out, you can give it a boost by dragging the slider to the right, and vice versa if the colors look oversaturated and unnatural. If the color saturation looks fine but the colors themselves don't look quite right, maybe the

Tip

At any stage in the process, you can use the Undo and Redo buttons on the Adjust toolbar to get a before and after view of the last change you made.

entire image has a predominant color cast. Or, if a sunlit evening doesn't look quite as warm and inviting as you remember it, position the cursor over the image and it will change to an eyedropper. Now find an area of the image that is, or should be, neutral in color; black and whites are usually the best options, but grays work just as well. Click on that part of the image to add a color sampler and you should see an immediate change in the overall color of the image. If you've selected well, the change will be an improvement. If it isn't, don't worry; just click again on another neutral area to add another sampler.

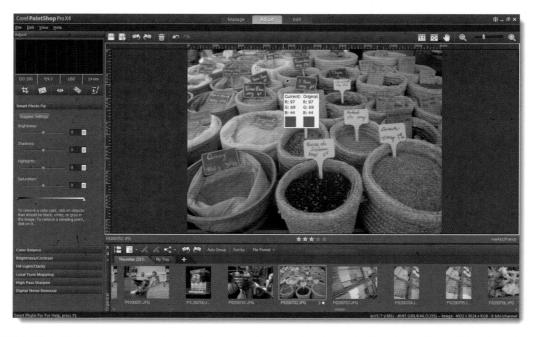

FIG 3.2 Adjust white balance and remove predominant color casts by placing samplers in the image using the eyedropper. You shouldn't need more than one or two sampling points.

You can add as many sampling points as you want, but two or three should be plenty. To delete a sampling point, just click in it with the eyedropper. As you hover over the image, you'll see a color swatch with a numerical readout that tells you the before and after RGB (red, blue, and green) values of the pixel beneath the eyedropper. The closer together these numbers are, the nearer to neutral the pixel already is (for example, 0,0,0 is black, 256,256,256 is white, and 128,128,128 is gray) and the less of a change you'll see if you add a color sampler. Clicking on a non-neutral pixel shifts the color of that pixel toward neutral and makes a similar adjustment to all other colors in the image. So, if you click on a bluish pixel, it will become grayer and all of the colors in the photo will become less blue and more yellow (the opposite or "complementary" color to blue). If you click on a yellow pixel, the reverse will happen.

Now let's take look at some of the other adjustments in the Adjust palette.

Color Balance

Color balance provides a different way of doing what I've just been talking about—making a global adjustment to all the colors in a photo to remove a predominant cast. Instead of Smart Photo Fix's color samplers, there are two sliders, one labeled Cooler/Warmer and the other labeled Purple/Green. If it makes it any easier you can think of the Cooler/Warmer slider as a Blue/ Yellow slider. With these two sliders you can add or remove pretty much any color cast from the image. More often than not, the Cooler/Warmer slider is the only one you'll need. You'll notice there's a numerical readout opposite both sliders. The Green/Purple one goes from —100 to 100, and the Cooler/ Warmer slider goes from 9500 at the cooler end to 2000 at the warmer end. This is the color temperature—a measure of the color of the light, which is explained in a little more detail on page 67.

Brightness/Contrast

Brightness/contrast is something that, at first sight, looks like a useful enough tool, but I'd recommend you treat it with caution. To see why, drag the Brightness slider to the right and watch what happens. Everything in the image gets brighter, which is perhaps what you'd expect, but keep dragging and eventually everything turns pure white. Now, you might think that as long as you keep the adjustments to a minimum brightness is OK, but the problem is it brightens all the pixels in a photo by the same amount when ordinarily you only want to brighten the darker ones. The result is that all the lighter pixels—the highlights in your photo—get blown out to pure white and the detail is lost forever.

The same thing happens for contrast, only doubly so—you lose detail in the shadows and the highlights at the same time. Contrast can make for quite a dramatic effect, but, if you're attempting to improve the tonal quality of your photos, you're much better off sticking to the slider in Smart Photo Fix or venturing into the Edit workspace and using some of the tools described later in this chapter.

Fill Light/Clarity

Fill Light/Clarity is a new tool in PaintShop Pro X4, which, like all of these Adjust palette tools, is also available in the Edit workspace. Fill Light is specifically for adding light into the shadow regions of photos and is particularly useful for shots that are slightly underexposed or where you should've used a fill flash but didn't.

The Clarity half of this tool is more generally useful and in fact I'm not at all sure why Corel has lumped it in with the Fill Light half, but there you are. What is does is difficult to explain but easy to see so have a go with the slider and see what you think. Clarity increases local contrast; in other words, it takes a clump of pixels and lightens the bright ones and darkens the dark

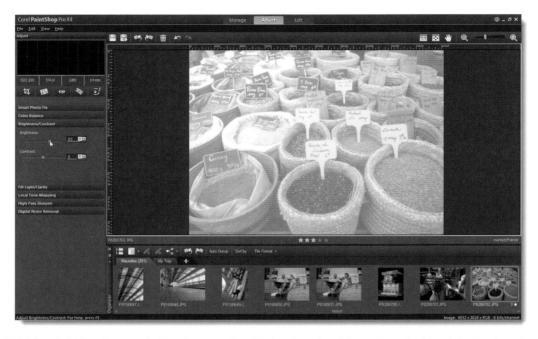

FIG 3.3 Treat the Brightness/Contrast tool with caution. Better still, avoid it altogether, as it won't improve the quality of your photos. No, not even the underexposed ones.

ones. It works in the same way as some sharpening filters only on larger groups of pixels, and the effect, rather than to sharpen the image, is to make it "pop." Well, I did say it was difficult to explain, but it's something that will make the majority of your photos look better. It depends on the individual shot and it's based on your personal judgment, but I'd say a setting of anywhere between 20 and 50 will give good results most of the time.

Local Tone Mapping

Even the Corel help file isn't much help in describing what this does. Tone mapping is a technique used in high dynamic range (HDR) imaging that enables the huge tonal range of an HDR photo to be represented in an 8- or 16-bit RGB file. Local tone mapping as applied in the Adjust palette seems to make little positive difference to image quality, but it can be used as a special effect.

High Pass Sharpen

High Pass Sharpen is a specialist sharpening technique that excels at sharpening image detail without exaggerating noise. There's a step-by-step project at the end of this chapter that demonstrates how to use it in the Edit workspace. If you just want to try it out here, first make sure to click the 1:1 button on the Adjust toolbar so you can see the results properly.

Digital Noise Removal

Again, there's a full description of how to use the Digital Noise Removal filter in the Edit workspace later in Chapter 4 on page 107. Briefly, this filter reduces the impact of digital noise—the graininess inherent in digital photos taken with the camera set on high ISO sensitivities for low light conditions. The detail slider applies the noise reduction so that the further to the right you slide, the more noise filtration will be applied. The problem is that beyond a certain point this will start to soften real image detail, so when this happens you need to back off a little. You can restore detail back into the image by using the Correction Blend slider to blend the noise-filtered version with the original and finally apply some sharpening.

Using the Histogram

The histogram is a graph of the values of all the pixels in the image. Dark pixels have low values and light pixels have high values. Black is 0, white is 255, midgray is 128. So the histogram shows the distribution of pixels in the image from black to white with darker pixels on the left and light ones on the right.

The shape of the histogram depends on the nature of the subject, but generally speaking it should show a reasonably even distribution from black to white. Typical problems like under- and overexposure have very characteristic histograms. In an underexposed image there's a predominance of dark pixels and few, if any, white ones, so the histogram tends to be bunched down at the left-hand end. In overexposed photos the histogram is bunched at the right-hand end, with no black or very dark pixels.

Another problem that is easily confirmed by a quick look at the histogram is lack of contrast. Images that lack contrast look flat and dull. They lack punch because of the absence of pure black and pure white pixels. The tonal range starts at light gray and ends at dark gray, and the histogram this time is all in the middle of the range with no pixels at either end.

In the Smart Photo Fix dialog box, when you make an adjustment with the Brightness sliders the histogram displays a pink overlay, which shows you how the tonal distribution of pixels will change; the original histogram appears in gray. If you drag any of the sliders toward the right (brighter) direction, you'll see the histogram move the same way. Dragging the Shadows and Highlights sliders moves the histogram at the ends, whereas the Overall slider moves the whole thing, but the middle more than the edges.

When making adjustments with the Brightness sliders it is important to remember not to let the histogram slip off either end of the chart—it should taper off just before reaching the end. If you allow pixels to drop off the end of the histogram, you are losing image detail—in the case of highlights, remapping light gray pixels to pure white and, in the shadows, turning darker detail pure black. This applies to all dark and light colors, which are represented by gray pixels in the red, green, and blue channels.

PaintShop Pro X4 for Photographers

FIG 3.4 Understanding histograms will help you make the right decisions about tonal adjustments. (1) In underexposed photos, the graph is bunched down the left-hand side. (2) The histogram for overexposed photos is squeezed up on the right-hand side. (3) The correct exposure shows most detail in the central area of the histogram, but the image lacks contrast. (4) Smart Photo Fix improves things by "stretching" the histogram to produce true blacks and whites. But be careful: using these settings will lose some highlight detail in the lighthouse building—note the clipped burch of pixels on the far right of the histogram.

Using the Edit Workspace

The Edit workspace is the heart of PaintShop Pro X4. In earlier versions of the application the Edit workspace was all you got. The Manage and Adjust workspaces have evolved over time to address the need for managing and applying straightforward adjustments to photos. So the Edit workspace is where you come to make more involved adjustments and to work on bigger projects.

The workspace can look a little intimidating if you're new to it, but the Organizer palette running across the bottom of the screen should be familiar, and the Learning Center, briefly introduced in Chapter 1, is on the right. In Chapter 1, we also walked through what's on the various menus, the toolbars, the palettes, and some of the more advanced editing tools.

Now we're going to take a more in-depth look at the tools available in the Edit workspace and how you can use them. Mostly, these tools are for the kinds of adjustments we've already looked at in the Adjust workspace, but they're more powerful and more versatile and therefore provide more scope both for improving photos and for creating something entirely new.

Tools for Correcting Color Problems

For most situations, Smart Photo Fix provides all the tools you'll need to sort out exposure problems and remove unwanted color casts from your photos. But it's not the best way to deal with every problem, and it's always good to have alternatives. The following tools not only provide an alternative route to sorting out problem photos, but can also be used creatively to introduce new color and tonal effects. Chapter 4 shows you how to introduce color into black-and-white images using some of these tools.

Color Balance

To use PaintShop Pro X4's Color Balance tool, select Adjust > Color Balance. You can check the Preview on Image box to preview the results on the main image, but if you click the Preview triangle on the left you can see before and after previews, which are much more useful, particularly if you maximize the panel.

The Color Balance tool has Basic and Advanced modes. In Basic mode it couldn't be simpler to use—you just drag the slider to the right to make photos warmer, and to the left to make them cooler. If you simply want to neutralize a color cast, check the Smart White Balance box and set the slider in the center.

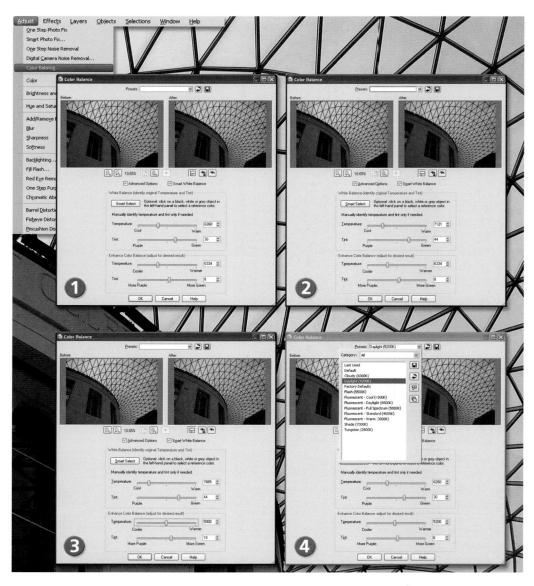

FIG 3.5 Nearly all digital cameras have an automatic white balance feature, which in most circumstances works well to assess the prevailing lighting conditions. It's not foolproof, however, and in this instance has resulted in a blue/green cast. (1) When you select Adjust > Color Balance, the image is automatically assessed and the preview thumbnail on the right shows you what the corrected image will look like. These settings are based on an automatically selected neutral area indicated by the cross-hair target. (2) To select a different neutral area, click anywhere in the left thumbnail; keep trying different locations to see if you can improve the result. (3) You can nearly always improve things by making your own adjustments using the sliders—in this case to produce a more neutral, slightly warm result. (4) The Color Balance dialog is one of the few to offer a useful set of ready-made presets—just pick the one that most closely resembles the lighting conditions under which the photo was taken. Here, the Daylight (5200K) preset produces near perfect results.

For more control over color balance, check the Advanced Options box. This divides the dialog box into two panels. The tools in the White Balance panel are used to identify the original conditions under which the photo was taken; you then use the sliders in the Enhance Color Balance panel to make further minor adjustments.

This can be a little counterintuitive if you're not used to it because dragging the Temperature slider in the White Balance panel toward warm actually makes the image cooler, or more blue. This is because you're telling the program that the original lighting conditions were warmer than those depicted in the unadjusted image.

For example, if you set your camera's white balance for indoor use and then take photos outdoors without resetting it, all of your pictures will have a blue cast. This is because daylight is much cooler (or more blue) than the artificial indoor light that you've set the camera up for.

In the Color Balance dialog, by dragging the White Balance Temperature slider toward cool, you're saying that the actual color temperature of the light this picture was taken in was much cooler than what the camera was set up for and recorded—and the blue cast is eliminated.

There's another way to get rid of unwanted color casts in the Color Balance dialog box, and that's to use the Smart Select button. This works in a very similar fashion to the Color Balance option in the Smart Photo Fix dialog box, except that you only get to place one target on a black, white, or neutral gray area. This isn't as much of a limitation as it might seem, as one sample is all you really need. If it doesn't produce the desired results, just click somewhere else in the image and carry on sampling until you hit somewhere that does. When you're happy that the color cast has been neutralized, you can use the sliders in the Enhance Color Balance panel to fine-tune the result.

Channel Mixer

Although it appears under the Adjust > Color menu, the Channel mixer isn't the best tool with which to make color changes to photos. The most practical use for the Channel mixer is to produce black-and-white images—this is covered in Chapter 4.

Fade Correction

The Fade Correction tool is intended for use on, you guessed it, faded photos. The inks and dyes used in photographic printing processes aren't permanent and, as anyone with prints more than a few years old will know, they tend to fade with age. Exposure to the air and light accelerates this process, but, even if you keep your photos in a sealed box, after a few years they won't look as good as the day they were printed.

Tip

In the Color Balance dialog box, clicking either side of the slider makes a fixed increment adjustment. The Color Temperature sliders increase or decrease by 100 and the Tint sliders go up or down by 10. Alternatively you can enter a figure in the number field or use the toggle buttons to increase or decrease the amount by one.

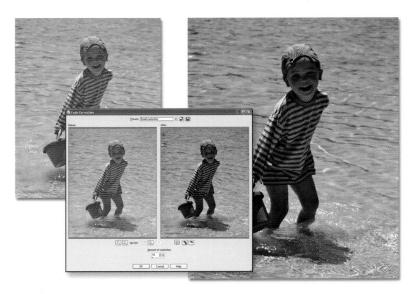

FIG 3.6 You can use Fade Correction on pictures that have faded through age, like this color slide, or those that just suffer from poor contrast.

The Fade Correction tool is a one-step solution to this problem. There's only one setting—use the Amount slider to vary how much correction is applied. Fade Correction boosts the saturation and makes a levels adjustment, so, if you're confident about making those changes individually, you'll have more control using Smart Photo Fix, or Hue/Saturation/Lightness and any of the tonal adjustment tools. It'll take a little longer, but you'll have more control and obtain better results.

Red/Green/Blue

The Red/Green/Blue tool allows you to add or subtract color from the individual RGB channels in the image. It works a little like the Channel mixer, only slightly more intuitively. The trick with Red/Green/Blue is to make sure all your adjustments add up to zero; otherwise you'll affect the brightness of the image. For example, if you add 20 to the Red channel you should subtract 10 from both the Blue and Green channels (or two other amounts that add up to 20).

Red/Green/Blue has a few useful presets, like "Sun exposure," which produces a color cast simulating the warm tones of late afternoon sun. And you can, of course, create and save your own presets.

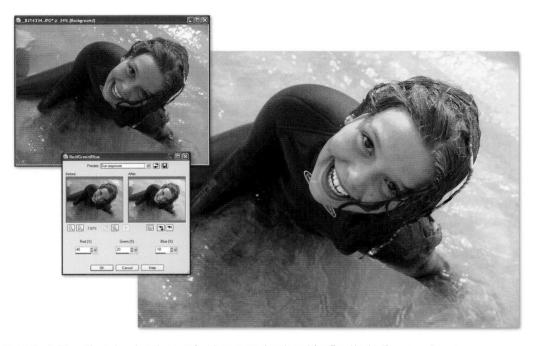

FIG 3.7 The Red/Green/Blue tool can be tricky to use for color correcting, but it's good for effects like this "Sun exposure" preset.

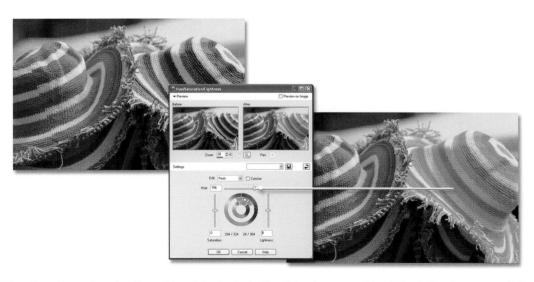

FIG 3.8 By matching a subject color with one of those displayed under the "Master" drop-down menu and then shifting the Hue values, you can radically change the color in one part of the picture while not affecting anything in the rest of the picture.

Hue/Saturation/Lightness

Although it's simple enough to change contrast and color in a photo using the Histogram and Color Balance tools, not all picture makers take the time to adjust the color hue and its intensity or "saturation."

PaintShop Pro's Hue/Saturation/Lightness or "FSL" tool (Adjust > Hue and Saturation > Hue/Saturation/Lightness) allows you to change specific color values within a picture. What this means, in Eng ish, is that you can choose the yellow values and shift them to blue. When this is done, all other colors shift the same amount. So reds shift to green, blues to yellow, and so on. The outer color circle in this dialog box represents the original color, whereas the smaller inner color circle represents where that original color has been shifted.

This tool can be used to remove slight color casts in a picture or to add specific color effects that you might not be able to achieve using one of the Color Balance tools. For my money, the real power in this feature is its ability to shift color values in individual color channels. On some pictures this works as if you have custom-made selections built into the picture.

For example, if you have a snap of a green-colored car, you'll be able to select "Green" from the "Master" drop-down menu and change the hue values so that only the car color changes. How neat is that? If there are other green objects in the frame, these will also change cclor proportionally; while the selection concept works, it's important to note that it's color-specific, not pixel-specific. Options include "Reds," "Greens," "Blues," "Cyans," "Magentas," and "Yellows."

What else can be done using this tool? Whereas hue is an expression of color values within a picture, saturation refers to the intensity of those colors. If you worked through the Smart Photo Fix section a few pages back, you'll have already discovered saturation, so I'll just reiterate my earlier advice about overdoing it. Oversaturated colors not only look unnatural but can cause problems when printing.

You can also use this dialog to change the lightness of the image—although there are plenty of other tools better suited for making tonal adjustments. Another neat effect is to colorize the picture by clicking the Colorize check box and increasing the Saturation slider. Colorize essentially applies an old-fashioned tinting effect to the picture; the higher the saturation, the stronger the tint. Click the Colorize check box and move the Hue slider, noting how the color in the tint changes. Move the Saturation slider to increase or reduce the intensity.

If colorizing as a special effect is all you are after, use the Colorize dialog (Adjust > Hue and Saturation > Colorize). This is faster and less complicated than the full-on HSL tool, plus it has the additional benefit of having varicolored "amount" sliders that display the part of the spectrum that the sample is taken from. This is a nice touch.

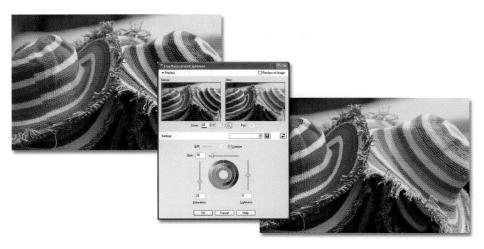

FIG 3.9 In the Hue/Saturation/Lightness dialog, check the Colorize box and watch as PaintShop Pro tints the entire image. Use the Saturation slider to temper the effect.

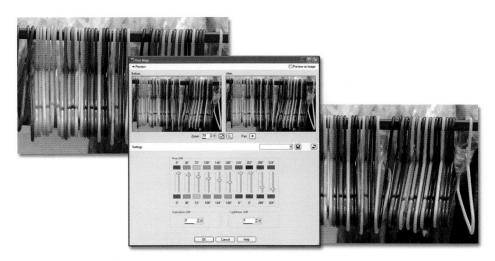

FIG 3.10 The Hue Map tool works like a graphic equalizer for colors. Use the sliders to change only colors in a specific band of the hue spectrum; here the blue hangers have been changed to red. Fine-tune the effect by using the two fields at the base of the dialog for Saturation.

Hue Map

The Hue Map is another slightly off-center tool used to change specific colors within a picture. This is similar to applying a color change using the HSL tool on a specific channel, as just described. You can select a particular color, move the appropriate slider to choose another hue for that color only, and check the results live.

Tools for Correcting Exposure Problems

On the Brightness and Contrast submenu of the Adjust menu you'll find no fewer than 10 tools for adjusting the tonal values in your pictures. Why so many? Well, many of these tools do the same thing in a slightly different fashion. As you become more experienced you'll no doubt find your own personal favorite. For some people, using the Levels tool is the only way to make tonal adjustments to an image; others swear by the Histogram Adjustment tool. There is at least one tonal adjustment tool that's probably best avoided, so we'll deal with that first.

Brightness/Contrast

This is the first option on the Adjust > Brightness and Contrast menu—give it a rearward glance every time you flash past it on your way to more useful tools. As we saw earlier, the problem with Brightness/Contrast is that it applies a blanket adjustment across the tonal range—there's little that's sophisticated or subtle about it.

When you drag the Brightness slider to the right, every pixel value is increased by the same amount and the result is that the highlights in your image quickly disappear. The same happens to the shadows when you go in the opposite direction. Let's waste no more time on it.

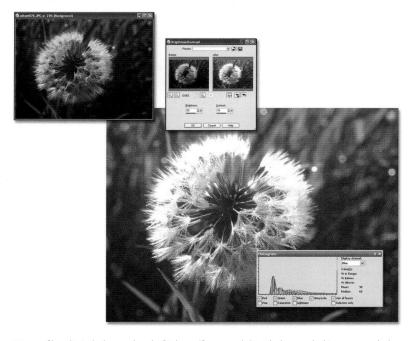

FIG 3.11 Okay, this is the last word on the Brightness/Contrast tool. A quick glance at the histogram reveals the damage—no more highlights, and shadows turned to mush. You have been warned!

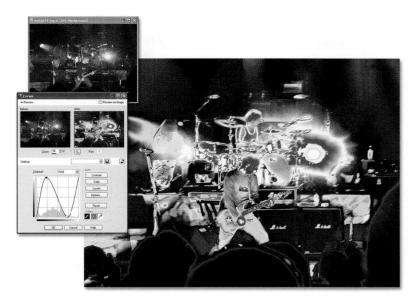

FIG 3.12 Use the Curves tool for ultimate control over specific parts of the tonal range, or special effects. Create a solarization effect using an S-shaped curve or reverse the slope for a negative.

Clarify

The Clarify filter applies a local contrast boost to photos, which makes them "pop." The filter is a sort of hybrid that combines contrast adjustment and sharpening. If you're interested in the technical wherewithal—and this is guesswork on my part—Clarity applies the Unsharp mask filter with a high radius setting and a low amount.

Curves

In some ways, Curves is the most versatile of the tonal adjustment tools because it allows you to experiment with altering pixel values in any one part of the range without affecting the rest. The curve is also a simple concept to grasp. Input values are displayed on the horizontal axis and output values on the vertical axis, so initially the curve is, in fact, a straight diagonal line running upward from left to right at 45 degrees.

Dragging the top end of the line horizontally to the left has the same effect as dragging the Highlight Input slider in the Histogram Adjustment or Levels tool to the left. If you click in the center of the line, a control point is added; dragging this is akin to moving the Gamma slider in Histogram Adjustment or Levels.

But neither of those tools can match Curves when it comes to tweaking a narrow range of tones. By adding points to the curve and adjusting

them, you can tweak the shadows while leaving the highlights untouched. You can also use Curves for extreme tonal effects. You can create a solarization effect (traditionally achieved in the darkroom by momentarily switching the lights on halfway through processing) by making the curve S-shaped.

Highlight/Midtone/Shadow

This could be quite a useful tool, as it provides individual control over the highlights, midtones, and shadows in your photos. However, it is complicated by the fact that, instead of pixel values, it uses percentages. It also has two different ways of applying the figures—an absolute and a relative method—which makes it even more difficult to work out what's going on. There are other tools, namely Histogram Adjustment and Levels, that are more versatile, provide better feedback, and are easier to use.

Tip

You can apply any of these histogram adjustments to selections. Make the selection first, save it, and then run the tone adjustment, as described.

Histogram Adjustment

The Histogram Adjustment dialog box can be a little intimidating at first glance, but, if you've read the earlier section on using the histogram, you'll already be well on your way to getting the most from this versatile tool.

As we discovered earlier, the histogram is a graphical representation of the tonal values of all of the pixels in an image. Black pixels appear on the far left, getting lighter as you move toward the right on the horizontal axis. The more pixels there are of a particular value, the higher the line appears at that point.

The three most useful controls in this dialog box are the triangles that appear beneath the histogram, which allow you to remap the black point, white point, and gamma. To produce an image with good tonal distribution and contrast, you should drag the Highlight Input slider (the white triangle) to the right edge of the histogram and the black triangle to the left edge. Use the central Gamma slider to make overall adjustments to the brightness.

There are other controls, like the slider on the right that allows you to expand or compress the midtones for solarization-style effects, but Curves is better suited to making these kinds of adjustments.

Histogram Equalize and Histogram Stretch

These two are essentially one-step applications of specific histogram (or levels, or curves, depending on how you want to look at it) adjustments. Equalize is the least useful of the two, as it averages out all the pixel values across the histogram (try pressing F7 to display the Histogram palette, then apply Histogram Equalize and you'll see).

Histogram Stretch automatically sets the black and white points to the values of the darkest and lightest pixels in the image. It's exactly the same as selecting Histogram Adjustment and dragging the triangle controls explained in the previous section to the ends of the histogram. As such, it's an excellent one-step contrast fix.

Levels

The controls in the Levels dialog box work in a similar way to those of the Histogram Adjustment tool. You can use the Output Levels controls to reduce contrast in the shadows and highlights. This is the best way to produce a "knocked back" image tint for a panel on a website or printed publication that has text running over the top. By dragging the black Output Levels slider to the right, you can lighten the dark pixels in the image and still retain detail in the midtones and highlights.

Threshold

Threshold converts an image to pure black and white—what used to be called "line art." Enter the value that determines whether pixels are converted to black or white in the Threshold dialog box. The default is 128—any pixels darker than a midtone gray are turned black and any lighter are turned white. As with desaturation, threshold removes the color but doesn't change the image mode, making it possible to add color back in and produce interesting graphic effects.

Using Fill Flash and Backlighting

Although the Histogram Adjustment tool provides ultimate control of image tonal values throughout the entire range, sometimes that can be its biggest drawback. Often you'll want to change tonal values in one part of the range—the shadows or the highlights. The difficulty with using the Histogram Adjustment tool in such circumstances is that, more often than not, although you can make considerable improvements in one part of the image, it's at the cost of lost image detail elsewhere in the tonal range.

For example, in trying to get back shadow detail in underexposed areas you'll often find that you lose detail in the highlights. Likewise, in attempting to restore detail in overexposed areas, the sky for example, you'll find that shadow detail disappears into the darkness.

You can get around this problem by making careful feathered selections, but PaintShop Pro X4 has two filters aimed at precisely this problem: the Fill Flash filter and the Backlighting filter.

Tip

Though not all the tonal adjustment tools have their own histogram display (Levels being the prime example), the new live Histogram palette can be used instead. Prior to selecting Levels (or Curves, or Highlights/ Midtones/Shadows), press F7 to display the Histogram palette. Now, when you click the Proof or Auto Proof button, the Live Histogram palette will automatically update.

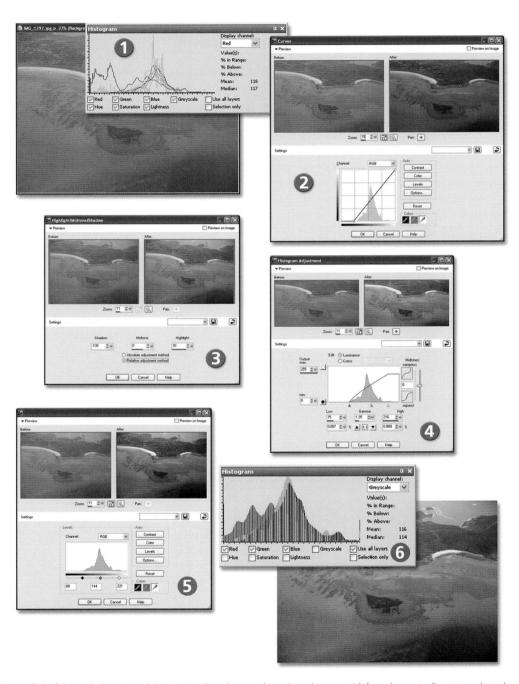

FIG 3.13 Each of the tonal adjustment tools has its strengths and any can be used to achieve a straightforward contrast adjustment as shown here.

(1) Press F7 to display the Histogram palette and confirm the problem. (2) Curves. (3) Highlight/Midtone/Shadow. (4) Histogram Adjustment. (5) Levels.

(6) The adjusted image with a new histogram covering the entire tonal range.

The Fill Flash Filter

As its name suggests, the Fill Flash filter provides the digital equivalent of fill-in flash—a photographic technique that uses flash in daylight conditions to provide fill-in lighting for shadow detail.

The kind of situation where you might use fill-in flash is where the subject is strongly backlit—for example, in front of a window or on a beach. Typically, camera automatic metering systems select an average exposure setting for such situations, resulting in very dark shadows. The Fill Flash filter allows you to lighten the tones in the shadows while leaving the midtones and highlights unaffected.

FIG 3.14 Use the Fill Flash filter to restore detail in shadow areas of strongly backlit subjects.

To use the Fill Flash filter, click the Fill Flash button on the Photo toolbar or select Fill Flash from the Adjust menu. Maximize the Fill Flash dialog box so you can see a generously sized before and after preview, and use the Zoom tools so that most of the photo is in view. You can adjust the amount of fill flash applied by entering a value in the Strength field or by using the slider just below it. The default setting of 40 works well with all but very underexposed images. If you need to apply more than 60, keep an eye out for noise—a speckled grainy appearance in areas of flat color or tone. The Fill Flash filter also includes a Saturation slider, which can be used to add or remove color.

The Backlighting Filter

The Backlighting filter solves the opposite problem to that addressed by Fill Flash. Where the camera has made a suitable exposure to capture good shadow

detail in an image with a wide tonal range, the highlight detail will be over-exposed. This often happens to the sky detail on photos taken in the shade on bright sunny days. The Backlighting filter can help restore highlight detail without affecting shadow areas. Select the Backlighting filter by clicking its button on the Photo toolbar or from the Adjust menu (Adjust > Backlighting).

FIG 3.15 Use the Backlighting filter to restore burned-out highlights.

Making Photos (Appear) Sharper

Sounds too good to be true? Although it's acceptable to change color, contrast, or saturation in a digital file, changing the sharpness is a little trickier.

PaintShop Pro has several tools designed to make pictures appear sharper than when they were scanned or shot using a digital camera. For some this might seem a godsend, but it's important to note that you can never really change an out-of-focus picture to one that looks pin sharp. Even well-focused digital shots can look a little soft, however, and that's something that can be fixed.

How does this magic work? Most sharpness tools act on picture contrast. You might have noticed this using the Histogram tools. A general contrast boost usually makes a picture appear sharper.

PaintShop Pro has several sharpness filters. Clarify is a one-button filter used to add a quick bump in contrast and image sharpness. Most times this works well; however, for total control you have to use the perversely named Unsharp Mask filter. What this does is apply a selected contrast boost, at pixel level, to parts of the picture with varying lightness levels.

The reason that this is the best picture-sharpening tool is that it has three adjustable controls written into the equation: Radius, Strength, and Clipping. Radius selects the number of pixels around the point of contrast difference. Strength controls the amount of contrast added to those pixels. Clipping affects the lightness of the chosen pixels.

One of the disadvantages in sharpening digital pictures is that the filter is nondiscretionary; it has a habit of sharpening the bits you don't want to sharpen as well as the bits you do. This includes any digital noise, film grain, or other electronic imperfections that have been added to the file along the way. So, the more the picture is sharpened, the more noticeable the imperfections (the digital noise) become. Help is at hand though, because the main reason for the dialog controls is to minimize this inevitable noise increase:

- Too much Radius creates a nasty-looking whitish halo throughout the high-contrast sections of the picture.
- Too much Strength adds an equally fiendish grittiness that looks particularly bad once in print.
- Too much Clipping makes the picture appear soft, destroying the sharpness effect entirely.
- Like all sophisticated photo editing tools, unsharp masking requires
 practice to get right. There's no "perfect" setting, because some pictures
 need more sharpening than others.
- The picture's application also has a profound impact on how you sharpen its pixels; inkjet prints need less sharpening than those designed for newsprint. If you are submitting pictures to a third-party publication, call the relevant art department first to check on that publication's specific material (sharpening) requirements, if any.

As a general rule start with the following:

- · A Radius of one or two pixels
- · A Strength of between 100 and 200
- A Clipping value of zero

If nothing seems to improve in the picture with these settings, increase the Strength value. Then try increasing the Radius value (a bit at a time). If the Unsharp Mask effect is applied to a high-contrast picture, you'll need to dial in a small Clipping value to soften its impact. The beauty of this is that you see what you are getting instantly and can make changes live before applying them to the full-resolution version.

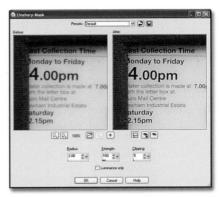

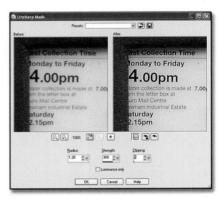

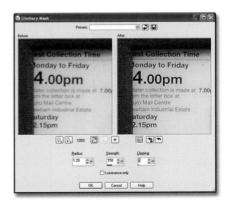

FIG 3.16 Different images require different Unsharp Mask settings, so a trial and revise approach is required. The trick is to increase overall sharpness without introducing sharpening "artifacts." Reducing the radius from its default setting of 2 and increasing the strength to 300 introduces unwanted white specks. You could eliminate these using the Clipping slider, but it's better just to reduce the Strength until they disappear. A final setting of Radius 1.20, Strength 150, and Clipping 5 results in a sharper image with minimal sharpening artifacts.

PaintShop Pro comes with two other no-brainer sharpen tools: the Sharpen and the Sharpen More filters. The Sharpen filter is a good place to start; it applies a preset contrast boost to a selected range of pixels. This might be enough to give most digital snaps a nice sharpen. For a stronger filter effect, try the Sharpen More filter. This is slightly more radical, though still by no means as radical as the Unsharp Mask filter can be. The good thing about these effects is that they are repeatable. If the effect isn't strong enough, repeat it using the keyboard shortcut $\operatorname{Ctrl} + \operatorname{Y}$ until it is.

High Pass Sharpening

As we've already mentioned, one of the problems with unsharp masking is that it can sharpen parts of the image you just don't want to sharpen. PaintShop Pro X4 includes a method of sharpening that doesn't suffer from these drawbacks because it confines sharpening only to edge detail and other high-contrast areas within an image.

High pass sharpening isn't new, but previously it was a complicated business that involved duplicating layers, applying a High Pass filter, or creating an edge mask and using layer blend modes. Although all this was great fun, the new High Pass Sharpen filter makes things much easier. See the step-by-step work-through at the end of the chapter to find out how to get the best from the High Pass Sharpen filter.

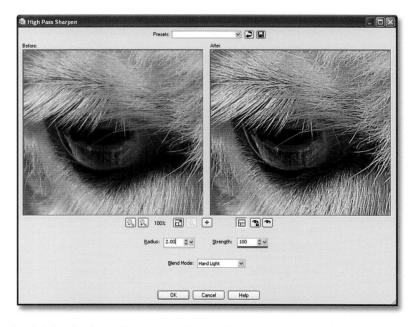

FIG 3.17 Use PaintShop Pro's High Pass Sharpen filter to sharpen edge detail without exaggerating noise and other unwanted detail.

Tips for making digital files appear sharper:

- If using a digital camera, make sure that the picture is exposed correctly and that the focus is correct for the subject. It's possible to enlarge the image on the camera's display screen to check the focus closely. If you think that there's a problem, erase that frame and reshoot.
- In Shutter (S) or Manual (M) shoot modes, pick a faster shutter speed
 (a higher number) to "freeze" action, essential if the subject is moving fast.
- Learn to use the autofocus (AF) lock in the camera. This works by half-depressing the shutter button that activates the AF system. Once the incamera audio "beep" confirmation sounds, you can then either press the shutter fully or reframe to position a subject off-center and then take the picture. The most obvious cause of out-of-focus snaps is from the subject not being in the camera's AF focusing area when the shutter button is pressed.
- Scans normally require unsharp masking to compensate for the scan process, which can make things appear slightly unsharp.
- Most scanner software comes with inbuilt Unsharp Mask filters to compensate for quality loss. Most will not be as good as PaintShop Pro's Sharpen tools. You might want to leave that feature switched off and sharpen the files using PaintShop Pro later. It's always preferable to have an untouched "master" file on your hard drive. Once an effect like unsharp masking has been added to a file, it's impossible to remove.
- The same can be said for in-camera sharpening functions. Switch this off, and apply it using your software.
- Use PaintShop Pro's Overview palette to move the view around the preview picture. Sharpening never has the same effect across all sections of a picture, so it pays to check the important bits up close.

Adding Soft Focus Effects

In a digital file, regular blur filters never produce as nice a result as you'd get using film and a real glass soft focus filter screwed to the front of a lens.

PaintShop Pro addresses this problem with a Soft Focus filter. The difference between this and the straight "blur everything" filter set (Average, Blur, Blur More, Gaussian Blur, Motion Blur, Radial Blur) is that the former applies more blur to the highlights than to the other tones. This produces an effect similar to the one you'd get using a regular glass photographic filter—only Paint-Shop Pro offers a wealth of controls over how you can influence the way that the blur looks.

You can vary the overall softness of the filter, as well as the edge importance (edge sharpness), plus there are three controls for adjusting the blur halo (Amount, Size, and Visibility).

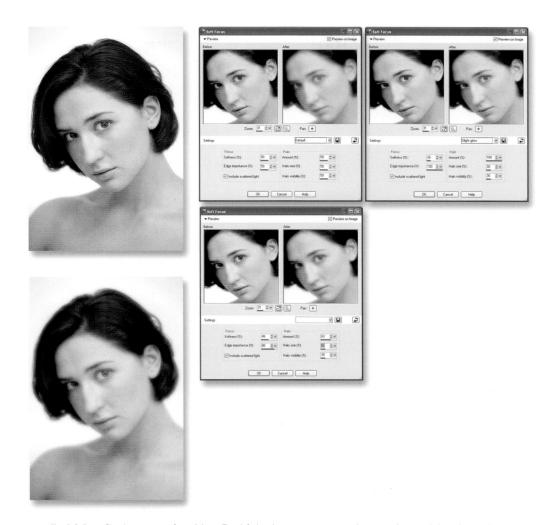

FIG 3.18 The Soft Focus filter has a range of possibilities. The default values may give an over-the-top result, particularly on low-resolution images. The presets provide good results, though, and you can experiment with the sliders to get the exact effect you're after.

Nathan Blaney, iStockphoto 1790776.

Much time has been put into creating this filter and it works extremely well, emulating the precise look of a glass filter costing more than PaintShop Pro itself. As with most filters, it's possible to try a combination of effects using the Randomize tab. You can also save a particular combination for use any other time via the Preset tab.

Step-by-Step Projects

Using Smart Photo Fix Improving Your Photos

Often, you can make big improvements to photos that lack contrast, look a bit washed out, are a little on the dark side, or are slightly substandard in some other way using One Step Photo Fix.

Sometimes, though, One Step Photo Fix doesn't result in a big improvement and you need to take matters into your own hands. If you don't feel confident about dealing directly with tools like Histogram Adjustment and Color Balance, then Smart Photo Fix is the tool for you. We've looked in detail at using Smart Photo Fix in the Adjust workspace in Chapter 1, but you can also use it in the Edit workspace, where it provides a little more control over some of the adjustments.

STEP 1 Open the photo you want to fix in the Edit workspace, and select Smart Photo Fix from the Adjust menu.

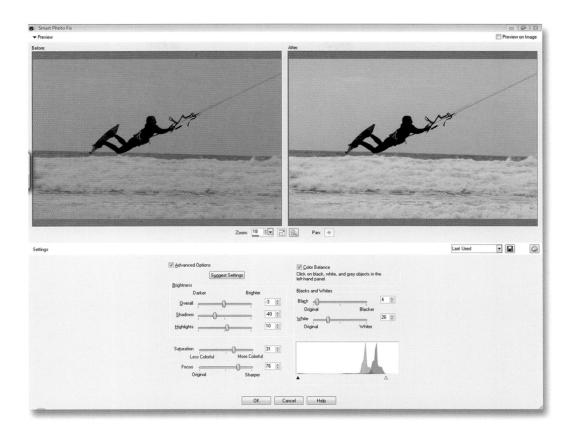

STEP 2 If it isn't already showing, click the Preview triangle to display the before and after views and maximize the Smart Photo Fix dialog box to fill the screen; you can also uncheck Preview on Image. Then check the Advanced Options box to display the histogram, the Black and White point sliders, and the Color Balance check box.

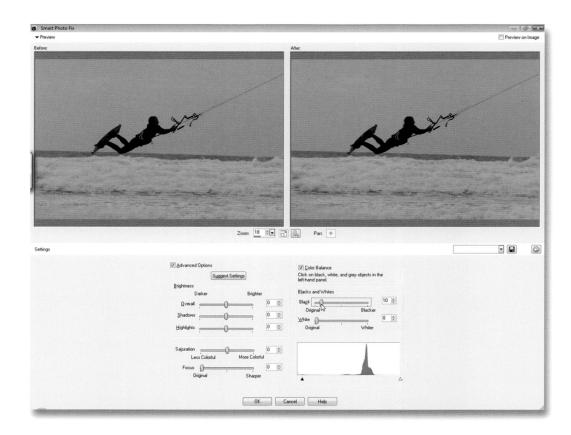

STEP 3 Select Default from the preset menu to return all the settings to zero. The first job is to set the Black and White point sliders so that the darkest and lightest pixels in the photo reach either end of the histogram. Drag the Black slider to the right and watch the black triangle under the histogram—it too moves to the right as you drag the slider. Stop dragging when you reach the first peak or bump in the histogram—in this case there's a small group of pixels at around the 10 mark.

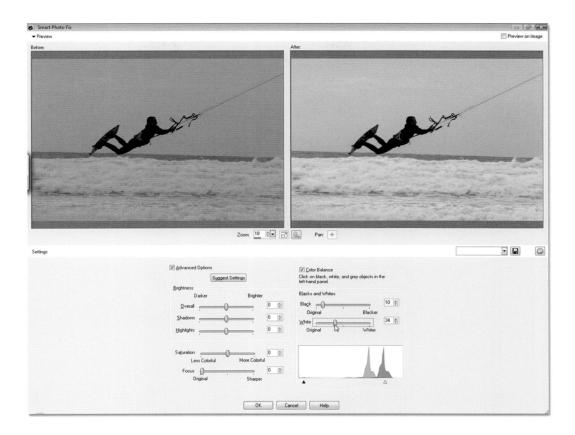

STEP 4 Now drag the White slider until the white triangle reaches the first bump or peak on the right side of the histogram—in this case there's a shallow plateau that starts at 34—before the big peak nearer the middle. What you've just done is remap the darkest and lightest pixels in the photo to pure black and white. The new histogram is overlayed in red on the old gray one. You can see the improvement in the after preview, but, if you're still not quite sure how you've managed this, take another look at "Using the Histogram" on page 65.

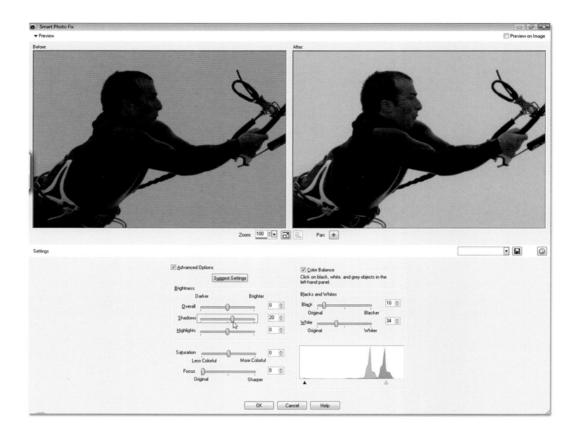

STEP 5 Often, adjusting the Black and White sliders will be all that's needed, but the brightness controls can be used to add detail to the shadows and highlights and to brighten or darken the image overall. Click the "Zoom image to 100%" button under the thumbnails and use the Pan tool to center the kite surfer. Drag the shadow slider to 20 to bring out the detail in his face and wetsuit.

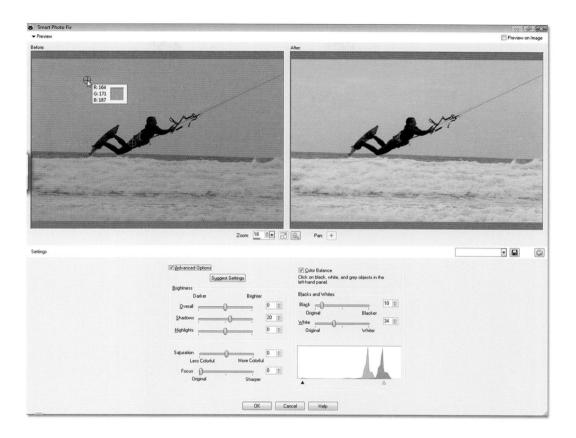

STEP 6 The next problem is the color balance. This photo looks much bluer than the actual conditions in which it was shot. Click the "Fit image to window" button and correct the blue cast by checking the color balance box and clicking with the eyedropper to place a color sampler on any part of the photo that should be neutral (i.e., black, white, or gray). Here I've placed markers on the kite surfer's black wetsuit and a white cloud. If positioning a marker produces unexpected or undesirable results, click on the marker again to remove it.

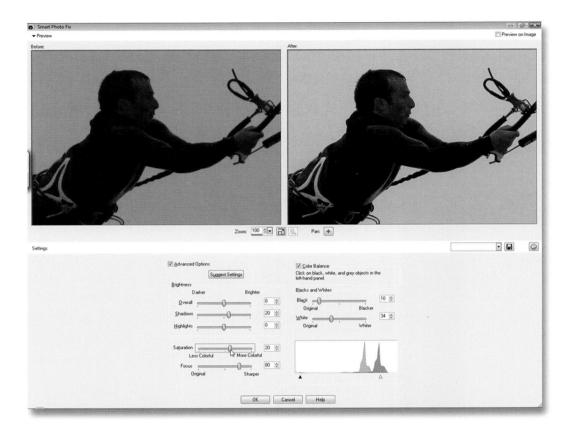

STEP 7 Before sharpening the photo, click the "Zoom image to 100%" button under the thumbnails. Drag the Focus slider to the right to sharpen the image, but don't go too far or you'll exaggerate noise and make the photo look grainy. Finally, drag the Saturation slider to the right, again (be careful not to overdo it) to give the color a bit of a boost, and click OK to apply the changes.

STEP 8 It doesn't end with Smart Photo Fix. There are lots of other simple things you can do to improve photos and give them more impact. Here I've used the Crop tool to remove some of the background, change the aspect ratio, and straighten the horizon.

Using the High Pass Sharpen Filter Sharpening Photos

The High Pass Sharpen filter is a real lifesaver with certain kinds of images. Although Unsharp Mask does a fantastic job 90% of the time, as we've seen, it's indiscriminate and can create problems, or at least make existing ones more obvious.

The kinds of photos you should avoid unsharp masking include the following:

- Those taken on a high ISO setting (400 and above), which will, depending on how good your camera is, display at least some visible noise.
- Photos that were badly exposed and have had a large tonal correction applied using Smart Photo Fix, Histogram Adjustment, or one of the other tonal adjustment tools.
- Photos with high JPEG compression applied, either because they were taken using a low-quality camera setting or because they have subsequently been recompressed using a low-quality JPEG setting.
- Photos that are well exposed, of a high quality, and fine in every other respect but have large areas of flat color, such as an expanse of clear blue sky.

For all of these images and anything else that fails to come up shining using the Unsharp Mask filter, follow these steps.

STEP 1 Open the image to be sharpened in the Edit workspace. If you plan on using "Preview on Image" to preview the effect, then first make sure to zoom in to 100% view (keyboard shortcut Ctrl + Alt + N). Always view sharpening adjustments at 100% magnification, as it's the only way you can really see what's happening to the individual pixels in the image.

STEP 2 Select Adjust > Sharpness > High Pass Sharpen to open the High Pass Sharpen dialog box and use the Pan button to select a representative part of the image. To preview the sharpening in the image window, check the "Preview on Image" check box having first zoomed to 100% view as described in step 1.

STEP 3 The High Pass Sharpen dialog box has three settings—Radius, Strength, and Blend Mode. The default values for these are 10, 70, and Hard Light, respectively. The Radius setting determines the distance within which the filter looks for dissimilar pixels to sharpen. A larger Radius value will result in more of the image being sharpened, a smaller one will sharpen less. With zero Radius, none of the image is sharpened. Use the Pan button to find part of the image you don't want sharpened (the sky or an out-of-focus background), and adjust the Radius to a value just below that at which you can see a change.

STEP 5 The Hard Light blend mode produces the most dramatic sharpening. To reduce the effect, change the blend mode to Overlay, and for even gentler sharpening use the Soft Light blend mode.

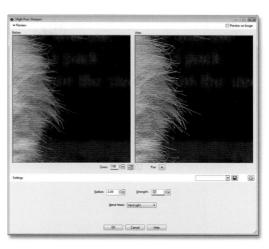

STEP 4 Now use the Pan button to center a part of the image that's representative of what you want to sharpen. If necessary, adjust the Amount slider to increase or decrease the amount of sharpening applied.

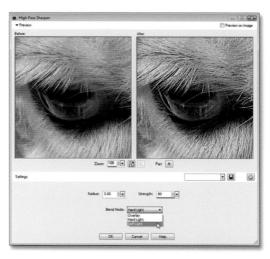

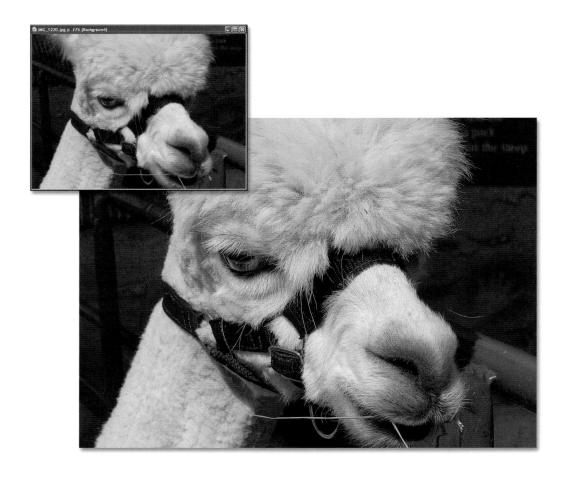

PaintShop Pro X4's High Pass Sharpen filter makes a fantastic job of sharpening edge detail in images like this, without affecting out-of-focus areas or compounding common digital image problems like noise.

Tip

Remember that sharpen filters work by increasing image contrast, and when you increase contrast you may inadvertently lose highlight and shadow detail from your photos. When using sharpening filters, always keep one eye on the Histogram palette (keyboard shortcut F7) to make sure you are not "clipping" the ends of the tonal range.

Using Camera RAW Lab Restoring Detail in Overexposed Photos

This shot of a horse's head is overexposed by around a stop. If you'd shot this as a JPEG, you might be able to recover the lost highlight detail in the front of the horse's head and the sky in the background, but with only 8 bits per channel of pixel information the chances are the image would begin to look harsh and contrasty before you recovered as much detail as you'd like.

Making the exposure corrections in Camera RAW Lab gives you much more scope—you can recover more detail without causing the kind of image degradation that editing pixels inevitably results in. Remember, what we're doing here is simply interpreting the raw data to give us a more acceptable starting point. Once the corrections have been made you can output the image as a 16-bit RGB file. Then, there's nothing to stop you making further improvements in the Editor workspace. With a rock-solid 16-bit RGB file you'll still be in a better position to make further improvements than you would have been with an 8-bit JPEG from the camera.

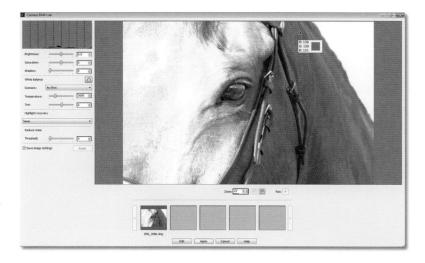

STEP 1 Select the RAW file thumbnail in the Manage workspace, then select the Edit workspace tab to open the file in Camera RAW Lab and click the maximize button at the top right to fill the screen. This is your first chance to get a look at the image as interpreted using Camera RAW Lab's default settings. As well as suffering from overexposure, the white balance is on the cool side; both problems are easily dealt with in Camera RAW Lab.

STEP 2 First deal with the exposure by dragging the Brightness slider to the left. In this case we've dragged it to -1.0—effectively reducing the exposure by one stop. It doesn't matter if you can't drag the slider to precisely 1.0, but if you do want more precise control use the nudge buttons on the exposure numeric field next to the slider.

STEP 3 The exposure is looking a little better, but the highlights are still blown out. PaintShop Pro X4's new revised Camera RAW Lab has a Highlight recovery tool to deal with this and it's extremely effective. Select Normal from the Highlight Recovery pull-down menu to restore the highlight detail.

STEP 4 The exposure is looking better, but now the shot looks dull and murky. To increase contrast in the shadows, drag the Shadow slider to the right. As you drag, the preview will update and you will need to make a visual assessment of how much Shadow to apply. You want to increase contrast in the shadows without losing any detail. Here we're aiming to make the horse's bridle black without losing detail in the neck and eye.

STEP 5 Increasing the contrast in the shadows has improved things, but the shot still looks a bit flat. Drag the Saturation slider to the right to increase the saturation a little. Don't overdo it—small movements of the Saturation slider have quite a large effect. Use the nudge buttons for precise control. Around 15 on the Saturation slider is enough to a give the color a bit of a boost.

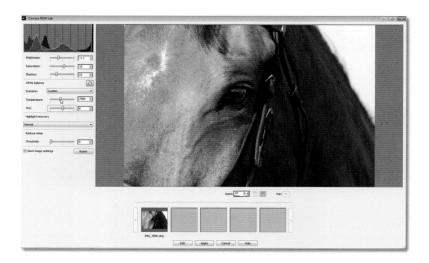

STEP 6 Now we can address the color cast. The "As Shot" white balance is 5000 but produces too cool a result—notice the blue highlight running down the horse's neck at the back. Selecting one of the presets—for example, Daylight or Cloudy—won't help as these are both lower and will result in more blue (see the section on white balance presented earlier in the chapter for a description of how this works). The simplest way to deal with most color casts is simply to drag the Temperature slider while assessing the result in the preview window. Because this shot was taken quite late in the evening, the light was getting very blue and the color temperature setting required to eliminate the cast and produce a more natural-looking result is around 7500.

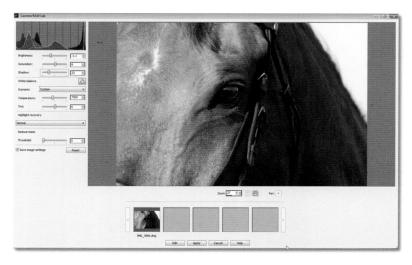

STEP 7 Notice how changing the color balance has increased the saturation of the yellows and browns? Our earlier saturation adjustment is now looking a bit over the top. Use the nudge buttons to knock the saturation back a little—to around 6 should do it.

STEP 8 If you don't want to edit the image in PaintShop Pro, clicking the Apply button will close Camera RAW Lab. If you take a look at the thumbnail in the Organizer, you'll see that it has been updated to reflect the changes you just made and has a small RAW badge to indicate it has been edited. These changes are stored in the PaintShop Pro X4 database.

STEP 9 To export the RAW image to an RGB file without opening it again in Camera RAW Lab, right-click its thumbnail in the Organizer palette and choose Convert RAW from the menu. Select an image type, and choose a location on your hard drive where you want the image saved. The Modify button allows you to add text or sequence numbers to the file name for batch conversion.

What's Covered in this Chapter

- So far we've looked at what PaintShop Pro X4 has to offer in terms of features and tools for organizing and editing your photos, and we've covered some of the basics of image editing. We've also looked at how to fix photos that have a problem with brightness or color.
- This chapter is subtitled "Beyond the Basics" because we're going to look at some more complex features than the one-step fixes and tonal and color adjustment tools covered in the previous chapters.
- The chapter begins by looking at some of the methods for removing scratches and blemishes from your photos. This is a particular problem with scans of prints, slides, and negatives and also when using digital SLRs, which can get dust on the sensor, leading to blotchy photos.
- The same techniques can be usefully applied to removing other things that
 you don't want in your photos, such as lampposts, trees, and people you're
 no longer on speaking terms with. You'll learn how to become an expert
 retoucher with the Clone tool, and you'll learn about some other tools for
 fixing damaged photos.

- As in the previous chapter, it's not all about fixing things. Later on in the chapter you'll discover how to produce black-and-white photos from color originals using Black and White Film photo effects and learn how to produce tints and color overlay effects to add extra depth and tone to black-and-white photos.
- Digital noise can be a real problem when shooting in low-light conditions using a high ISO setting on your camera. PaintShop Pro X4 has one of the best tools around for dealing with this problem, and I'll go into detail on how to get the most from it. Paradoxically, I'll also show you how to add noise to your photos to create atmospheric grain effects.
- Finally, there's a brief introduction to PaintShop Pro's scripting features.
 Scripts are one of PaintShop Pro's most powerful features, allowing you to automatically record and apply a sequence of editing steps to any number of photos.
- The step-by-step projects at the end of the chapter guide you through the process of restoring badly damaged photos and applying a hand-colored effect to black-and-white pictures.
- No matter how careful you might be when scanning film or prints, dirt always gets in the way and inevitably ends up on the scan. PaintShop Pro has a good range of filter-based tools designed for cleaning up or removing these problem areas, however bad they might appear. Dirt isn't only a problem with scanned photos. If you use an older digital SLR (many recent models vibrate the sensor to remove dust), you may have noticed slight dark blotches on your photos. These are caused by small particles of dust that find their way into the camera body and settle on the sensor. Eventually, you will need to clean the sensor, or have it done for you, but in the meantime you can use the techniques described here to fix the problem.

Removing Scratches and Blemishes from Scans

You might never realize quite how dirty scans can be unless they are magnified to a size that reveals the mess. If you only enlarge your snaps to about 6 inches \times 4 inches, the worst dust blemishes may never become apparent. If you print to 20 inches \times 16 inches, however, you might get a shock when you see the dirt and surface scratch marks picked up by the scanner!

The first thing to do is rescan the print or negative. Clean the flatbed scanner's glass plate, the place where the print is positioned. Use a mild window cleaner and a soft, lint-free cloth (e.g., linen). Finger grease, however minimal, is a great dust attractant, so don't forget to gently wipe the surface of the print as well. If scanning film, use an appropriate film-cleaning solution and soft cloth.

Tip

Don't use filters to remove large blemishes; they aren't that effective and will degrade the overall picture quality. Use the Clone or Scratch Remover tool instead. Once the scan is made, open the file in PaintShop Pro and enlarge the file to between 200% and 400%. Do you see dust specks that weren't there in the original? They probably were there, but they were just too small to notice. If you are planning to enlarge and print to A3 or bigger, you might need to run one, or more, of PaintShop Pro's cleanup filters over the file to improve the quality.

Here's how. Open the picture and crop to suit. Many scanners are more than generous with their flatbed scan areas, adding extra "real estate" to the edges of the print or transparency. Select the Crop tool from the Tools toolbar. When the Crop Box appears, drag it to the required dimensions and click the Apply button. (To maintain the aspect ratio, use the "Maintain aspect ratio" check box in the tool's Options palette.)

Assess the damage. Enlarge the file to 400% or 500% by clicking on the picture with the Zoom tool (keyboard shortcut "Z"; left-click or push your mouse wheel forward with your index finger to zoom in on the affected area) and, using the Pan tool (keyboard shortcut "A"—it sits under the Zoom tool), move the picture around the screen for a closer inspection. Increase or decrease the magnification according to the amount of detail you might want to retouch. If it's a high-resolution scan (i.e., scanned for A2 output), you'll have to zoom in on the image further, say up to 400%, to see the same (scratch) detail as if it were scanned to A4 and magnified only to 200%.

A quick way to remove dust spots blanket fashion is to run a filter over the entire picture. Zoom to 100% view and select the Automatic Small Scratch Removal filter from the Adjust > Add/Remove Noise menu (Adjust > Add/Remove Noise > Automatic Small Scratch Removal). To preview the effect, check the Preview on Image check box in the filter dialog box. Most filters and effects have this option and, though it takes a while longer to display, you get a much clearer picture of the result than with the dialog box thumbnail previews.

Try the default settings first. The reason there are many variants is to cover the multiple quality situations scanning introduces. Note that there are check boxes for "light" and "dark" scratches, a contrast inhibitor (move the sliders to the center to limit the contrast range), as well as three filter strength settings. It's important to remember that, with this and most of PaintShop Pro's other filter-based tools, the dialog window offers multiple options so that you can customize all actions to suit whatever image you have open on the desktop. If the filter effect doesn't work fully the first time, try another combination.

Scratch Removal filters apply their effects globally. For difficult or large blemishes, use a Scratch Removal tool locally first. This is a more effective technique because you can limit the filter's softening action to a small area of the scan only. There is no point in softening the entire picture to remove one or two scratches.

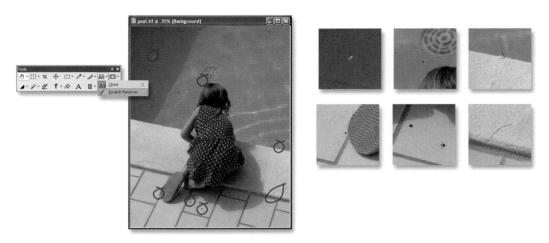

FIG 4.1 Color negatives and transparencies are among the worst culprits for attracting dirt and scratches. Although they may look okay to the naked eye, the high degree of scanning enlargement necessary to produce a decent-sized digital image also enlarges the dirt. A global filter won't do the job—you will need to individually retouch these marks out with the Scratch Remover and Clone tools. The same applies for blotches caused by dust on the sensor of a digital SLR.

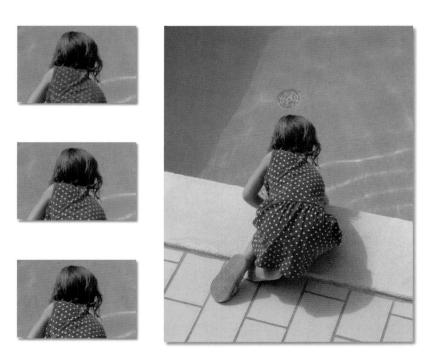

FIG 4.2 The Salt and Pepper (top), Median (middle), and Edge Preserving Smooth (bottom) filters can be used for removing dust or subtly softening skin blemishes, but the filter strength required to remove larger spots and scratches results in unacceptable loss of overall image quality. The best result (right) is achieved by repeated application of the Scratch Remover and Clone tools.

Click the small black triangle next to the Clone brush and choose the Scratch Remover tool from the fly-out. Drag the cursor over the blemish to remove or soften it. PaintShop Pro clones/blurs out the damaged pixels. This is quite a fast tool to use, and, like most of the tools in PaintShop Pro, it has a preset save function, allowing you to create your own custom scratch remover brushes. Once satisfied that PaintShop Pro has removed/diffused enough of the small scratches to make the scan appear credible, save the file under another name before continuing with further editing (always keep the original file untouched, where possible).

Other smoothing filters to try include the following:

- · Salt and Pepper filter
- · Despeckle filter
- · Median filter
- · Edge Preserving Smooth filter

(All of these tools are found on the Adjust > Add/Remove Noise menu.)

Controlling Digital Noise

Photos taken with a digital camera all suffer, to a greater or lesser extent, from a phenomenon called "digital noise," which gives digital photos a speckled, grainy appearance. Noise is generated by a camera's electronic circuitry, mostly when the electrical current generated by the image sensor is amplified before being digitally sampled.

If you've owned a film camera, you'll be familiar with film grain—clumps of silver in a photographic emulsion that become visible when enlarged—and you'll also be aware that fast films—those with higher sensitivity to light—exhibit more grain than slow ones.

With digital cameras it's the same story; if you set your camera to a higher ISO rating to capture images in low-light conditions, the digital noise becomes worse. Depending on your camera, you may not notice noise on images

FIG 4.3 The Digital Camera Noise Removal filter allows you to remove noise from some areas of the image while protecting others.

FIG 4.4 Noise-wise, this is about as bad as it gets. The original image (*left*) was shot with the camera set to 1600 ISO. The center section shows the results of the Digital Camera Noise Removal filter on the default settings; the image on the right shows the same settings sharpened at 70%.

taken at an ISO setting of 200 or lower, but at settings above 400 ISO, particularly at larger image sizes, noise can become very intrusive.

Digital noise can also occur as a result of long exposures—shots taken at night are often prone to noise because of the high ISO setting used, combined with long exposures.

In some circumstances you can live with noise. Like film grain it can provide a gritty atmospheric realism. Mostly, though, it's something you'd rather do without. You can't get rid of noise entirely, but you can reduce it. Before version 9, PaintShop Pro users had to rely on techniques using the Salt and Pepper, Median, Texture Preserving Smooth, and other filters on the Adjust > Add/Remove Noise menu. Now we have the Digital Noise Removal filter, which, for the sake of brevity, I'll call the DNR filter.

Select Adjust > Digital Noise Removal, or click the DNR button on the Photo toolbar. The DNR filter provides a sophisticated dialog box with the usual before and after preview windows and two tabbed panels labeled Remove

Noise and Protect Image. Maximize the dialog box to get the biggest preview possible so that you can see the noise and what the filter is doing to the image detail. Use the Pan tool (it appears automatically in most of the filter dialog boxes when you mouse over the right-hand (after) preview) to select a representative area of the image.

In the Noise Correction pane, the three input boxes and sliders control the degree of noise removal for small, medium, and large noise artifacts. Clicking the Link Detail Sizes box locks these three together, maintaining the relationship between them—so, if you increase one of them by, say, 5, they all increase by 5.

In practice, you'll get better results by using a higher value in the Small field than in the other two, but much depends on the image and you'll need to experiment. When you apply the DNR filter, it combines the corrected image with the original one and the value in the Correction Blend field determines the proportions of the two. A value of 100 means that you are working with a 100% corrected image and no part of the original remains. By lowering this value, you lessen the degree to which the correction is effective but also minimize overall loss of image detail. Finally, you can sharpen, which will help restore detail softened by the noise reduction process.

On the right of the Remove Noise tab there's a thumbnail preview with, initially, two cross-hair targets on it. These are the sampling regions; they appear in the Before preview window as rectangular marquees with resize handles. You can move and resize the existing sampling regions (by clicking and dragging them) and create new ones (by clicking and dragging anywhere in the left preview window). Try to sample image areas where noise is particularly bad or ones that are representative of noise in large areas of the picture. Careful sampling will help the DNR filter to distinguish noise from genuine image detail.

Tip

You can save DNR filter settings as a preset and easily reapply them to other images taken on the same camera with the same ISO settings.

FIG 4.5 (*left*) Adding noise can transform a photo into something quite special. Here I have drawn an elliptical selection. (*right*) The next stage is to apply a feather to this selection to soften the edges (in this example, by 143 pixels).

FIG 4.6 Use Levels to brighten the center of the picture (i.e., the bit that's selected), then press Ctrl + D to select none and add the grain effect to the entire image using the Add Noise. The final stage involves adding a blur effect using the Radial Blur filter in Zoom mode. You can restrict the effect to the outside of the image—keeping the center sharp either by using the filter's Protect center controls or by making a selection.

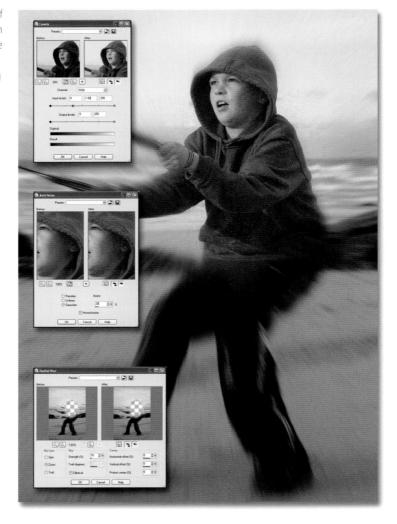

Another way to protect parts of the image from the unwanted attention of the DNR filter is to use the Protect Image tab, where you can select a range of colors from within the image that you don't want processed by the filter. The simplest way to use this feature is to Ctrl-drag the area you want to protect in the left preview window.

PaintShop Pro also has a filter that is ideally suited for adding noise (Add Noise). Why add noise to a digital photo? For several reasons.

All retouching, whether you are using a filter effect or a specific retouching tool (like the Clone or Scratch Remover tools), smoothes out textures. This is an excellent result for portraits, glamour, fashion, and any other applications where flattery pays.

But, if one area of the picture has had too much retouching, it will look smoother than the rest of the image. Add noise to the retouched section to make it appear more like the rest of the photo rather than attempt to smooth out the entire picture. You can also add noise to increase the grittiness and overall impact in a picture (see Fig 4.6). There are several ways to do this:

- Add noise to the retouched section using one of the textures from the Materials palette.
- Copy the background layer, make sure that the new layer is selected, and
 use PaintShop Pro's Add Noise filter to add a suitable quantity of noise to
 match the rest of the image. Then, using the Eraser tool, rub out the bits of
 the top layer that have not been retouched.
- · Apply noise using a selection.

Retouching Using the Clone Brush

The Clone brush is possibly the most useful of all PaintShop Pro's retouching tools because it can be used for repairing damaged pictures and for improving photos with distracting background or other unwanted detail. Learn how to use this tool with skill, and it'll open up potential you never thought possible with your current photo-retouching skills.

FIG 4.7 The Clone tool can do a lot more than remove a few spots and scratches from old photos. Use it to remove distracting background detail, unwanted objects, and even people from your pictures.

There's no big mystery to the Clone brush. It simply copies one part of a picture into the clipboard or temporary memory (this is called the "Source") and pastes it over another part of the picture (called the "Target"). You can feather the edge of the Clone brush and adjust its opacity to make your changes blend in.

Cloning in Practice

Choose the Clone brush from the Tools toolbar (keyboard shortcut "C"). This is shared with the Scratch Remover and Object Remover tools, so you might have to click the latter's icon and reselect "Clone" from the fly-out menu. Make sure that the Tool Options palette is also open on the desktop by right-clicking on the menu bar and choosing "Tool Options" from the palette's submenu. Pressing F4 toggles the Tool Options palette on and off.

To make the Clone brush work properly, you must select a Source area. First off, find a spot in the picture that is tonally close to the tone in the section to be replaced. There's no point in trying to copy a dark patch over a light patch. The light patch goes dark with the copied pixels and ends up looking unconvincing.

Move the brush over this area, and right-click once with the mouse. This sets the Source point and copies the pixels that are under the brush. Move the brush to the target section of the picture, left-click, and drag to paint. This pastes or "clones" the copied pixels over the damaged pixels. You should see the target section disappear or, at least, reduce in intensity.

The Clone brush has several options designed to fine-tune the brush performance. These include "Size," Shape, "Step," brush "Density," brush "Thickness," brush "Rotation," brush "Opacity" and "Blend mode." The most important controls to try first are the brush size, brush opacity, and, finally, the blend mode.

Setting brush size is important. If there are huge scratches, large fade spots, or ripped sections in the picture, choose a brush size that's smaller than the damaged areas. Do this because building up the repair gently is preferable to trying to do it with a single brushstroke, and, besides, there might not be enough of the Source area to copy from. Several softer brushstrokes always produce a smoother finish and inevitably a more convincing result.

Change the brush size during the retouching operation as well as the Source area. Many novices copy and paste with such enthusiasm that they don't notice the telltale step-and-repeat tracks left across the print surface because they have not reselected the Source area. This is something to be avoided. Moving the Clone Source point often is the best way of avoiding these telltale marks and (usually) produces a more convincing retouched result.

The Options palette also offers an Opacity setting. This affects the brightness of the pixels copied from the Source area. Effectively, this slows the

Tip

To replace larger sections of an image with background detail, try making a featherededged selection and copying and pasting it.

FIG 4.8 The Clone tool Options palette provides a wealth of brush presets and other settings so that you can adapt the tool to the job in hand. Before you do anything, create a new raster layer to clone into, keeping all your changes in one place and keeping the original unmarked. Make sure to check the "Use All Layers" box on the Options palette so that you can clone from one layer to another. Start with a small brush and use lots of small strokes so that if you make a mistake you can easily undo. Change brush size frequently to match the area being cloned and experiment with brush hardness, opacity, and blend mode to get the best result. Here, the background layer opacity has been reduced so you can more clearly see the cloning on top. If you're not happy with your first effort, just erase the cloned sections from the "cloned bits" layer and start again.

retouching process noticeably as you end up trying to cover damaged areas with less-dense pixels (reduced opacity). Several mouse clicks might have to be made to achieve the same as one set at 100% opacity. However, it's always better to reduce the opacity to get a smoother tonal result.

Another control to experiment with is the blend mode. Blend modes, which we discuss in detail in Chapter 5, influence the way copied pixels react with

the underlying, original, pixels. For example, click the default "Normal" drop-down menu in the Options palette and try cloning using Burn (darken), Dodge (lighten), or the Color Blend mode.

Other tools can be used to fix damaged pictures:

- · Scratch Remover tool (to remove blemishes locally)
- · Small Scratch Remover tool (to remove small blemishes only)
- · Clarify filter (to make a picture sharper and clearer)
- Fade Correction (to rejuvenate contrast and color)
- · Histogram Adjustment tool (to increase the contrast)
- · Makeover tool

Other Tools to Try

Like many of PaintShop Pro's tools, the Dodge and Burn brushes perform the digital equivalent of a conventional darkroom technique. During printmaking, areas of the paper exposed under the enlarger are held back, or given additional exposure using masking tools. In this way it's possible to bring out detail in parts of the print that wou d otherwise be over- or underexposed.

FIG 4.9 The Dodge and Burn tools provide, in the form of a brush, the power to add (or subtract) exposure to for from) a photo. Before using any retouching tool, duplicate the background layer, call it "retouching," and make all your changes to this new layer. That way you can compare before and after versions by toggling the layer visibility, you can also go back to the original should things go badly wrong. The secret to successful burning (and dodging) lies in the Tool Options palette. Too much burning produces these telltale dark smudges. Use a large, soft-edged brush and reduce the opacity so that each brushstroke makes only a small difference. Then gradually build up the effect using multiple strokes. Just press Ctrl + Z to undo if something doesn't look right.

FIG 4.10 This is what the Burn tool can do for a photo—completely transform an image that would have otherwise perhaps found its way to the trash bin but is now worth showing to others.

The Dodge and Burn brushes do exactly the same thing. Dodge lightens the pixels to which it's applied and the Burn brush darkens them—the equivalent of giving more exposure under the enlarger. You need to be careful not to overdo it with these tools, or your intervention will become obvious. With each application of the tool, the effect becomes more obvious. It's a good idea to duplicate the background layer before using the Dodge and Burn brushes and apply the changes to the copy. Use large, soft-edged brushes and reduced opacity settings to avoid burning hard-edged holes. You can use the left and right buttons to switch between Dodge and Burn, but I wouldn't recommend this; if you've overburned an area, undo, or use the History palette to get back the detail.

Creating Black-and-White Pictures

Despite the fact that digital photography makes it no more difficult or expensive to shoot in color than black and white, monochrome images are proving as popular as ever. For some subjects, removing the color altogether produces an aesthetically desirable result, and digital image processing makes it easier than ever to produce toning effects like sepia, split toning, and cross-processing that, in the days of chemical processing, were messy, time-consuming, and often produced hit-and-miss results.

Tip

The Channel mixer produces the same effect as yellow, red, or other colored filters on the camera with blackand-white film; use it to create dramatic skies and other effects.

One of the simplest ways to produce black-and-white photos is to set your camera to Black and White mode but, other than in exceptional circumstances, I'd advise against this. Shooting color in the camera and converting the images to black and white, as we shall see, gives you a much greater degree of control over the process and provides many more creative opportunities. It also gives you the option of keeping the color photo as well.

FIG 4.11 *Top:* Converting a photo to grayscale using Image > Grayscale removes the color data, which results in a smaller file size but is irreversible. *Bottom:* Use Hue/Saturation/Lightness to convert to black and white but retain the color data should you want to reintroduce color to the image later.

PaintShop Pro X4 provides several methods of converting color images to black-and-white ones:

Image > Grayscale. This converts the image to an 8-bit single-channel grayscale image and discards the color information. Once the image is saved in this mode, there's no getting the color data back, so, if you want to keep the color image, make sure to keep a backup copy and choose File > Save As so you do not overwrite your original.

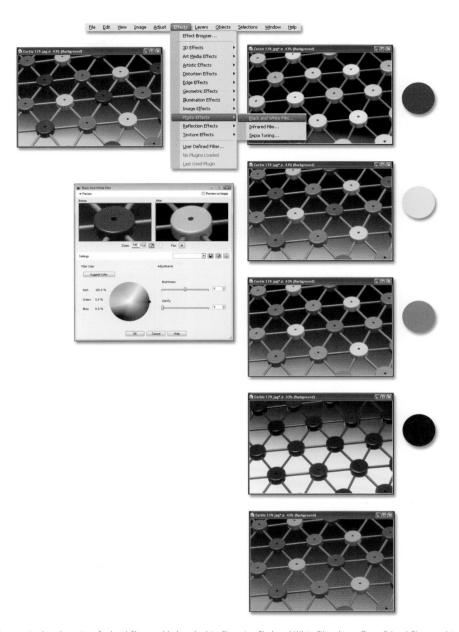

FIG 4.12 You can simulate the action of colored filters on black-and-white film using Black and White Film photo effects. Colored filters used in this way lighten the tone of same-colored objects and darken those with complementary colors. On this image, red lightens the red discs and darkens the blue background. Because of its proximity to yellow and orange, red also lightens the yellow and orange discs to a degree, but yellow and orange have a greater effect on their respective colors in the image. Blue has the reverse effect, lightening the blue background and darkening the discs. You can save commonly used filters like yellow, orange, and red as presets. Bottom: You can also use the Photo Effects Sepia filter to apply a quick sepia tone to an image, but the Colorize option on the Hue/Saturation/Lightness dialog box provides more scope for color tinting of black-and-white photos.

- Adjust > Hue and Saturation > Hue/Saturation/Lightness. By dragging the Saturation slider all the way to zero in the Hue/Saturation/Lightness dialog box, you can completely desaturate the image. The difference between doing this and converting to grayscale is that, although you can no longer see it, the color information is still there. You can go back to Hue/Saturation/Lightness at any time and put the color back by dragging the slider in the opposite direction. You can also introduce new color in ways we'll look at shortly.
- Effects > Photo Effect > Black and White Film. This filter can convert your photos to black and white and at the same time simulate colored filters placed over the lens to help differentiate colors with similar gray tonal values. For example, a yellow filter is commonly used to darken blue skies and help pick out cloud detail when shooting black-and-white landscapes. Like Hue/Saturation/Lightness, the Black and White Film effect retains the color channels in the file so you can add new color effects, but the effect isn't reversible—you can't get the original colors back once the file is saved.
- Adjust > Color > Channel mixer. The Channel mixer works in a similar way
 to the Black and White Film effect, only it provides a lot more control.
 Whereas the Black and White Film effects are confined to a limited number
 of filters (Red, Green, Yellow, Orange, and Blue), using the Channel mixer to
 combine the data from the red, green, and blue channels, you can produce
 a widely variable range of tonal effects.

Tinting Black-and-White Photos

In the last section we described ways to use PaintShop Pro to convert a color picture to black and white. Now we'll take a look at how to color tint a black-and-white photo. Why color tint? Most black-and-white pictures reproduce only a limited tonal range: 256 tones to be exact. The addition of color, albeit in subtle amounts, produces a print apparently much richer in tonal scale.

This process is sometimes called a "duotone." Adding two colors to a black-and-white photo in the same fashion is called a "tritone." Adding a third color makes this a "quadtone." Aside from increasing tonal depth, making a duotone can be a cheaper way of introducing color to commercially printed jobs (because adding a second color is cheaper than producing the full four-color print process).

How It's Done

Aside from using Effects > Photo Effects > Sepia Toning, which, as we've seen, limits you to fairly crude applications of a single color, the simplest way to tone a black-and-white photo is to use the Color Balance feature. Remember, you can only produce color effects like this (or in fact carry out any color editing, such as adding colored text) on an image that, though it may appear black and

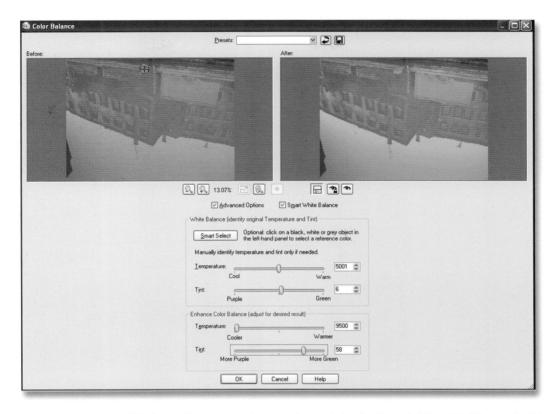

FIG 4.13 Use the Color Balance dialog box to add a tint to previously desaturated images. Stick to the sliders in the Enhance Color Balance panel, which work more intuitively than the others.

white, is an RGB color file. So, if you're starting with a full-color image, desaturate it, as explained on the previous page. If it's a grayscale image, convert it to an RGB one by selecting Image > Increase Color Depth > RGB—8 bits/channel. Now open the Color Balance dialog box by selecting Adjust > Color Balance and uncheck the Advanced Options box to turn off the advanced controls if they are displayed. Now all you have to do is drag the slider to the right or left to make the image warmer or cooler. Warmer adds red and yellow to the image, and cooler adds blue. The further you drag the slider, the more color is added. To add other colors to the image, check the Advanced Options box and use the More Purple/More Green slider.

It's easy to get confused when using the Color Balance dialog box in advanced mode. It helps if you stick to using the sliders at the bottom of the dialog box in the Enhance Color Balance (adjust for desired result) panel, as these work intuitively. The sliders at the top are for manual identification of an existing color cast in the image that you want to remove and so can

Tip

Color Balance and Hue/ Saturation/Lightness are best applied as adjustment layers, so that changes remain editable and can be removed later if required. (See Chapter 5.)

FIG 4.14 For the ultimate in tinting control, the Hue/Saturation/Lightness dialog box is hard to beat. Control the tint color with the Hue slider and strength using the Saturation slider. You can also adjust image brightness using the Lightness slider, though adjustments of this kind are usually best left to Levels.

appear to work counterintuitively. For example, if you drag the Tint slider toward purple, this is telling PaintShop Pro that the image has a purple cast that you want to remove—so it adds green.

You can add a wider range of tints to a photo using Adjust > Hue and Saturation > Colorize. This is actually pretty simple to use. First, select a color using the Hue box on the left—the colors won't mean much to you, so click the down arrow to display a color picker. Next, adjust the strength of the tint using the Saturation slider.

Again, if you click the down arrow you can work with a visual tint gradient rather than a number.

You can also use the Hue/Saturation/Lightness dialog box with the Colorize box checked to tint a monochrome photo. This works in pretty much the same way as the colorize method, using the Hue and Saturation sliders to set the tint color and strength. The Hue/Saturation/Lightness dialog box (as its name implies) also provides a Lightness slider.

Tip

For an interesting effect, use a Hue/Saturation/ Lightness adjustment layer in Colorize mode to apply a tint, then reduce the layer opacity to blend it with the original color.

FIG 4.15 The Colorize command provides the best balance between control and ease of use. Just select your tint color using the Hue color picker, then adjust the strength using the Saturation slider.

Whenever you're tinting images in this way, it's a good idea to use an adjustment layer, rather than applying color changes directly to the image. Using an adjustment layer will allow you to easily make changes to the tint at a later stage in the editing process—for example, if you add some text and decide that a different-colored tint would work better. You can even remove the tint altogether if you decide against it.

Adjustment layers also provide additional control over the effect. You can reduce the strength of the effect and blend it with the original using layer opacity and blend modes. See Chapter 5 for more about how you can use adjustment layers to edit images nondestructively.

Creating Color Overlay Effects

In the earlier editions of this book we devoted these pages to a technique that involved using the Color Balance tool to apply a multitone effect, using different colors for the image shadows, highlights, and midtones. Although PaintShop Pro's Color Balance tool is now easier to use, it no longer lets you apply color changes individually to the highlight, midtone, and shadow regions of a photo. But we're not going to let that get in the way of a good technique! Here's how to achieve the same effect using a layer property called Blend Range, which masks parts of a layer that fall within a tonal range that you specify.

Open the image you want to tint and duplicate the background layer twice by selecting it in the Layers palette, right-clicking it, and selecting Duplicate from the context menu. Rename the new layers after the color you intend to use for the tints; here I've called them red and blue. Tint the layers using the colorize technique described on page 120.

Tip

Like adjustment layers, the changes you make using blend ranges aren't permanent and you can go back and edit them at any stage. Try combining blend ranges with blend modes to produce interesting graphic effects.

Double-click the top "blue" layer in the Layers palette to open the Layer Properties dialog box and click the Blend Ranges tab. If it isn't already selected, choose gray channel from the Blend Channel pull-down menu and take a look at the two graduated bars underneath it. You can use these bars to control how pixels in the two layers are displayed. The top bar, labeled "This layer," can be used to hide pixels on the upper (blue) layer using the four triangle-shaped buttons. Drag the buttons on the left to hide pixels in the shadows and those on the right to hide highlight pixels. By dragging the top and bottom triangles to different positions, you can create a smooth transition between the layers, rather than have the color change abruptly.

The bottom slider essentially does the same thing in a different way. Think of it as forcing pixels on the layer below (in this case the blue layer) to show through the top (red) one. I find it keeps things simpler to ignore the Underlying Layer controls and just use the controls for the upper layer to choose which parts of the tonal range I want to appear in that color.

Using the Warp Tools

PaintShop Pro has several powerful brush tools that can be used to radically bend and distort the pixels in a photo. These are the Warp brushes. Why use a Warp brush?

- To create zany, surreal pictorial effects.
- To increase eye size in a portrait (i.e., to enlarge a model's pupils for that wide-eyed look; it can also be used to reduce the size of other unsightly body parts like noses, if it's important).
- · To straighten facial details (e.g., a broken nose).
- · To entertain your kids.

The Warp brush works just like any other brush in PaintShop Pro in that you can run it over the picture and it will apply a direct change. In this situation you have massive influence over how the pixels bend and warp under the brush. Some computing power is needed to make this work swiftly.

There are eight warp modes that can be combined or used individually. The brush effects are "Push," "Expand," "Contract," "Right Twirl," "Left Twirl," "Noise," "Iron Out," and "Unwarp."

FIG 4.16 Use the Blend Range feature to confine color tints to parts of the image like the highlights or shadows. (1) Confining the top blue layer to the highlights creates a hard-edged transition between red sea/land and blue sky. (2) Soften the transition by creating a "ramp," allowing the red to bleed into the sky and vice versa. (3) You can use this technique on high-contrast images to produce two-color posterization effects.

If you don't like what this brush does, click the Cancel tab. Other options include "Brush Size," "Hardness," "Strength," "Step," and "Noise." When you have finished the warping process, click the OK checkmark to render the warping action. The neat thing about this tool is that you can preview everything in four different Draft-quality modes, depending on how much of a hurry you might be in, and then finish the job in two final Render-quality modes.

If you are in a hurry, set Coarse Draft-quality in the Tool Options palette. This doesn't affect the final result, so for best-quality results you should check the Best-quality box regardless of the Draft-quality setting.

FIG 4.17 The Warp tools have many uses, not the least of which is to make domestic pets look absurdly funny.

Scripting

Scripting is a powerful PaintShop Pro feature that was introduced back in version 8. It allows you to automatically combine several editing steps and apply them to another image. Say, for example, you have a whole folder of images and you want to do the same thing to each of them—open them, resize them, unsharp mask them, add a frame, and save them. That's the kind of repetitive work that scripting was designed for. (PaintShop Pro's One Step Photo Fix is a script.)

Scripts are easy to create. The Scripting toolbar works a little like a VCR, with a record button that when pressed keeps track of everything you do and produces a script so that the same process can be applied with a single click to any other image. There's also a selection of presupplied scripts, including "Border with drop shadow," "Black and white sketch," "EXIF captioning," "Photo edges," "Sepia frame," "Simple caption," "Vignette," and "Watercolor."

You can add scripts as buttons to toolbars, which makes them even easier to apply. Right-click on the toolbar and select Customize from the contextual menu, click the Scripts tab in the Customize dialog box, and select the script you want to add from the pull-down menu. Choose an icon, click the Bind button, and the Script button will appear in the Bound Scripts pane. Now drag this icon from the Bound Scripts pane onto the toolbar. Now all you have to do to apply the script to any image is click the button.

Prewritten scripts are all very well, but what if you want a script to handle a repetitive task that doesn't appear on the Scripts toolbar drop-down list? Well, you can record your own, but you can also edit the existing scripts. PaintShop Pro's scripts are written in a scripting language called "Python." You don't need any special scripting knowledge to edit existing scripts, but if you're interested in finding out more about Python take a look at http://wiki.python.org/moin/BeginnersGuide.

FIG 4.18 At a basic level, scripting allows the user to run a prerecorded action over an image (or images) in order to produce a quick—and predictable—result. Or you can record your own script and save it for use another time.

To edit a script, click the Edit Script button on the Script toolbar. Some of the PaintShop Pro scripts provide editing tips. For example, the Thumbnail 150 script begins:

if you want thumbnails generated at a different size, just change this to the desired value.

MaxThumbnailSize = 150

The # symbol at the beginning of the first line denotes a comment—what follows is ignored by the script interpreter—but its meaning is clear enough to anyone else.

PaintShop Pro X4 has an even easier way of creating scripts—called "Quickscripts"—using the History palette. The History palette automatically records everything you do in PaintShop Pro. You can use the History palette as a super-undo feature. Whereas selecting Undo from the Edit menu (or pressing Ctrl + Z) will take you back through recent editing in linear steps, the History palette can be used to selectively undo. You can, for example, undo the Lens Distortion filter effect you applied 10 minutes ago but keep the cropping, Red-eye Removal, and Automatic Color Balance subsequently applied.

To create a Quickscript, select the steps you want to use by Shift-clicking (Ctrl-click to select noncontiguous steps) them in the History palette and clicking the Save Quickscript button. To apply the Quickscript to the current image, click the Run Quickscript button. What could be simpler? Well, it would be nice if you could save more than one Quickscript. As it is, when you save a new Quickscript it overwrites the old one. Perhaps multiple Quickscripts are something we can look forward to in PaintShop Pro Photo XII.

FIG 4.19 Use the Script toolbar (left) to select and apply scripts to the current image. You can create Quickscripts from the History palette (center). Combining scripts with the Batch Processing feature (right) is the route to major effort-saving automation.

Clearly, scripts can save you a lot of legwork if you need to apply the same editing sequence to a large number of images. But you still have to open the image and click the button. It may not sound like hard work, but if you have to do it 300 times, or every time you download a batch of pictures from your digital camera, you'd be forgiven for considering it a chore. This is where batch processing comes in. Batch processing can automatically apply editing commands to an entire folder of images. Combine batch processing with scripting and you have some real image-editing power at your fingertips.

PaintShop Pro's Batch Processing feature grew out of a Batch Convert feature designed to allow you to convert a bunch of files from one format to another. It was extended to allow you to apply scripts, and there's also a useful Batch Rename feature, which you can use to change the anonymous file names of digital camera images to something more meaningful.

To open the Batch Process dialog box, select File > Batch Process. Click the Browse button, navigate to the folder of images you want to process, and click the Select All button. Before you do this make sure to back up the originals somewhere safe and work on a copy of the images so that, if something unexpected happens, you still have the originals to fall back on.

Check the Use Script box, select a script from the pull-down menu, and check the Copy radio button. This will save a copy of the processed image into the folder you specify in the Save Options pane. Click the Browse button and create a new folder called something like "processed files" on your hard disk. If you check the Silent Mode box, Batch Process will run the selected script and apply the settings you used when you recorded it. If you leave the Silent Mode box unchecked, a dialog box will open at relevant points in the script for each processed image, requiring you to enter values.

When you're sure everything is correctly set, click the Start button, sit back, and watch while PaintShop Pro does the hard work for you.

Step-by-Step Projects

Restoring Badly Damaged Photos

Tip

A pressure-sensitive stylus and tablet makes retouching much easier. Use the Brush Variance palette to determine how the brush responds to stylus pressure. When you press harder, the brush can get bigger, or change opacity or thickness.

Once you've mastered the retouching techniques demonstrated in this chapter and elsewhere in the book, you'll be able to make improvements to digital photos that aren't quite "right" as well as scanned pictures in need of restoration. With skilled use of the Clone brush in combination with the other retouching tools, there's little you won't be able to fix. This step-by-step project shows how to restore an old photo that's suffered bad damage, in this case more because of lack of care than the aging process. Don't be put off attempting to restore old photos because they look past saving. Even severe damage, such as tears, staining, fading, and folds, can be reduced or eliminated altogether with the repeated application of the simple techniques shown here. And, if your first efforts don't meet with much success, keep trying; retouching is one of those things that improves with practice.

STEP 1 This photo is about 40 years old. It hasn't aged too badly, but it has a couple of serious fold marks, one running upward from the dog's ear and another running vertically through the middle, as well as a nasty stain from a coffee cup. Overall, the picture has accumulated some dirt and grubbiness, most noticeably in the white border area.

STEP 2 Even if the original is black and white, scan it as an RGB color image. The additional channels in an RGB image can bring out (or cover up) detail that will help in the retouching process. Scan at a high resolution so you can zoom in and work on small details; you can always down-sample the photo later for printing or web use.

STEP 3 Crop the picture to get rid of that grubby border. Depending on the shot, you can save yourself a great deal of work by cropping close and removing a lot of material that you might otherwise have to retouch, but here we want to keep everything other than the border.

STEP 4 From the Image menu select Split Channel > Split to RGB to separate the photo into its constituent red, green, and blue channels. Select Tile Horizontally from the Window menu to compare the channels. Notice how the coffee stain isn't nearly so obvious on the red channel. This is the one we'll use for our retouching. Close the original scan and the green and blue channels and resave the red channel.

STEP 5 Click the New Raster layer button at the top of the Layers palette to create a new layer; call it "retouching." First we'll deal with the coffee stain. Sometimes it's easier to deal with big problems like this using copy and paste rather than the Clone brush. Use the rectangular marquee with a feather setting of 1 and select an area just above the stain. It's a lucky coincidence that this selection is exactly the same, bar the stain, as the area below it, but you'd be surprised how often this happens.

STEP 6 Select Copy Merged from the Edit > Copy Special menu followed by Paste As New Selection and position the pasted selection over the coffee stain, taking care to match the horizontal line of the wood cladding. Press Ctrl + Shift + F to defloat the selection. Repeat the process with different selections to cover as much of the stain as possible. Press Ctrl + D or choose Select None from the Selections menu.

big enough to cover the width of the fold in one hit. Set the hardness to around 50 and make sure that Aligned mode and "Use all layers" are both checked. Right-click with the brush just to one side of the fold to set the sampling point, then move onto the fold and left-click to clone. If your cloning isn't seamless, try again from a slightly different start point. You'll need to experiment with the brush size, opacity, and blend mode; you'll get better results using many short strokes, rather than one long one, and you'll also need to frequently reset the source point.

STEP 8 Continue with the Clone brush down the length of the fold. Usually the best results are achieved by sampling close to the area to be cloned, as you will get a better match. Sometimes this will be to the left of the damaged area, sometimes to the right. Occasionally you may find there is no suitable material close by and you'll need to sample from a more remote location with similar detail. After cloning out the two fold lines, I've gone back and removed the traces of the coffee stain from the area below the fence using the Clone tool. Picking the Red channel, where the mark was least visible, meant that very little work was needed to remove the remaining traces. Finally, I've added a nice clean white border.

Hand-Coloring Black-and-White Photos

In the days before color photography, a commonly used technique was to add color to black-and-white prints using inks and a small retouching brush. The aim of this process wasn't to create an exact facsimile of a scene in full color, but rather to add a little color detail to heighten the realism and add life to what otherwise may have appeared drab and austere.

If you've ever seen a hand-colored black-and-white print, you know just how charming they can be. Using PaintShop Pro, you can recreate this effect either to add a new dimension to archive family photos or to produce an interesting new take on more recent digital images.

STEP 1 If you're starting off with a scanned black-and-white photo in gray-scale mode, you'll need to convert it to RGB by selecting Image > Increase color depth > RGB - 8 bits/channel. If it's a color image, desaturate it using Hue/Saturation/Lightness as described earlier in the chapter.

STEP 2 You'll get a more realistic result using a limited color palette. Using the Materials palette in Swatch mode, create up to six colors. Depending on the image, you might, for example, choose a skin color, red to add color to lips and cheeks, one or two colors for items of clothing, and another one or two swatches for other detail such as sky, a car, or, as in this case, a pedalo. You might also find it helpful to name the swatches appropriately (e.g., "skin tones").

STEP 3 Select the Paint Brush and choose one of your color swatches. Use the Tool Options palette to set the brush size, shape, hardness, and other parameters. To a degree these will depend on the detail you are coloring, but generally you'll find that soft-edged brushes with reduced opacity give good results. You might also try the airbrush.

STEP 4 Create a new raster layer on which to add the color. There are two reasons for this. First, it's always a good idea to keep any retouching on a separate layer, as it leaves the original untouched on the background layer and if things go drastically wrong you can always delete the retouching layer and start again. Second, it gives you a lot more control over your editing. You can change the opacity to fade the retouching and make it less obvious and use PaintShop Pro's blend modes to produce a more natural look.

Tip

You'll find it much easier to hand-color and carry out other retouching tasks using a pressuresensitive tablet and stylus. It's much more natural to paint with a stylus than with a mouse, and PaintShop Pro's Brush tools respond to pressure—the harder you press, the more paint is deposited. Some styli even have an eraser on the end, so you can flip them over and rub out!

Tip

When you change the layer blend mode to Color (Legacy), the paint that you've applied with the Brush tool adopts the tonal characteristics of the underlying (gray) pixels. Dark pixels pick up darker color and vice versa. It pays to be realistic in your choice of colors. If your subject is wearing a dark shirt, you won't be able to paint it light blue. If colors don't come out as expected, try using the Hue/Saturation/Lightness controls to change the color of the paint layer—another good reason for keeping each color tint on a separate layer.

STEP 5 Making sure the new layer is selected, start to paint over the background image. At this stage the paint will go on thickly and may even completely obliterate the detail below, producing a crude and ugly result. Don't worry! Once you've applied a few strokes to a small area of the picture, stop painting.

STEP 6 In the Layers palette, change the blend mode from Normal to Color (Legacy). Now, your brushstrokes apply color to the image but maintain the original tone, producing a more natural effect. As well as retaining the underlying detail, you'll notice that the color varies from your original swatch, depending on how light or dark the underlying pixels are.

STEP 7 When you've finished painting all of the image detail in one of your palette colors—for example, all the skin tones—create another new layer and continue painting in the next color. You could put all your colors onto one layer, but using a different layer for each color gives you more control over the finished result. Suppose, when you are nearing completion, everything looks okay but the skin tones look a bit over the top, like everyone's had a bit too much sun. By reducing the opacity of the skin tones layer, you can correct this problem without affecting the other colors.

STEP 8 The great thing about hand-coloring is you don't have to be a great artist or even incredibly accurate, as this screen of all the paint layers at 100% opacity in Normal mode shows!

The final result.

Using Selections Controlling Change

What's Covered in this Chapter

- This is a short chapter, but it covers crucial techniques that will take your
 photo editing skills way beyond what we've covered up to now. This
 chapter is all about selections and how to make them. Selections, and their
 close relatives mask layers and alpha channels, allow you to confine
 changes to a part of the image—a bit like using a stencil.
- PaintShop Pro X4 has more than 20 selection tools, but the most commonly used are the Geometric selection tools, the Freehand selection tool, and the Magic Wand. One of the keys to successful selection is knowing which tool to use for particular selection tasks, how to set the tool options so that you get exactly what you want—nothing more and nothing less—and, if you don't get quite what you want, how to add to and subtract from existing selections.
- The selection tools can take you only so far. For one thing, they're not
 permanent, so if you want to close your photo and come back to work on it
 later you'll need to save your selection. This is where alpha channels and
 mask layers come in. As well as allowing you to make selections permanent,

alpha channels and mask layers can be worked on with Paint Shop Pro's brush tools. Masks produced in this way can show or hide anything in your photos, even things with indistinct edges, like fur, hair, clouds, and water. Once the mask is made, you can use it as the basis for selectively applying filters, making tonal and color changes, or anything else. This chapter introduces alpha channels and mask layers. In Chapter 5, you'll learn some more advanced masking techniques using layers.

• The step-by-step projects at the end of the chapter demonstrate how to use selections to achieve three different outcomes: blurring the background to produce artificial 'depth of field', fixing an overexposed sky, and cutting out an object from its background. There's also a step-by-step guide to using PaintShop Pro X4's improved HDR Photo Merge feature.

Tip

As with many other aspects of photo editing, making selections, particularly with the Freehand selection tool, is much easier with a graphics tablet and stylus than with a mouse.

Understanding Selections: Adding Creative Power

PaintShop Pro has several tools that allow you to isolate specific areas within a picture based on certain selection criteria such as color, tonality, or contrast, or simply by drawing around it. You have to distinguish the best selection tool, or tools, to use for the picture in question. For example, sometimes it's possible with one mouse click to get a good, c ean selection around an object. Sometimes it is not so easy because the photo might be multicolored or irregular in tone. In this case you'd use a combination of selection tools to successfully "grab" the object cleanly. PaintShop Pro also has a number of tools that you can use to clean up these selections once started. These are called Selection Modification tools.

Selection tools are divided into three types:

- The Freehand selection tool, which has edge-seeking ("magnetic"), point-to-point (polygonal line), smart-edge (linear "magnetic"), or just freehand characteristics.
- The Geometric Marquee selection tool comes in rectangular, square, circular, star, triangular, and 10 other preset shapes.
- The Magic Wand tool finds pixels of a similar contrast, color, hue, brightness, or opacity within the picture.

That's a combination of 20 selection tools to choose from.

Bear in mind that the Tool Options palette has more refining controls for most of the tools mentioned (some already mentioned are accessible through this palette only). Controls include a Tolerance level, Blend mode, Anti-aliasing, Smoothing, Feathering, and Match mode.

In addition to the selection tools, PaintShop Pro X4 has a couple of ways to cut out and remove objects from photos. These aren't, strictly speaking, selection tools; they go beyond mere selection and actually remove parts of the image for you in a single operation.

The Object Extractor does exactly what it says: it cuts out part of an image—say, a person, car, flower, or whatever your subject happens to be—removing the background. To use the Object Extractor, select Object Extractor from the image menu. The Object Extractor opens in its own window, which displays a large image preview below which are some tools and settings. To use it you select the brush tool, set an appropriate brush size, and paint an outline around the edge of the object you want to cut out. If you make a mistake, you can erase with the eraser. When the outline is complete, click inside it with the Fill tool to fill the selected area with a red mask, then click the Process button.

PaintShop Pro X4 now makes a first attempt at extracting the object from the background. If it doesn't get it right the first time, try experimenting with the accuracy slider—each time you move it the image is reprocessed and you'll have to wait a few seconds. Subjects with more detailed edges will require a higher accuracy setting (and better skills with the brush), but, as long as the subject that you're attempting to extract is reasonably well isolated from the background, you should be able to get a good result. To get a better look, check the Hide Mask check box, and if you want to go back and edit the outline in an attempt to improve the result, click the Edit Mask button. When you're happy that you've got the best possible result, click the OK button to extract the object. The background is deleted, leaving your object cut out on its layer.

FIG 5.1 The Object Extractor makes light work of removing a subject from its background. It works best on subjects like this, which are clearly defined against a plain background like the sky. It's simple to use: you just paint an outline around the subject, fill it, then click the Process button. PaintShop Pro X4 then deletes the background detail.

The Object Extractor, like the Background Eraser, which works in a similar fashion, works best on objects that are well isolated from their backgrounds (e.g., those shot against a plain background—like the sky in our example). To cut out objects with more complex backgrounds you'll get a better result using the selection tools already discussed and, even better, by masking.

Tip

Instead of trying to select an object, it's often easier to select the background, then invert the selection (press Ctrl + Shift + I). You can also try using a Levels adjustment to make a light background completely white and much easier to "grab" using the Magic Wand tool.

which is explained toward the end of this chapter. You could also take a look at the step-by-step project at the end of this chapter that shows exactly how to deal with objects that have fussy background detail.

One other feature of PaintShop Pro X4 that I want to mention here is the Smart Carver, which combines retouching and cropping in one operation, allowing you to resize an image while preserving some details and removing others. Again, though it's not strictly speaking a selection tool, it uses simple selections as a basis for automating what would otherwise be a complex retouching task.

The Smart Carver is on the Image menu just above the Object Extractor and opens in its own window. It has two brushes, one for preserving detail and the other for removing it. You simply paint over what's important with the green brush and daub what you want to lose with the red brush. I use the word daub advisedly. The great thing about the Smart Carver is that you don't need to be too careful about going over the edges. As long as what you want to keep or lose is covered in paint, it works just fine.

FIG 5.2 Smart Carver resizes photos, removing unwanted detail in the process. Unlike cropping, the bits you want to get rid of don't have to be near the edges. You can seamlessly remove detail from anywhere in the frame.

Having done your painting, there are buttons for resizing the image both vertically and horizontally. The most useful of these are the Auto-contract buttons on the right, which resize the image sufficiently to remove all unwanted detail.

What else can you do with selections?

- All selections can be saved and stored for later use in an alpha channel or to a designated area on your hard drive like any other file.
- Selections can be used like a painter's drop sheet—to inhibit brush actions along straight edges and to stop paint from getting into areas that you don't want to get paint into.

FIG 5.3 PaintShop Pro has a wide range of special selection tools, but for cutting irregular objects out from a background the best options are the Freehand selection tool or the Magic Wand tool. Few objects are perfect geometric shapes, and these selection tools are really intended for producing graphics by making a selection and filling it. If you are taking a photo of objects you intend to cut out, shoot them on a white or plain-colored background to make the task of selecting them easier.

- All selection tools have an "Add To" and a "Subtract From" function. Hold
 the Shift key when making a second selection and it's added to the first.
 Keep holding the Shift key to add further selections. In this way you can
 build, or reduce, extremely accurate selections.
- To further refine the process, selection tools are interchangeable. Make an
 initial selection using the Magic Wand tool, for example, and add to that
 using a Marquee tool. Finish off using the Freehand selection tool. Use the
 Shift and Control keys to apply additions and subtractions, or set the same
 parameters in the Tool Options palette.
- Use the Options palette to make custom selections using numerical values in the fields provided ("Customize Selection" in the Options palette).
- PaintShop Pro also has an Edit Selection mode (Selections > Edit Selection). In this mode, all the raster painting/drawing tools and many filter effects can be used to modify the selection marquee. In this mode the selection is rendered in a red opaque color so it's easy to see. This is a powerful and fast way to make an average-looking selection into something that has professional accuracy.
- Perfect the selection using the Selection Modify tools. These will allow you to produce surprising accuracy from even the roughest of initial selections.

FIG 5.4 (*top*) To select these objects using the Magic Wand tool, I first duplicated the background layer and used a layers adjustment to make the background as white as possible. (*bottom*) Refine the selection using the Magic Wand tool in Add mode (or hold down Shift). You should be able to select all of the background using this method.

FIG 5.5 (top) Invert the selection (press Ctrl + Shift + I) and choose Edit Selection from the Selections menu to alter the selection using the brush tools. (bottom) Using the brush tools with Edit Selection enables you to make a very accurate, soft-edged selection that won't "show the join" when you paste.

Using the Geometric Selection Tools

PaintShop Pro's Geometric selection tools are the easiest to use because they are "preset." They don't rely entirely on the accuracy of the mouse action.

Open a picture and duplicate the background layer (Layers > Duplicate) so that you can practice on a copy of the original rather than the original itself. Make sure that the top layer is active (click it in the Layers palette).

Choose the Rectangular Marquee selection tool from the Tools toolbar, left-click, and drag the cursor across the picture about 20% from the edge of the image. The moving line that appears where the selection was drawn is called the "selection marquee." Any further editing on the picture applies to the area inside this selection only. Because we want to add an effect to the area outside this selection, it must be reversed or "inverted."

Choose Selections > Invert from the Selections drop-down menu and note how the entire image is selected up to the borders of the original area selected. Use the keyboard shortcut Ctrl + Shift + M to hide the marquee to make it easier to see any tone changes you make. Note that, though it is hidden, the selection is still active.

Open the Levels dialog window (Adjust > Brightness and Contrast > Levels) and drag the gray diamond slider (the middle one) to the right. This darkens the selected area. Push the slider far enough to make the edges significantly darker but still keep them semitransparent.

You can refine all selections using the Feather adjustment. This blurs the selection line across an adjustable pixel width so that you can soften those typical scalpel-sharp selection cut lines.

Adding to the Selection

To add to a selection, hold the Shift key down and make several more geometric selections, adding one on top of the other to build up a complex irregular but still geometric selection with each new mouse drag. Change the shape of the selection (circular, square, octagonal, etc.) using the Options palette. Remember at all times to update the save to preserve the selection information in an alpha channel (Selections > Save to Alpha Channel).

The Magic Wand Tool

You may find that the Geometric selection tools are not accurate enough or simply not the right shape to capture the subject in the picture. In this case, the Magic Wand tool is what you need. This is the most versatile selection tool available to you and can capture just about any selection you ask of it. The key to success with the Magic Wand tool lies in correctly setting the options, and this often involves some trial and error. With a little experience, however,

it will become second nature to you and take very little time—certainly a lot less time than having to make the same selection manually.

Select the Magic Wand tool from the selection tool fly-out on the toolbar, and click inside an image on an area of fairly similar color and tone. The resulting selection marquee may cover a little of the image or a lot of it, and it may be one big selection or there could be smaller islands of selected image dotted about—it all depends on the image.

What the Magic Wand does is select pixels of similar values, within a range that you specify, throughout the image. As a starting point the Magic Wand tool uses the pixel that you click on. It then selects all the pixels with an RGB value within the range specified by the value in the Tolerance field of the Tool Options palette; the larger the tolerance, the more pixels will be selected. If what you're trying to select is a specific color—a red door, for example—you can use a low tolerance setting to select all of it. If it contains a wider range of colors, like a sky or the leaves on a tree, you might need to increase the tolerance to capture all of the hues.

Tip

Feathering is measured in pixels. If you feather a selection by 10 pixels on a low-resolution image, it will have a much bigger effect than on a high-resolution one.

FIG 5.6 Successful use of the Magic Wand tool depends on making good tool choices and adopting appropriate techniques. In this case it's easier to select the background and invert the selection to capture the subject. Rather than increasing the tolerance in an attempt to get everything in one bite, which will most likely just capture unwanted areas of the image, use a smaller tolerance setting and Shift-click to add to the original selection.

Sometimes, increasing the tolerance means you capture pixels you don't want that happen to have similar values to those you do. If this happens you need to try a different tack. One method is to Shift-click to add to the existing selection. If you get an unsatisfactory result, press Ctrl + Z rather than trying to subtract from the selection by Ctrl-clicking with the Magic Wand tool. Alternatively, it's often easier to select a background with the Magic Wand tool and then invert the selection (Selections > Invert or press Ctrl + Shift + I) to capture the subject.

Tip

The results of a Magic Wand tool selection depend on the precise pixel you click on. Even in what looks like an area of flat color, pixel values vary, so if your first attempt isn't successful, press Ctrl + Z to undo and click again on a neighboring pixel.

There are other options that can help you fine-tune a Magic Wand selection. Match modes enable you to make a selection on the basis of color, hue, brightness, and opacity as well as RGB values. Using the Brightness Match mode is one way to select shadow or highlight detail if you want to make selective tonal adjustments to an image.

Click the Use all layers check box if you want the Magic Wand tool to base its selection on all pixels in the image, rather than just those in the active layer (if you get very unexpected results with the Magic Wand tool, e.g., everything is selected wherever you click, it's probably because you're clicking in an empty layer with Sample Merged turned off). "Contiguous" selects only pixels that are next to each other, so you get one selection marquee. Turn off Contiguous and the Magic Wand tool can jump over nonselected pixels to select in-range pixels anywhere within the image. In Noncontiguous mode you'll get little pools of selection all over the image.

Finally, you can elect to antialias a Magic Wand selection's edge pixels. Use the pull-down menu to determine whether pixels outside or inside the selection border will be antialiased.

The Tool Options palette isn't the last word on modifying Magic Wand selections. On the Selections > Modify menu you'll find a host of additional fine-tuning adjustments that will allow you to, among other things, expand, contract, select similar, feather, smooth, and remove specks and holes from your selections. These can, of course, be used with any selections, not just those created with the Magic Wand tool.

Tip

Using the brush tools to paint directly onto a mask layer is often a much easier way to obtain a selection than using any of the selection tools.

Alpha Channels and Masks

When you make a selection, PaintShop Pro stores it in an alpha channel. Channels are a bit like layers; an RGB image is composed of three channels, one each for the red, green, and blue image data. Alpha channels are grayscale—pixels in them are black, white, or one of 254 shades of gray. In an alpha channel, pixels within a selected area are white, unselected pixels are black, and gray pixels are partially selected.

How can you have a partially selected pixel? Well, pixels in a feathered selection are partially selected. If you were to look at the alpha channel for

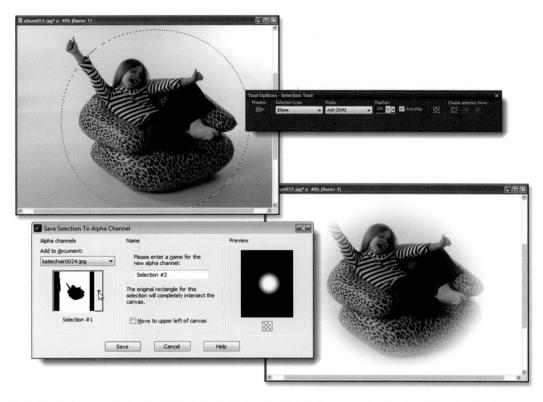

FIG 5.7 This selection was made using the elliptical selection tool feathered by 200 pixels. The corresponding alpha channel shows the selected area in the center, gradually fading to black, and the bottom right image shows the actual selected pixels.

a circular feathered selection, there would be a white hole in the middle with a soft edge gradually fading to black. Any editing applied to image pixels selected using an alpha channel with gray pixels will have a partial effect, which is extremely useful for subtle image editing without "hard" edges. It means you can apply filters and other effects with a gradually tapering effect.

At their simplest, alpha channels are a useful method for permanently storing selections. To do this, all you have to do is click Selections > Load/Save Selection > Save Selection to Alpha Channel. Usually, you'll want to save a selection to the image you created it from, but you can also save and load selections into other documents.

Masks

Masks are a little like alpha channels in that they use a grayscale image to determine what happens to corresponding image pixels. Masks are, in fact, a special kind of layer. Grayscale mask pixels determine the opacity of image pixels in underlying layers. Masks provide a useful means of hiding image pixels without actually deleting them. By directly editing masks (and, for that matter, alpha channels), you can perform sophisticated image-editing techniques in a nondestructive way, without altering the pixel values in the affected layer.

To create a mask, first make a selection, then choose Layers > New Mask Layer > Show Selection to show the selected parts of an image layer and hide the rest. To mask (hide) the contents of the selection and show the unselected bits, choose Layers > New Mask Layer > Hide Selection.

Selections, alpha channels, and masks are interchangeable. You can turn a selection into an alpha channel or a mask, create an alpha channel from a mask, load a mask from an alpha channel, and, of course, load selections from masks and alpha channels. You can discover more about masks in the following chapter.

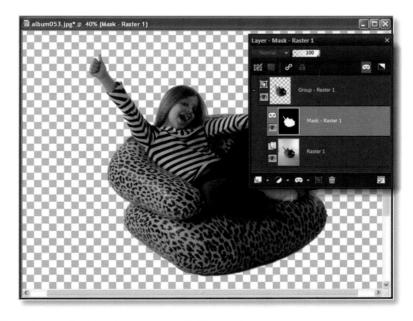

FIG 5.8 A mask layer hides parts of underlying layers without actually deleting pixels.

Step-by-Step Projects

Creating an Artificial Point of Focus

Because life is never straightforward, PaintShop Pro has a Freehand selection tool. This is used to manually draw around an object for the purpose of isolating it from the rest of the picture. Although this can be the most accurate of all the selection tools, it can also be the most tricky because you have to rely on the accuracy of the mouse, which is a bit like drawing with a bar of soap at the best of times.

This project shows you how to achieve an artificial narrow depth of field effect using freehand selections and the Gaussian Blur filter. PaintShop Pro X4 has a Depth of Field effect, which can achieve something similar quickly and with much less effort (see page 24). Doing it this way takes longer and is trickier, but the accurate selections you make will produce a more realistic effect—one that looks like it was produced in the camera rather than with software.

As with all tools, the Freehand selection tool comes with a wide range of control options available through its Tool Options palette.

You can blur distracting background detail in a photo by shooting with a wide aperture. You can achieve a similar effect after the event by using carefully made selections and the Gaussian Blur filter.

STEP 1 Open the photo and copy (duplicate) the background layer by right-clicking it in the Layers palette and selecting Duplicate. Rename the new layer "Focus."

STEP 2 Choose the Freehand selection tool and determine its selection parameters. The Freehand tool works simply by dragging the mouse over the canvas. Its Edge Seeker option works as if it has slightly magnetic properties. Use the Smoothing option to make the selection line, well, smoother. "Point to point" draws a straight line from point to point, creating points with each mouse click, and is ideal for selecting regular objects such as products. The Smart Edge mode drops a wide line over the desired edges and locates the contrast or color differences underneath that line. Draw your selection around the object or person in the picture you have opened.

STEP 3 Select the Focus layer in the Layers palette, click the New Mask Layer button on the Layers palette and select Show selection. This creates a mask layer, which covers up the background detail in your Focus layer and allows the background layer to show through.

STEP 4 Press Ctrl + D to select none and click on the background layer in the Layers palette. Choose Blur > Gaussian Blur from the Adjust menu, and set the radius to around 20. Click the Preview on Image box to see the results. Don't overdo it—too much blur will look unnatural.

STEP 5 In the example on the previous page, the background is all the same distance from the camera. Where the background stretches away into the distance, a more natural result can be produced by making several feathered selections radiating out from the subject (three is usually enough) and blurring each one by a progressively greater amount. This simulates objects becoming more out of focus the farther away from the camera they are.

Fixing an Overexposed Sky

All cameras have a habit of making exposure mistakes. Often this produces a picture with a correctly exposed land section and a poorly exposed sky section. This is usually because the sensor in the digital camera cannot cope with the contrast differences between the land and the sky. Even with many film types of camera, a wide contrast range is hard to record accurately.

The problem can be fixed, but it requires a little ingenuity. If you make an overall Levels adjustment to darken the sky, you'll darken the subject as well, so in this project we'll use a mask layer so that the Levels adjustment applies only to the sky and the correctly exposed subject is untouched. The advantage of this approach is that, if the sky is beyond saving with a Levels adjustment, you can simply replace it.

STEP 1 Duplicate the background layer by rightclicking it in the Lavers palette and selecting Duplicate; call the new layer "sky." Select the sky layer and use the Magic Wand to select the sky. You might need to Shift-click the sky several times to grab all the tones. Use Tool Options to vary the Tolerance value to make this more accurate. Consider using the range of Selection Modifiers (Selections > Modify) to make the sky "grab" more accurate. Here I was lucky and managed to get it all in one hit with a Tolerance setting of 20. You can also apply a small feather to this selection to soften the line where the sky and the land join (i.e., set the selection feather to a value of one or two pixels only). Alternatively, try using the Background Eraser brush to cut out the sky (i.e., to make a matte).

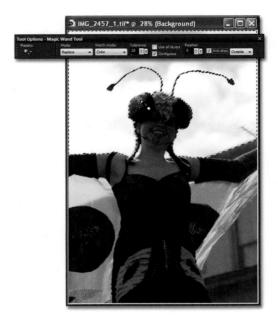

STEP 2 Check the accuracy of the selection up close using Selections > Edit Selection to display the mask (or clicking the Edit Selection button on the Layers Palette). If there are any missing bits, I'd suggest using the Remove Specks and Holes Selection Modifier (Selections > Modify > Remove Specks and Holes) to clean the selection up. (Make sure to turn off Edit Selection first as when the Edit Selection is active (red highlights) the Selection modifiers are disabled). When you're happy with it, select the sky layer, click the New Mask Layer button, and choose Show Selection. This masks everything but the sky on the sky layer. With the mask in place you no longer need the selection, so press Ctrl + D to select none.

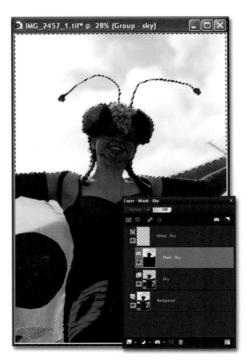

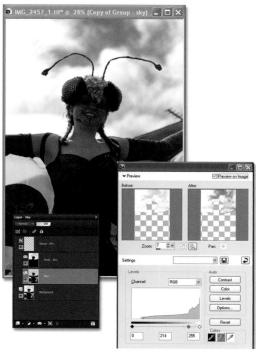

STEP 4 If there's no tone in the original (unlikely, unless the sky is drastically overexposed), you'll have to copy another sky from a different picture. Here's where the advantage of using a mask layer becomes apparent. Just paste the sky detail as a new layer within the mask group.

STEP 3 Select the sky layer and choose Brightness and Contrast > Levels from the Adjust menu. Drag the center diamond under the histogram to the right to darken the sky.

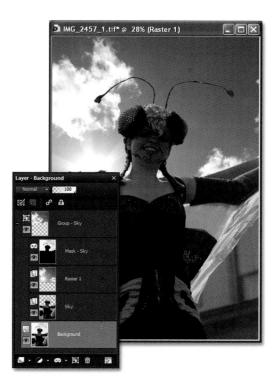

STEP 5 Another advantage of using mask layers to either make tonal adjustments to the sky or paste in a new one is that you can make adjustments to the rest of the image without affecting what you've already fixed. Here a Levels adjustment has been used on the background layer to brighten the subject detail.

HDR Photo Merge

This project has been included here not because it involves making selections but because it uses a feature introduced in Paint Shop Pro Photo X2 and improved in X4 that helps to overcome burned-out skies and similar exposure problems. The previous project showed you one way of solving the problem. HDR (high dynamic range) Photo Merge is a relatively new way to deal with subjects where the range of brightness is too great for your camera to cope with.

To be able to use HDR Photo Merge, you need to take several pictures of a scene, and you also need to be able to manually adjust the exposure controls on your camera. Even compact digital cameras that automatically calculate the exposure for you usually have some form of manual override, and some cameras will automatically take several bracketed exposures for you. Check your camera documentation to see if this is possible. If you know all about your camera's aperture and shutter speed settings, then you're ready to take advantage of a new and exciting development in digital photography.

Throughout this book you'll see references to exposure problems where the range of light in a scene is too great to be adequately recorded by your digital camera's sensor. Either the shadows are dense and filled in or the highlights are "blown"—registering as pure white. HDR Photo Merge allows you to take several different exposures of the same scene and merge them to produce one high-dynamic-range image with much more detail than it's possible to record in a single exposure. In this example we've used three photos; you can use between two and nine, but the best results are achieved with from three to seven exposures.

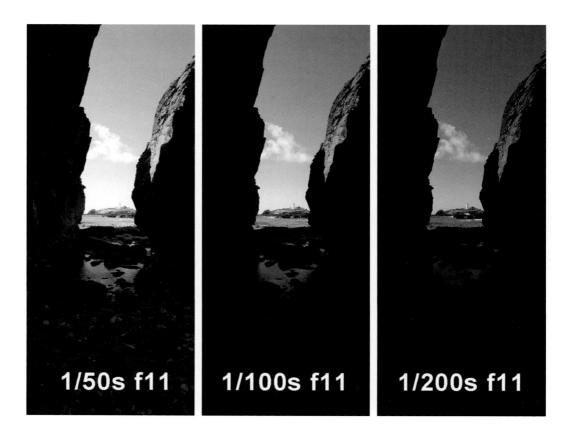

STEP 1 Take at least three shots using different exposure settings. Make the first exposure using the correct setting as determined by your camera's metering system, then take additional shots over- and under-exposing in one-stop increments. Here I've made three exposures, one at the indicated setting of 1/100th of a second at f11, another at 1/50th of a second at f11 (one stop overexposed), and a third at 1/200th of a second at f11 (one stop underexposed). It's better to vary the shutter speed, rather than the aperture, so as to maintain the same depth of field in all three exposures.

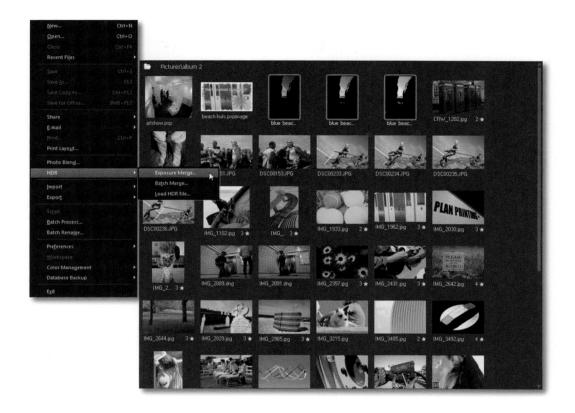

STEP 2 Select your bracketed shots in the Manage workspace and choose HDR > Exposure Merge from the File menu.

Tip

When shooting, use a tripod if you have one, or rest the camera on something—a wall, the car roof, anything that will keep it steady from shot to shot. Try to ensure there is nothing moving in the frame—wait for people, cars, cyclists, or other moving objects to get out of the way.

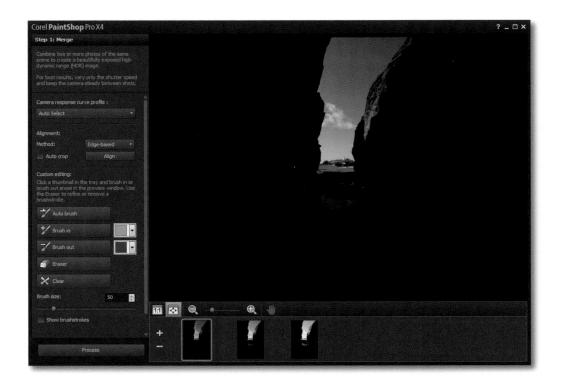

STEP 3 The Exposure Merge window opens with your images arranged in the panel at the bottom below the preview window. There are quite a lot of tools here, but, if you've shot your images using a tripod and there was nothing moving in the shot, you won't actually need most of them. The Camera response curve profile produces perfectly good results when left on automatic, though it might be worth experimenting. The align method allows you to choose between edge and feature-based algorithms to align images, but this will only make a difference if you're using handheld rather than tripod-based shots. The custom editing brushes can be used to paint out areas of an image where a moving subject is causing ghosting in the final result. For example, a car may be present in one frame but not the others, in which case you can paint over it with the Brush out tool.

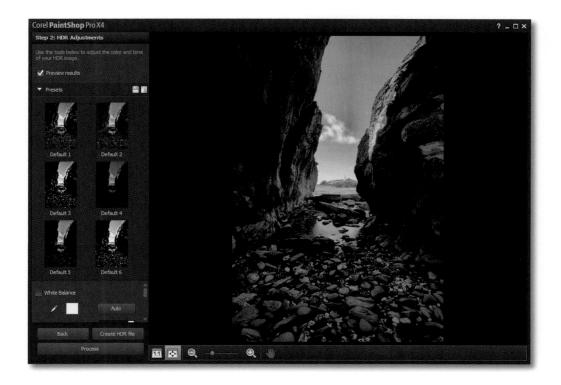

STEP 4 I've touched nothing and just hit the Process button to get this result, which I think is pretty impressive and a big improvement on what I managed to achieve with the previous HDR Photomerge tool in PaintShop Photo Pro X3. So, if you want to experiment with HDR and are using X3, it's well worth upgrading for this feature alone.

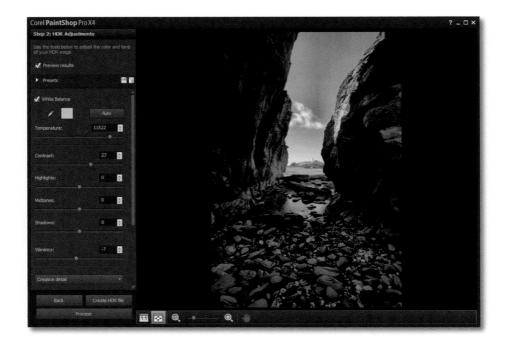

STEP 5 If you're not happy with the initial result, you can hit the Back button and try again with different settings. This should only be necessary if you've got problems with alignment or ghosting from elements that aren't in all of your shots. If the tonal reproduction is the problem, first try one of the six presets (though these tend to produce stylized results) or click the arrow to collapse the presets and tweak the adjustment sliders. I like the blue cast in the shadows areas on this result, but I've ramped up the color temperature slider to add some warmth to the sunlit areas and reduced the vibrancy a tad to give a more natural result.

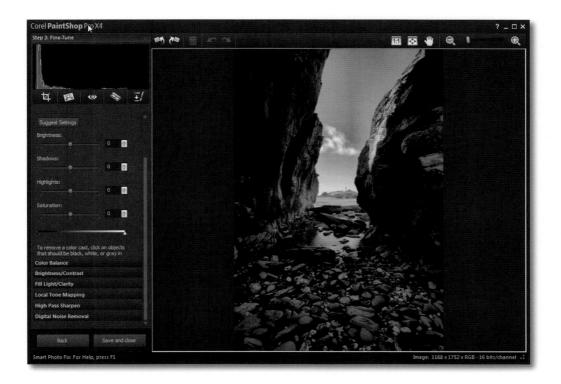

STEP 6 Click the Process button a second time to progress to the Fine Tune screen. Here you can make further tone and color adjustments (you'll recognize some of these from Smart Photo Fix) before saving the image.

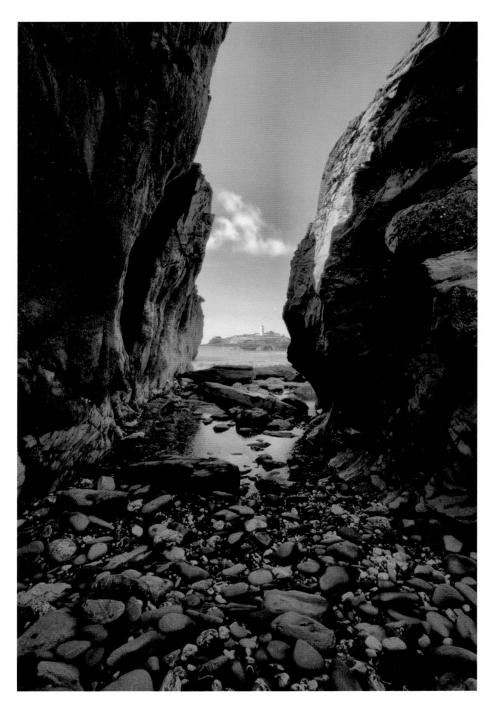

The final result saved as an 8-bit JPEG file.

Object Cutout

Creating a cutout, either to replace the background in a photo or to move an object from one photo into another without its background, requires a high degree of selection accuracy. If your cutout isn't pixel accurate, telltale messy edges will give the game away. But, with a little care and a technique designed to make the work of the selection tools easier, you can achieve seamless cutouts.

STEP 1 Open the image to be cut out and rename the background layer "Original." Duplicate it twice and rename the two new layers "Cutout" and "Selection," so that the layers are ordered, from top to bottom, "Selection," Cutout," and "Original."

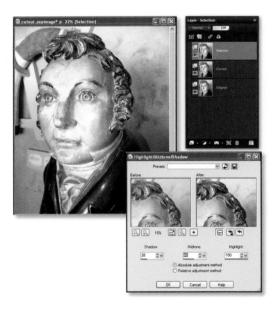

STEP 2 Click the Selection layer in the Layers palette and select Adjust > Brightness and Contrast > Highlight/Midtone/Shadow, and increase the Highlight value to 100. This creates greater edge contrast between the figurehead and the background, making it easier for the selection tools to differentiate between the two.

STEP 3 Make sure the "Use all layers" box in the Tool Options palette is unchecked and use the Magic Wand tool, with a fairly low Tolerance setting, to select portions of the background by Shift-clicking. If you inadvertently select object pixels, press Ctrl + Z and try again, changing the Tolerance or Match mode if it helps. Don't worry if the selection isn't perfect at this stage.

STEP 4 Choose Selection > Modify > Remove Specks and Holes, and save the selection to an alpha channel (Selections > Load/Save Selection > Save Selection to Alpha Channel). In Edit Selection mode (Selections > Edit Selection), paint out any remaining holes in the selection and tidy up the edges using a small soft-edged brush.

STEP 5 Exit Edit Selection mode (Selections > Edit Selection) and resave the selection, overwriting the existing alpha channel. Press Ctrl + Shift + I to invert the selection, then—and this is very important—in the Layers palette click the eye to turn off the Selection layer and click the Cutout layer to make it active.

STEP 6 Press Ctrl + C to copy the selection, and open the image you want to paste it into. Press Ctrl + E to paste the selection and position it. Press Ctrl + Shift + M to hide the selection marquee.

STEP 7 Finally, press Ctrl + Shift + F to defloat the selection and add it to the current layer, or Ctrl + Shift + P to promote it to its own layer; then save the new image.

Combining Images Layers and Masks

What's Covered in this Chapter

- This chapter is all about layers. We've already come across layers in earlier chapters and in some of the step-by-step projects, and we've seen how you can use adjustment layers to make editable changes to image tones and color.
- Layers are extremely useful as they allow you to combine different
 elements—photos, text, and graphics—all in the same document. Layers are
 a little like sheets of tracing paper in a pad—you can see through the
 topmost layers to those below. PaintShop Pro X4's Layers palette allows you
 to organize layers into groups, shuffle them around so that some things
 appear on top of others, change their opacity to make them semitransparent,
 or even change the way that upper layers interact with what lies beneath.
- As well as learning how to use the Layers palette, this chapter shows you
 how to combine several photos into one image using layers; how to use
 PaintShop Pro X4's rulers, grids, and guides to position and align layers;
 what you can do with adjustment layers; and how to combine layers.
- We'll also take a detailed look at Mask layers, briefly introduced in the last chapter. In the step-by-step projects section at the end of the chapter, I'll show you how to use layer deformations to create realistic shadows, and how to mask an adjustment layer to produce a graduated color effect.

Layers allow you to combine several images—each stacked one above the
other—in a single document. The biggest advantage of layers is that they
allow you to put elements on top of one another without destroying what's
underneath. But, as we shall see, the advantages of using layers go far
beyond that.

Understanding Layers

What is a layer? A layer is simply one picture sitting directly on top of another. Layers can contain whole photos, text, vector drawings, scanned art, or anything else that can be digitized. You can add as many layers as you want in one document, depending on your requirements. The reason for building up these layers is to maintain the pictures' editability. While a picture retains its layers, it can always be edited. Flatten (or squash) those layers, so that the picture can be emailed, for example, and you lose the power to edit it.

PaintShop Pro has sophisticated layering capabilities. Not only does it allow you to create montages from multilayered documents, but it also has a range of features such as adjustment layers that open up even more editing possibilities—so much so that every stage in the image-building process can be deconstructed, changed, altered, improved, and returned to its place, over and over again, with incredible accuracy and remarkable ease.

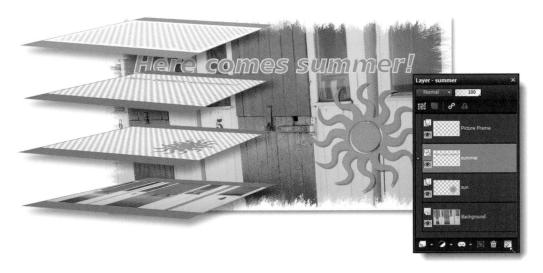

FIG 6.1 The illustration here shows how a layered image works. Viewed from above (i.e., in the work area, the picture looks perfectly normal, but exploring the Layers palette shows that it is in fact composed of four separate layers—all of which can be moved or can have their color/tones changed independently. Layers files must be saved as either ".pspimage" files or, in the ".psd" (Adobe Photoshop) file format. Using either of these file formats preserves the layer integrity.

Who Uses Layers?

Layers are used by anyone who adds text to a document, whether a single character or a page of copy for a brochure. Layers are used to make multi-image montages where several pictures blend seamlessly into one. Layers are used extensively by designers, illustrators, and web designers—anyone, in fact, who uses images that have more than one picture element in them.

What Can You Do with Layers?

A layer is like a clear sheet of acetate. Layers can be opaque or transparent, and they can contain pixels (bitmap) or vector data (text and shapes).

You can cut, copy, and paste layers from one document to another. Layers can be flipped, rotated, resized, distorted, rearranged, or grouped in any number of combinations. You can apply color and tonal adjustments to single layers—and you can add a full range of filter effects, as if one layer were a single picture. Only while the layered document retains its original layers does it remain editable. For seasoned image makers, this layer editability remains a powerful attraction. How many times have you finished working only to spot something you missed but now can't change? If you use layers, and have saved the layered version of the image (as mentioned previously), you can make that change!

Before you get too excited, layers have some disadvantages. Multiple layers create a spaghetti-like complexity that can be hard to keep track of. And, the more layers you add to a document, the larger the file becomes, occupying more space on your hard disk and taking longer to process every time you make a change in PaintShop Pro. If the number of layers in your document starts to get unwieldy, you can merge selected layers into each other. You'd do this to layers, or groups of layers, that are similar or are finished with (i.e., you are sure that they'll never need changing).

Layers offer tremendous potential for the creative image maker. Simply adjusting the opacity of an individual layer allows you to see everything on the layer beneath. Each layer also has a range of blend modes. These can be adjusted in order to radically change the way the pixels in the layer react with the pixels in the layer directly below.

We already know that PaintShop Pro has an almost limitless Undo feature (Ctrl + Z). This means that you can reverse the picture-building process by up to 1000 steps; however, in accepting an Undo command and then saving, those steps are lost forever. If you are working with layers, you can apply major editing stages to different layers and retain everything in the one document, regardless of whether you are using it or not. Each layer has a small eye icon called the "Visibility toggle." Click the Visibility toggle to switch the layer off, click again to switch it back on.

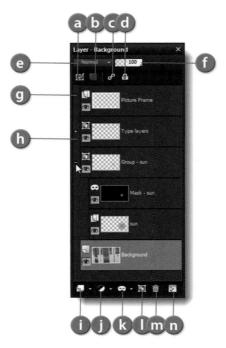

FIG 6.2 The Layers palette is the control center for layers and the things on them. It helps you organize and keep track of all the layers within an image. There are five layer types—Raster, Vector, Art Media, Adjustment, and Mask. Layers are arranged in order in the Layers palette. The topmost layer in the image appears at the top of the palette; you can rearrange the layers by dragging and dropping. The Layers palette here shows the individual layers and thumbnail images of the content on each one. There are several layers, some of which are organized into groups (you can expand and collapse groups by cicking the little + or - sign alongside). (a) Edit Selection, (b) Show/hide layer effects, (c) Link/unlink, (d) Lock/unlock, (e) Layer blend mode, (f) Layer opacity, (g) Layer type, (h) Visibility toggle, (i) New layer, (j) New Adjustment layer, (k) New Mask layer, (l) New layer group, (m) Delete layer, (n) General preferences.

You might also do this to layers that, once merged, can be separated again if necessary using a selection. Though merging or flattening layers frees valuable computer resources, RAM (random access memory) is cheap enough, so I'd suggest buying more and keeping the layers for editing because you never know.

What can be done with layers?

- · Move the picture elements on layers in any direction.
- · Change the tone, color, contrast, and alignment of any layer.
- · Mix vector and bitmap layers in one document.
- · Create new, blank vector, and bitmap layers at the press of a button.
- · Collect selected layers into layer groups.
- · Copy single layers, or groups of layers, into the same or a new document.
- · Convert selections into layers.

- · Paste layers and selections from other documents into a new document.
- · Reorder layers by dragging them up or down in the Layers palette.
- Switch layers on and off by clicking the Visibility toggle (the eye icon) in the Layers palette.
- · Paste the contents of the clipboard into a new layer.
- Duplicate a layer using the Duplicate command (Layers > Duplicate).
- Use the Edit Selection button in the Layers palette to edit a selection (Selection Edit mode).

Combining Pictures

PaintShop Pro allows you to create and save every stage of the image-building process as a separate layer. These layers can be switched on or off according to their application. You can also store masks and selections as separate channels in layered documents. These too can be switched on and off. In PaintShop Pro, any document that has layers, masks, or selections has to be saved in the native PaintShop Pro file format, with a ".pspimage" file ending.

Although the .pspimage format retains layers, it is for use only in PaintShop Pro; you cannot use .pspimage files on the web or in a Word document, for example. The file has to be converted first or copied to a more suitable file type, such as JPEG or TIFF. First you must flatten the file by selecting Layers >

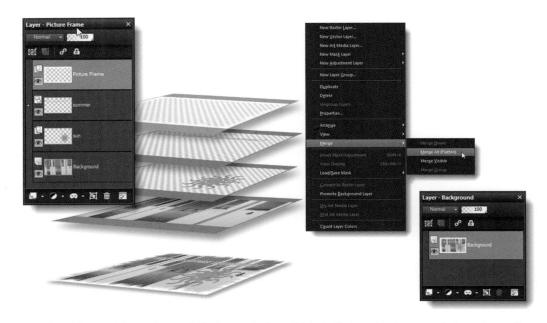

FIG 6.3 A layered (pspimage) document is more editable than any other format. This is why it's also too large for many applications, such as emailing or storage on a limited-size disk. For this reason it is important to make a copy and to flatten or merge those layers so that the resulting single-layered document can be resaved in a smaller file format, like JPEG or TIFF.

Merge > Merge All (Flatten). Doing this turns it into a single-layered document. This loses most of its editability, which is why you should only do this to a copy of the original .pspimage file. Save your layered documents as master files, and then make copies from that master for use in other, non-layered file applications.

The simplest way to combine two pictures into one document is to copy one and paste it as a new layer into the other. While these multiple layers are totally separate to each other, it's important to note that they can be edited at any time as if they were two totally different picture elements. However, because they are in the same document, you also have to contend with their relationship. While copying and pasting one picture into another is by far the easiest way to add another picture to a document, there are a few points to consider first.

The resolution of the pasted image, measured in pixel dimensions or dots per inch, is relevant (see Chapter 9 if you want to know more about resolution). For example, if this is larger than the receiving image, it will overspill (bleed off the edges) once pasted. However, even though it locks as if the edges of the pasted image have disappeared, the program does not discard them; they are still there but only become visible if dragged into view using the Move tool ("M").

Another factor to watch out for when combining pictures is their respective color spaces. Providing that the color space of the master document is either 24-bit or grayscale, it will prevail over what is being pasted into it. So, if you copy an 8-bit picture into a 24-bit color picture, the color space of the pasted picture will increase to match that of the host document. On the other scale, if you try to paste a color picture into a black-and-white image, it will be converted into the mono layer.

PaintShop Pro offers a number of ways to paste copied images into another document: via the Edit menu, by right-clicking in the new document, or using keyboard shortcuts (see Appendix 2). These options are as follows:

- Paste as New Image. This creates a new picture on its own background.
- Paste as New Layer. This adds the contents of the clipboard to the selected document background. PaintShop Pro automatically creates a new layer for the pasted image. If the pasted image matches the physical dimensions of the target image, it will obscure the lower layer or background picture.
- Paste as New Selection. This pastes the newly selected picture into the target document, but it remains attached to the cursor so that it can be positioned somewhere other than directly on top of the background. Left-click to offload the layer and view the selection marquee. The pasted layer then becomes a floating selection until it is deselected. You can save this selection as an alpha channel (in case it is needed again: Selections > Save to Alpha Channel). If you already have a floating selection, it will be defloated and deselected before another picture can be pasted into the document (i.e., you can't have two floating selections in one document).

Tip

The base layer is called the "Background" and is, in fact, not a layer at all. However, it can be "promoted" (converted) into a layer if needed (right-click on the background layer in the Layer palette and choose Promote Background Layer from the contextual menu). If you don't want to promote the background, you can simply duplicate it.

Tip

To maintain the aspect ratio of a layer while resizing it (in other words, to avoid stretching or squeezing it), use the right mouse button to drag a corner handle.

Paste as Transparent Selection. This command does the same as the Paste
as New Selection command, but it enables you to import transparency
from another image. Because of this transparency, the pasted layer is
attached to the Move tool for easy repositioning. Click in the image to free
it once it is in the right position.

What can you do with layers?

- 1. Change the individual tonal appearance of each layer.
- 2. Make and edit selections on individual layers.
- 3. Add blend modes to individual layers for special effects.
- 4. Save layer selection and mask information to an alpha channel and to disk.
- 5. Add adjustment layers.
- 6. Apply any of PaintShop Pro's filter effects to a layer.
- 7. Bend and transform the shape of any object on a layer.
- 8. Convert vector layers to bitmap layers.

Advanced Layout Tools

As we have seen, there are many ways to use PaintShop Pro for combining multiple layers into a single document. In the following section we'll take a look at some of the features designed to make it easier to lay out and arrange multiple picture documents. You'll find these tools useful for positioning and aligning multiple photos as well as for adding annotations labels.

FIG 6.4 PaintShop Pro's rulers, guides, and grid enable you to accurately position and align elements. The Snap to Grid and Snap to Guides options make the grid and guides behave as though magnetized—they attract and hold dragged objects that are in close proximity. Double-click the rulers (or select View > Change Grid, Guide & Snap Properties to change grid spacing and other grid and guide properties.

Tip

To remove all of the guides on a photo, select Change Grid, Guide and Snap Properties from the view menu (or double-click one of the rulers), click the Guides tab if it isn't already displayed, and check the Delete guides box. You can delete guides from the current image or from all open images.

Under PaintShop Pro's View menu there are a number of highly useful productivity-enhancing features designed to make aligning and arranging multilayer images faster and easier. These are as follows:

- Rulers. Keyboard shortcut Ctrl + Alt + R adds rulers along the x- and y-axes of the picture window. You can change the units of measurement (pixels/inches/centimeters) through the program's General Preferences (File > Preferences > General Program Preferences, then click on Units in the Preference Column on the left). Place the cursor anywhere in the image and you can read the exact location in the corresponding margin. It's a handy tool, especially if you are working with extremely small picture elements on multiple layers.
- View Grid. If you find the grid too heavy, double-click on the rulers in the margin and you'll see the Grid, Guide & Snap Properties dialog. Change the units used and the color to make it appear friendlier. You'll need to make adjustments every now and then for different-sized pictures. This is a useful feature for precise layer or picture element alignment.
- View Guides. This is one of the neatest design assistants in PaintShop Pro. It works only if the Rulers feature is switched on. Guides are colored lines that can be pulled out of the margins (using the cursor regardless of the tool currently selected) and dragged over the picture to form, well, design or layout guides. There are no limits to the number of guides that can be used in one document. Guides can be repositioned by grabbing the guide handle (that's the thicker bit of guideline that appears inside the ruler margin as you move the cursor over it). If you want to change the guide properties, double-click the ruler to open its window or just click the guide handle in the margin to open the Grid, Guide & Snap Properties dialog. This allows you to change its color, position, or existence!
- Snap to Guides. This function adds tremendous power to the task of aligning multiple layers along a common axis—by selecting this option and making sure that, in the Grid, Guide & Snap Properties dialog, the Snap Influence setting is set to more than 1. Now, if you grab an image layer using the Move tool and drag it toward the guide, it will appear to be magnetically attracted to the line. In fact, it "snaps" to the line. Increase this value to increase the magnetic power.

You can change any of these settings for the opened document only, or for the default settings. This feature is a real production enhancer. Under the Layers palette:

Layer Opacity. All layers have an opacity scale controlled from the Layers
palette. The default setting is 100%. Reducing this allows you to see
through the layer to whatever lies beneath. Do this to help align specific
pictures or graphic elements with stuff that lies beneath.

Under the Layer menu:

- Arrange. This feature allows you to swap the layer order, although you can
 also do this by using the cursor to grab a layer in the palette and dragging
 it to another position in the stack.
- View. This feature controls which layers are visible and which are not. You
 may also switch a layer on and off by clicking on the eye icon in the palette
 itself.
- Merge. The Merge feature allows you to do just that: merge or blend selected layers. Merge Visible flattens only the layers with the eye icon switched on (i.e., those that are visible on the desktop).

Using Adjustment Layers

Making tonal adjustments to a digital photo—for example, brightening the midtones and shadows with a Levels adjustment, changing the color balance, or using the Fill Flash filter—changes the value of pixels within the image. Other than by pressing Ctrl + Z to undo, these changes are irreversible. Opening, say, the Levels dialog box and making an adjustment in the opposite direction will not get you back to where you started.

But what if you could apply such changes and, if you later changed your mind, remove them, as if they'd never been applied in the first place? Adjustment layers allow you to do exactly that. Adjustment layers are a safer, more versatile way of applying image adjustments because, as well as being able to turn them on and off just like other layers, you can apply adjustment layers to one or several layers within the image.

You can also go back to adjustment layers and edit the settings at any time without causing any degradation in image quality. With adjustment layers, doing the opposite to a previous adjustment does get you back exactly where you started.

Earlier we spoke of layers as being like acetate sheets stacked on top of the background image. Think of adjustment layers in the same way—as clear sheets to which you can apply adjustments and through which you view the layers below. The appearance of the pixels in the underlying layers is affected by the adjustment layer, but the pixels themselves are not altered.

Whereas an adjustment affects only the active layer, an adjustment layer acts on all the layers beneath it, or all the layers within a layer group. By careful positioning of adjustment layers, you can change only one part of an image. Adjustment layers are frequently used when combining images to make the new image elements match in terms of color and lighting.

Tip

To change the ruler units, choose File > Preferences > General Program Preferences and select Units from the list in the Preferences dialog box. You can choose between pixels, inches, and centimeters.

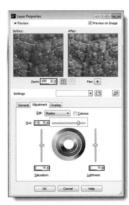

FIG 6.5 (top) Here I've made a rectangular selection on the right of the image and added a Hue/Saturation/Lightness adjustment layer. The new Layers palette displays a thumbnail of the mask. (middle) Filling an adjustment layer with a linear gradient applies more correction at the top, which gradually reduces toward the bottom. (bottom) An adjustment layer is infinitely editable with no loss of image quality; to alter the color, just double-click the adjustment layer in the Layers palette.

Another way of limiting adjustment layers is by editing them in the same way as mask layers. You'll remember from the previous chapter that mask layers are grayscale, and pixel values in the mask layer affect the opacity of corresponding pixels in underlying layers. Adjustment layers are also grayscale, and their effect on underlying layers is likewise dependent on the pixels within the mask. Black pixels apply no correction, white pixels apply the full amount of correction, and gray pixels apply varying amounts of correction in between.

You can vary the overall effect of an adjustment layer using its Opacity slider in the Layers palette. Alternatively, you can apply the adjustment layer to a selection or paint directly onto it to isolate the parts of the layer you want the adjustment to affect.

Adjustment Layer Types

You can add the following types of adjustment layer:

- · Brightness/Contrast
- · Channel Mixer
- · Color Balance
- Curves
- · Fill Light/Clarity
- · Hue/Saturation/Lightness
- Histogram
- Invert
- · Levels
- · Local Tone Mapping
- Posterize
- Threshold
- Vibrancy

Advantages of Adjustment Layers

- Can be used to add a range of tone and effects changes to a layer or layers without actually changing the original layer.
- Useful for applying overall color or tone changes to multiple layers at a time.
- · Can be removed by deleting the adjustment layer or switching it off.
- · Ideal for working with panoramas.

Creating Layer Blend Mode Effects

Blend modes determine how pixels in a layer interact with corresponding pixels in underlying layers. The default blend mode is "Normal"—the pixel in

the top layer is superimposed on (and therefore hides) the pixel in the underlying layers (subject to transparency settings).

There are 20 other blend modes in addition to "Normal," and each provides a slightly different result. "Darken," for example, displays only pixels in the selected layer that are darker than corresponding pixels in underlying layers; lighter pixels in the selected layer disappear. The "Lighten" blend mode does the opposite. "Color" applies the hue and saturation of pixels in the selected layer to underlying layers without affecting lightness, and "Difference" subtracts the selected layer's color from the color of underlying layers.

Some blend modes have practical applications. "Darken" and "Lighten" are useful for retouching and cloning. You can also use "Darken" to get rid of a white background on a logo or other artwork. "Multiply," which combines the colors in the selected layer with underlying layers to produce a darker color, is useful for procucing realistic drop shadows.

Because the outcome depends on initial pixel values in the selected and underlying layers, the results of some blend modes can be hard to predict. If you are working with two layers, simply swapping the layer order can produce very different results. This makes the blend modes function an excellent tool for creating special effects with multiple images; it works especially well with text, but a certain amount of experimentation is often required to get a good result.

Blend modes can be selected for most of PaintShop Pro's Brush tools as well as layers—the Blend mode pull-down menu in the Tool Options palette provides exactly the same options as are available in the Layers palette.

Using Mask Layers

A mask layer works a bit like a stencil—holding back some parts of the image and revealing others. We briefly looked at mask layers in the previous chapter, on using selections. Mask layers, alpha channels, and selections are a bit difficult to pin down in terms of definitions because they all do pretty much the same thing—control which parts of the image are displayed or affected by an adjustment—in slightly different ways.

Earlier, we saw how adjustment layers can be used as mask layers to confine their corrections to one part of the image, but a mask layer is more often used to hide parts of the image without actually deleting them. The advantage of this capability should be fairly obvious; you can subsequently edit the mask to reveal hidden parts of the underlying layers or, conversely, to hide more.

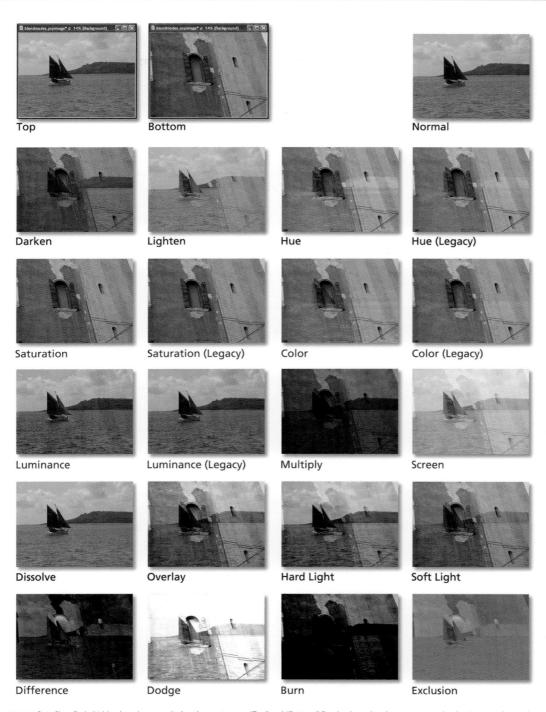

FIG 6.6 PaintShop Pro's 21 blend modes as applied to the two images "Top" and "Bottom." Results depend on layer content and order. Layer modes can be particularly effective when used with text layers. Legacy modes maintain compatibility with earlier versions, so, if you want to replicate an effect you created in PaintShop Pro 9, you shouldn't have any difficulty. Generally, though, the newer versions produce better results.

Usually, the best starting point for creating a mask is a selection. Make a selection using one or a combination of the selection tools and modifiers and from the Layers menu choose New Mask Layer > Show Selection to create a mask that shows the selected parts of the layer and hides everything else. To create a mask that hides the selected area, choose Layers > New Mask Layer > Hide Selection. If you are masking a background layer, Paint-Shop Pro will display an alert box notifying you that "the target must be promoted to a full layer"; click OK.

PaintShop Pro automatically creates a new layer group containing the selected layer and the new mask. This is so that the mask doesn't affect other layers in your image. If you want the mask to apply to all the layers beneath it, drag it in the Layers palette from the layer group to the top of the layer stack. With the mask in place, you can press $\mathsf{Ctrl} + \mathsf{D}$ or $\mathsf{Selections} > \mathsf{Select}$ None. If you need it, you can recover the selection at any time with $\mathsf{Ctrl} + \mathsf{Shift} + \mathsf{S}$ or $\mathsf{Selections} > \mathsf{From}$ Mask.

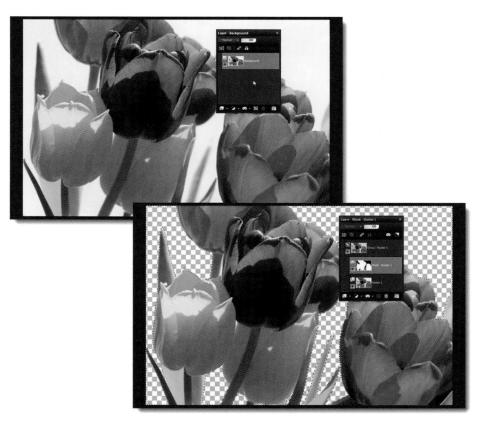

FIG 6.7 A selection is often the best starting point for a mask. The existence of two options—Show Selection and Hide Selection—negates the need to invert the selection if you want to hide the selected area, as here.

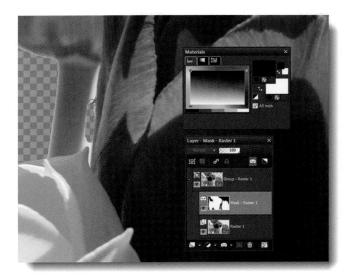

FIG 6.8 Painting on a mask layer provides a simple, yet effective, method of cleaning up selections. Click the Highlight mask area button to display the mask as a red tint on the underlying layer; turning the mask layer off allows you to view both masked and unmasked detail.

Modifying Masks

One of the best things about masks is that you can use PaintShop Pro's Brush tools to edit them. Painting masks is often an easier and more accurate way to clean up selections than using the selection modifiers. You can, for example, use a soft-edged brush to clean up the edge detail of difficult subjects like fur, hair, or indeed anything that doesn't have a clearly defined edge.

To use the Brush tools to directly edit a mask layer, select the mask layer in the Layers palette and choose the Paint Brush tool. You may have noticed that the foreground and background swatches in the Materials palette change to grayscale when a mask layer is selected; remember, mask layers are grayscale, so you can only paint on them using black, white, or one of 254 levels of gray. Painting on the mask with black will add to the mask and remove detail from the underlying layer. Painting with white will remove the mask and reveal detail on the underlying layer. If you paint with gray, you'll make parts of the underlying layer semitransparent. It's usually easiest to use just black and white and change the brush settings in the Tool Options palette to achieve the required effect. As I've said before, this kind of editing is made much easier using a tablet and stylus.

Adding to the mask—painting out detail on the underlying layer—is straightforward because you can see what you are doing. Painting detail back in by removing black areas from the mask is trickier because you can see neither the mask nor the detail. To display the mask, click the Mask Overlay button on the Layers palette. This overlays the mask layer with black areas displayed as a 50% red tint over the target layer(s).

Combining Layers

Some digital image makers work with multiple images and image masks. In this situation it is vital to remember exactly what you are doing and what the final planned result should look like. To this end, use sketches to keep your mind clear about where each image is to be placed in the frame, and try to label all the layers, layer groups, and masks. Doing this (by double-clicking each layer and entering the details in the dialog) will make the masking and blending process somewhat clearer, especially when there are 20 or more layers to contend with.

As we've seen, images with lots of layers create large file sizes and it's often difficult to discover which bits of the image are on what layer. You can simplify PaintShop Pro images and drastically reduce the file size by flattening them, or merging layers together. There are four merge options on the Layers > Merge menu—Merge Down, Merge All (Flatten), Merge Visible, and Merge Group. Masks that are associated with underlying layers as part of a layer group can easily be merged using Layers > Merge > Merge Group.

When you do this, the mask is applied to the image and masked areas are deleted. Simply deleting the mask has the same effect.

Merging layers means you no longer have the editing flexibility that they provided, so, if you're likely to want to carry out further changes later, make a backup copy with all the layers intact using File > Save Copy As before you start merging.

Tip

Displaying the mask overlay, but turning off the mask layer itself, shows the mask on top of the unmasked layer below, making it much easier to see what you're doing when painting onto the mask.

Saving Masks

To save an image with masks, use the .pspimage format. You can save a mask layer to its own file on disk—choose Layers > Load/Save Mask > Save Mask to Disk. The default location for saved masks is in the Masks folder in the My PSP Files folder, which is installed to your My Documents folder by default. This folder is where all your custom content (tubes, masks, selections, etc.) is saved. You will also find a selection of ready-made masks in the Masks folder in the PaintShop Pro program folder. These can be used for framing and other effects.

Only two formats support images with masks and other layer types: they are the .pspimage and .psd (Photoshop) formats. If you want to save your image with all layers intact, use one of these two file formats. If you attempt to save your image in a file format that doesn't support layers, PaintShop Pro warns you before flattening the image and saving it.

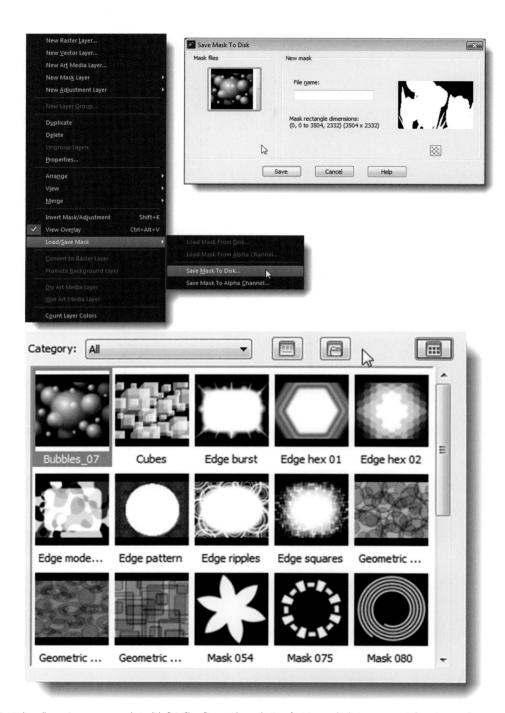

FIG 6.9 As well as saving your own masks to disk, PaintShop Pro provides a selection of existing masks that you can use to frame layers and create special effects.

Step-by-Step Projects

Creating the Perfect Shadow

PaintShop Pro's Drop Shadow layer style and filter are great for adding drop shadows to two-dimensional objects like photos and text, but, if you want to add a realistic drop shadow to a three-dimensional object, you need to create additional layers and use the deformation tools to produce a realistic shadow shape. It's not a difficult technique, and once you've mastered it you'll be able to add realistic shadows to all manner of things from signposts, cars, and coffee cups to people, even painters and decorators.

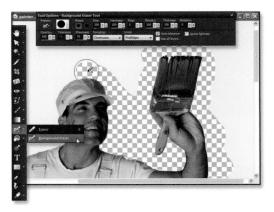

STEP 1 Right-click the background layer in the Layers palette and select Promote Background Layer. Unless you're lucky, the object you want to create a shadow for won't be on a transparent background, so you'll have to cut it out. If it's on a complicated background, you can use the object cutout technique demonstrated on page 160. This one has a white background that the Background Eraser tool makes light work of. While you're using the Background Eraser, hold down the space bar to temporarily access the Pan tool and move around the image.

STEP 2 When all of the background is removed, duplicate the layer by right-clicking it and selecting "Duplicate" from the context menu. Rename the duplicated layer by clicking its name in the Layers palette (or by right-clicking the layer and selecting "Rename") and overwriting it. Call it "shadow." The Layers palette should now look like this.

STEP 3 Open the Brightness and Contrast dialog box (Adjust > Brightness and Contrast > Brightness/
Contrast) and drag the Brightness slider all the way to the left until the Brightness field reads -255. You'll see the preview thumbnail turn black and the image window will mirror this change if you check the Preview on Image check box. Click OK to apply the adjustment.

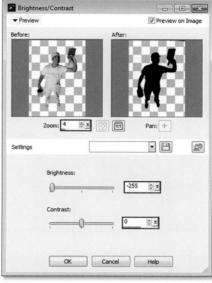

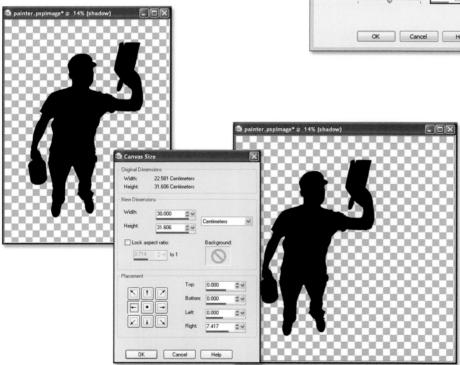

STEP 4 You may need to add more canvas to fit the shadow in. Select Image > Canvas Size and increase the width and height as necessary. To add canvas on the right, click the top left placement button, select Centimeters from the pull-down menu, and add around 4 cm to the existing width value (e.g., if the original width is 16.5 cm, make it 20.5 cm). If you add too much canvas, either press Ctrl + Z to undo and try again or remove the excess using the Crop tool.

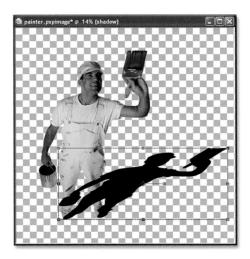

STEP 5 Select the Pick tool and click on the shadow object. Hold down the Shift key and drag the middle handle on the top edge sideways to the right to skew it. Let go, then drag the handle (this time without holding down Shift) downward to shorten it. Make further skew and shortening adjustments until the shadow shape fits with the kind of lighting setup you are trying to create. The higher the light, the shorter the shadow will be, and the further to the right, the more skew you will need.

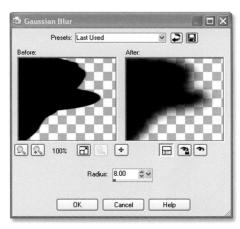

STEP 6 It's beginning to look more like a shadow, but we're not there yet. Select Adjust > Blur > Gaussian Blur and enter a value in the Radius field of around 8, just enough to soften the edges. Click the "Preview on image" button to preview the effect in the image window. Pixel value settings like Radius are dependent on the size of the image, so, if you're working on a smaller photo for the web, a lower Radius value of 2 or 3 would be enough.

STEP 7 The problem with adding computer-generated effects to photos is that they lack texture, and everything in a photo, even shadows, has texture. Use the Add Noise filter (Adjust > Add/Remove Noise > Add Noise) to put some texture into the shadow. Check the Gaussian button and Monochrome box and use a noise setting of around 15%. Click OK to apply the noise.

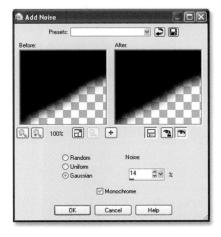

STEP 8 Shadows generally appear behind rather than in front of objects, so drag the shadow layer to the bottom in the Layers palette. You could also rename the other layer "painter" or something else appropriate to your subject. Naming your layers can help you keep track of things. It's not so important when there are only one or two layers, but in more complex images with multiple layers and mask layers it helps to keep things organized.

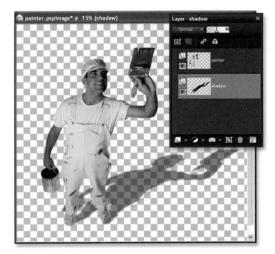

STEP 9 Shadows are rarely solid black. Reduce the shadow layer opacity by dragging the Opacity slider in the Layers palette to around 50%.

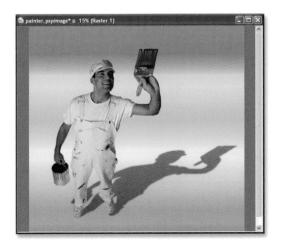

STEP 10 Add a background layer. Select Layer > New Raster Layer and click OK to accept the default settings. Drag the layer to the bottom of the Layers palette, then use the Materials palette to select and apply a solid color, gradient, or pattern to the new layer.

You can, of course, place your transparent object and shadow on any background, including other pictures. Here the painter has been superimposed on the rock image from Chapter 7. His shadow has been deformed, like the type, to follow the contours of the rock face using the displacement map technique described on pages 234 to 238. The paint on the brush and in the tin has been changed from blue to red using the Hue Map.

Creating Graduated Effects with Masks

As we've seen in this chapter, you can use masks to selectively apply adjustments, effects, filters, and other changes that are usually global to specific parts of an image. We've seen how you can make a selection, save it as a mask, and then paint on the mask to restrict or spread the scope of changes at will.

All of this takes time and a little skill. In this project I'll show you how you can apply effects selectively using masks produced with a gradient fill. This is simple and takes only a few seconds, but the results can look stunning. You

can use these masks with adjustment layers, special effects filters, or any other process you've applied to an image, so the possible applications are limited only by your imagination.

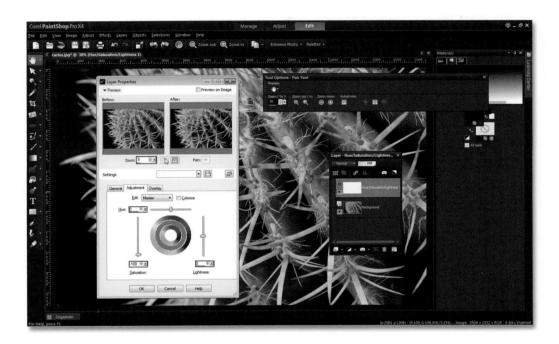

STEP 1 Open the photo you want to work on in the Edit workspace. From the Layers menu, click the New Adjustment Layer button and select Hue/Saturation/Lightness from the Adjustment Layer menu. Drag the Saturation slider (the one on the left of the dialog box) down as far as it will go, to -100, then click OK.

STEP 2 The image is now desaturated—but the color is still there in the background layer. Take a look at the Layers palette and you can see the untouched background layer with the layer thumbnail showing the full-color photo. Above it is the Hue/Saturation/Lightness adjustment layer. Its thumbnail shows the layer mask; in this case it's completely white, indicating that the adjustment layer is working on the entire image area.

Tip
Click the Mask Overlay
toggle button in the
Layers palette to overlay
and edit the adjustment
layer mask on the image.

STEP 3 Now, to choose a gradient that we'll apply to mask the Hue/Saturation/Lightness adjustment layer, click the Color button in the materials palette and select the Gradient fly-out, then click the Foreground and Stroke properties swatch to open the Material Properties dialog box. Choose from one of the available gradients—this one is called Gray Accent; click the Sunburst Style button to make the gradient radiate out from the center to the edges, then click OK. When used as a mask, the black areas will hide the adjustment layer and the white areas will show it, so there will be color in the center and the image will fade to black and white toward the edges. For color at the edges fading to black and white in the middle, click the Invert button.

STEP 4 Select the Flood Fill tool from the Tools toolbox, make sure the Hue/Saturation/Lightness adjustment layer is still selected in the Layers palette, and click anywhere on the photo to apply the gradient. First, the color will reappear in the center of the photo as the gradient fill is applied to the adjustment layer's mask. Second, take another look at the Hue/Saturation/Lightness adjustment layer thumbnail in the Layers palette and you'll notice that it now shows the gradient fill that you just applied. Everywhere that appears black on the adjustment layer thumbnail, the effect of the adjustment layer is masked and the background layer color shows through.

STEP 5 If you're not happy with the way things look, just press the Delete key to remove the fill from the Adjustment Layer mask, or press Ctrl + Z to undo. Then select a different gradient and try again. On the website at www. gopaintshoppro.co.uk you'll find an extended version of this project that shows you how to use a similar technique to mask filter effects.

Here I've deleted the gradient fill used in step 4 and applied a linear white/black/white gradient, which I created by editing one of the gradient presets in the Material Properties dialog box. This is easy to do; just select one of the presets, click the Edit button, and experiment with the color sliders on the gradient ramp. As layer masks are grayscale, it's best to stick with black-to-white gradients, but you can apply the color presets—they're automatically converted to grayscale when applied to a mask.

Text and Shapes Understanding Vector Graphics

What's Covered in this Chapter

- It may seem over the top to devote an entire chapter to text in a book about photography—after all, PaintShop Pro X4 isn't a word processor. But the fact is that there are all sorts of occasions when you need to add words to your pictures. Whether it's producing family calendars and Christmas cards, event posters, or advertising, or just having a laugh with some speech balloons, PaintShop Pro's Text tools will help you get the job done.
- Text works in a fundamentally different way from photos—the shapes are
 described by mathematical formulae rather than being just a bunch of
 pixels. Objects, including text, that are produced like this are called vector
 graphics and this chapter starts out with an explanation of the difference
 between pixel-based things like photos (sometimes called bitmap or raster
 images) and vectors.
- As well as the Text tool, PaintShop Pro has a range of tools for creating geometric and irregular shapes. You'll learn how to use all of these, including the all-powerful Pen tool, which can be used to draw any shape that you can imagine.

- As well as showing you how to create text, this chapter shows you how you
 can manipulate it. You can apply any of the filter effects to text providing
 you first convert it to a raster layer. PaintShop Pro X4's layer effects have no
 such limitations, and you'll find out how to use these to good effect to
 produce striking and impactful typography. Ycu'll also discover how to
 make text follow any path—around a circle, or along a wavy line, for
 example—and how to distort letter shapes to create your own type forms.
- At the end of the chapter, you'll find a step-by-step project that shows you
 how to use text selections to create special type effects.

How Text and Vectors Work

Up to now, nearly everything we've done in PaintShop Pro has involved manipulating pixels. Text and vector objects wo'k in a different way to pixel-based images, and this provides them with some advantages. Whereas a pixel-based bitmap is composed of many individual dots, each described in terms of its red, green, and blue component values, vector objects and text are mathematically defined shapes. The object's properties are defined, and from these the computer constructs them. A circle, for example, might be described in terms of its radius, stroke weight, color, and fill. The user isn't necessarily aware of this and just uses the available Shape tools and the Materials palette to draw the required shape, or the Text tool to enter type.

Vectors have two distinct advantages over bitmaps. Because they need minimal data to describe them, they take up very little memory and disk space. And, because they are generated by the computer, they are resolution independent, which is another way of saying you can make them as big as you like with no loss in quality.

Vectors also have their limitations. They're a good way of producing regular shapes like letterforms, geometric shapes, and even irregular curvy shapes, but they're not great at representing real-world textured, detailed scenes, which is why we need pixels for photographic images. For this reason, vectors tend to be confined to type and two-dimensional illustration with flat color or mathematically predictable gradations.

Adding Basic Text

PaintShop Pro's Text tool is used to add text to any type of document, whether photo, vector illustration, or scan. Choose the Text tool from the Tools toolbar and double-click anywhere in the document. If you're using an earlier version of PaintShop Pro, this will open the Text Entry dialog box. Type what you want in this box, click OK, and watch as the text appears somewhere in the document canvas.

When you click on an image with the Text tool and begin to type, text is added directly in the image workspace (in versions prior to X3, a text box

appears and you type text into it; it's then added in its own layer when you click OK).

The program automatically places the text data onto a vector layer in the Layers palette. It remains in a vector format until you need to apply special effects to it. If this is the case, PaintShop Pro asks you to convert the layer from vector to raster (more on this in the next section).

FIG 7.1 To create text, select the Text tool, click anywhere in the image window, and start typing. Set the type size in either points or pixels and apply other text attributes including alignment, direction, antialiasing, and stroke width, then click the Apply button on the Tool Options palette. Characters within a text block can be individually styled.

You can format text using the Tool Options palette to select the font, size, style, alignment, and other attributes. The text fill and stroke color are determined by the foreground and stroke properties and background and fill properties swatches in the Materials palette. To apply the formatting, click the Apply Changes button (the tick) on the left of the Tool Options palette or click the Cancel button next to it to exit text editing mode without saving your text. You won't be able to switch tools, make any menu selections, or make any other editing changes until you either apply or cancel your text edits.

Once you click the Apply button, the text is added on its own vector layer, but you can click on it with the Text tool and change the formatting at any time.

And, by selecting just a part of the text with the I-beam cursor, you can apply individual formatting to sections of the text.

There are a couple of other formatting controls on the Tool Options palette that are worth a closer look. The Anti-alias menu has three settings—Off, Sharp, and Smooth—that determine the amount of smoothing applied to the edges of characters. When set it to Off, type is not antialiased and you can see the stepped edges that result from the attempt at producing curved edges with square pixels (though text is defined by vectors, it is displayed on screen and when you print using pixels). A smoother look is achieved using semitransparent pixels to fill some of the gaps. As a general rule, antialiased text looks much better so, other than for very small type, you'll usually want to set this to either sharp or smooth.

The next control determines the stroke width of your text and can be used to produce a stoked outline effect if you set different foreground and background colors. For small text it's best to set the stroke width to zero, though you can use a narrow stroke of the same color as the fill to embolden text slightly. The stroke extends in both directions—inward and outward—so you need to take care not to overdo it and distort the shape of the type characters. Used moderately, however, applying a stroke to text is a great way to quickly produce a very classy-looking text effect.

There's one last thing on the Tool Options palette I want to look at before moving on to type effects. The Create As dropdown menu on the Tool Options palette is set by default to Vector. This means that, when you click the Apply button, the text is added as a new vector layer in the Layers palette. There are two other options that you might also want to consider using in some circumstances.

Selection creates a marquee selection from your text, which you can then use to create text filled with images, text cutouts, and other effects. Floating creates the text as a floating selection—it looks the same as your vector text but is added to the image as a floating selection, which you can move and transform. When you defloat raster text (Selections > Defloat or Ctrl + Shift + F), it's merged with the underlying raster layer unless you promote it to a layer with Selections > Promote Selection to Layer, or Ctrl + Shift + P.

Creating text as selections is fine for a quick-and-easy route to text effects, but it's usually better to create the text as a vector layer then make a selection from it. That way you can easily edit the text and reselect without having to start again from scratch. I'll look at the best way to do this a little later in this chapter.

Assuming you've created text as a vector layer, once you click the Apply button the text appears with corner and edge handles and can be moved and transformed in the usual way, by dragging the corner handles to resize, rotate, and skew. Transformed text remains editable at all times—just select the Text tool and click within the type area.

Tip

Use the Presets button on the Tool Options palette to save frequently used combinations of text font, size alignment, and other attributes. You can then apply all the necessary text styling with a single click.

FIG 7.2 Once text has been created as a vector layer, it can be transformed—here sheared and rotated; the text remains editable throughout.

FIG 7.3 Antialiasing is the process of introducing semitransparent pixels at the edges of an object or text character to smooth out jagged edges, or stepping, caused by square pixels. This is more noticeable at low resolutions, where fewer pixels are used to make up the characters. PaintShop Pro has three antialiasing options: off (*left*), sharp (*middle*), and smooth (*right*).

Special Text Effects

Now that you have had practice adding text to a picture, you'll want to try adding special effects to jazz up the results. In this section we run through some techniques for making your text look simply stunning.

Layer Styles

Layer styles make it much easier to create, edit, and apply certain special effects. You can apply layer styles to both raster and vector layers, and they work particularly well with type. When you apply a filter effect such as the drop shadow from the Effects > 3D Effects menu, the effect is added as pixels to the layer, which makes it difficult to edit. If you decide your drop shadow is too dark or not in the right place, you have to undo it and start over. And, if you want to apply effects filters to text, you must first rasterize the layer (i.e., convert it from a vector to a bitmap or raster layer). This makes it uneditable, so if you later discover a spelling mistake you're in big trouble.

The great thing about layer styles is that they are "live" editable effects. If at any stage in the editing process you decide you want to change the size, opacity, position, or color of your drop shadow or any other layer style, you can. What's more, you don't have to convert type layers to raster layers to apply layer styles to them, so you can also edit the text with the Text tool and the layer style will automatically update.

To apply a layer style to some text, double-click the vector layer in the Layers palette to open the Layer Properties dialog box, and click the Layer Styles tab; click the Fit Image to Window button if you can't see the text in the preview. To apply a layer style and access its controls, click the check box next to it in the list. The layer itself is also included in the layer styles list, so you apply a layer style but make the layer itself invisible.

FIG 7.4 To access the Layer Styles feature, double-click the layer thumbnail in the Layers palette and select the Layer Styles tab in the Layer Properties dialog box. You can apply any combination of the six styles available.

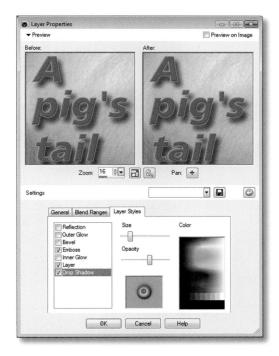

There are six layer styles to choose from:

- · Reflection
- · Outer Glow
- Bevel
- Emboss
- Inner Glow
- · Drop Shadow

You can apply more than one layer style at once—for example, you might want to Emboss your text and add a drop shadow—but be careful not to go overboard. Once you've selected a layer style, use the controls to change its size, opacity, position, color, and any other available attributes. As with most of PaintShop Pro X4's effects, once you've found settings that work well, you can save them as presets so you don't have to rediscover them every time you want to apply them in similar situations.

Tip

Preview on Image can slow things down considerably, particularly if you have an older PC. Use the before and after previews to get the job done more quickly.

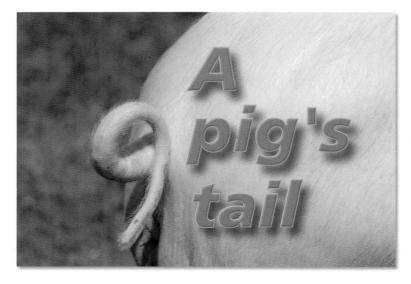

FIG 7.5 Layer styles work well with text layers. Here I've combined the Emboss and Drop Shadow styles to make the type stand out from the pig's, er, rear end.

Special Effects Filters

With PaintShop Pro you can add a wide range of effects to your text layers. For most actions, with the notable exception of layer styles, the vector text layer must first be converted to a raster layer—a warning dialog appears and PaintShop Pro asks you if this is okay (if you don't want to be asked every time, click the "Don't remind me" check box from the dialog that pops up on screen).

Select Chisel from the Effects > 3D Effects menu. The opening dialog offers a range of control options. The chisel effect extrudes the text shape outward. Use the Size slider to determine the extent of the extruded effect, and select one of the radio buttons to choose either a solid or transparent color fill. To select a color for the effect, you can click the color swatch and use the Color Properties dialog box. Better still, move the cursor over the photo and it will change to an eyedropper tool, which you can use to sample a color from the photo itself.

Other 3D effects for adding impact to text include Drop Shadow, Cutout, and Inner Bevel. Most of the 3D effects are available as layer styles and, as a general rule, where you have the option it's better to use a layer style than a filter effect. If you need to add something slightly more esoteric, then try some of the filters from the Artistic, Art Media, Distortion, or Texture filter drop-downs. Any of these filters will work on the text layer as long as it has been converted into a bitmap (raster) layer first.

FIG 7.6 Over and above regular text effects, added via the Materials palette, it's possible to add tremendous three-dimensional power using any of PaintShop Pro's filter effects. To do this you might have to convert the layer from vector to bitmap, but still, the resulting effects, as seen here, are very impressive.

Using Filter Effects: A Warning

Though almost all the filters under the Effects menu will have an effect on raster text layers, not all work well and some may not appear to do anything at all. This is because the filter action works across the entire frame and not just on the text on its own. If the filter has a global effect, then it is more than likely to be seen on the text layer, but if it is of a more random nature it might or it might not. To make it work correctly you must first select the text and then apply the filter action. Do this by choosing Selections > From Vector Object or use the keyboard shortcut Ctrl + Shift + B and then apply the filter.

Adding Text to a Path

Adding text to a path can make for a dynamic and interesting design and is especially useful for creating company logos, web buttons, badges, CD and DVD labels, and the like. You can add type to shapes created with any of PaintShop Pro's shape tools (see "Vectors: Learning the Basics" on page 200), but it works best on gently sloping curves. Anything with sharp angles and lots of turns is unlikely to look good or even be readable.

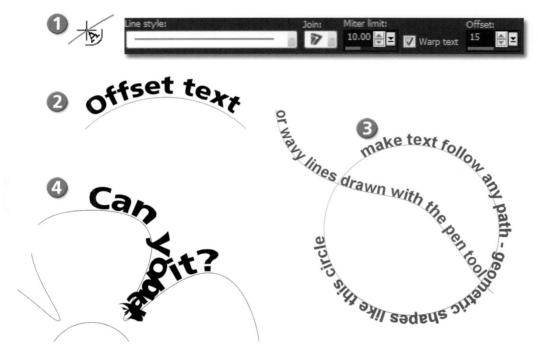

FIG 7.7 To align text to a path, position the Text tool over the object's edge and click to enter the text when the tool changes (1). To move the text above or below the line, enter an offset in the Text Tool Options palette (2). You can run text along any vector path (3), but avoid sharp curves and sudden direction changes, which will render the text unreadable (4).

To add text to a shape, all you need to do is first draw the shape and then select the Text tool and position the cursor on the edge of the shape. You'll see the cursor change from the normal cross-hairs with a capital A in the bottom right quadrant to cross-hairs with an A at 45 degrees and a curved line below it. When this happens, click on the shape and any text you type will follow the outline of the shape:

Tip

Hold Shift while clicking the text tool to open the text entry dialog, hold Ctrl and click to select multiple layers, hold Shift when clicking on the image with the text tool to open the Text entry box.

- To move the text along the path, choose the Pick tool and click-drag the text. The small circle icon indicates the new start position of the text.
- To raise or lower the text on the path, enter a value in the Offset field of the Text tool's Options palette. A positive value raises the text above the path, a negative value lowers it.
- If you don't want the path to show, either select a transparent stroke and fill or click the Layer Visibility icon in the Layers palette to turn it off.
- To detach text from the path, select either the text or its path using the Pick tool, and choose Detach Object from Path from the Objects menu.
- To attach existing text to an object, select the text with the Pick tool, Shiftselect the object, and choose Fit Text to Path from the Objects menu.

Editing Text Shapes

By converting text to a vector object you can use PaintShop Pro's Vector Editing tools to alter the shape of individual characters by adjusting individual nodes. To convert text to a vector object, select it with the Pick tool and choose Objects > Convert Text to Curves. There are two options. You can convert the entire text block into one vector object by choosing Objects > Convert Text to Curves > As Single Shape. Alternatively, you can convert each letter of the text into a separate vector object by selecting Objects > Convert Text to Curves > As Character Shapes. Once the text is converted, select the Pen tool and click the Edit mode button in the Tool Options palette to edit the character shapes.

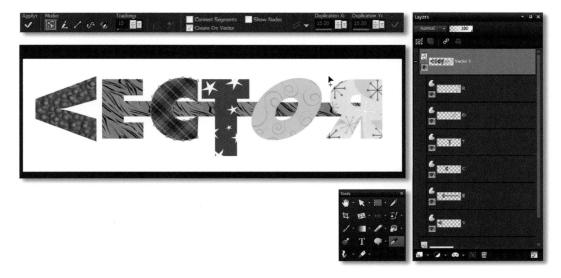

FIG 7.8 Once text is converted to paths, you can edit individual character shapes using the Pen tool.

Bear in mind that once the text has been converted to curves it can no longer be edited in the usual way, so now is not the time to discover you've made a spelling error! You can cover yourself by duplicating the layer before converting it, so you have the original text to go back to if necessary. Once the text is converted to curves, especially as individual character shapes, you will need to pay special attention to how the individual elements stack up in the Layers palette.

Making Selections from Text

Text selections form the basis for all kinds of effects using photos. You can paste photos inside a text selection, a particularly effective technique when combined with layers. Typically, an image layer is copied, pasted inside a selection, and overlaid on top of the original with the opacity reduced, the color desaturated, or some other effect applied.

You can make a text selection directly by selecting the Text tool and choosing Selection from the Create As pull-down menu in the Tool Options palette. This is useful for a quick text selection, but once the selection is made it can't easily be edited. A better method is to create the text as a vector, then

FIG 7.9 To create this text, I made a selection from it using Selections > From Vector Object and then turned the text layer's visibility off. I pasted the background image into the selection (Edit > Paste Into Selection) then promoted the selection to a layer and applied the Emboss layer style. Finally, I made the background layer black and white using Black and White Film effects.

choose Selections > From Vector Object. That way, if you decide to edit the text, even if it's only to open up the tracking a little or reduce the leading, you can easily make a new selection.

Vectors: Learning the Basics

Vector images differ from bitmap (raster) images. Whereas a bitmap image is made entirely of pixels, a vector image is made from a set of mathematical instructions or coordinates. Vectors have several advantages:

- · Vectors are quick to work with.
- · Vector file sizes can be small and still display a large dimension.
- Vector graphics are highly editable with absolutely no loss of quality.
- · Vectors create perfectly clean, antialiased lines and curves.

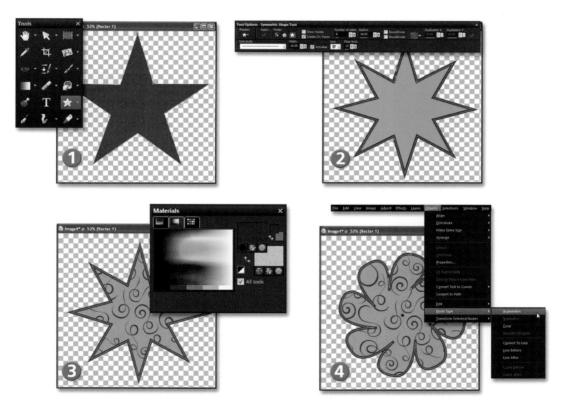

FIG 7.10 (1) Use the Symmetric Shape tool to create highly editable polygons and stars. (2) Edit the line style using the Tool Options palette, and choose Stroke and Fill colors from the Materials palette (3). You can edit all of the nodes on a symmetric shape at once (4), so it's easy to quickly create variations on a basic shape theme.

FIG 7.11 The Preset Shape tool offers a powerful and quick way to make almost any size or shape of object for illustration.

FIG 7.12 Take this one step further by adding drop shadows, bevels, and a range of other specialist (filter) effects to make those flat, unexciting shapes something special.

Vectors, therefore, are ideal for illustrations where scalable drawing, text, and shapes are required. PaintShop Pro's Preset Vector Shape tool has myriad fully editable subjects in its library. If, for example, you like the shape in one of the presets but not the color or edge detail, you can edit it using its Edit palette. If you need to create your own vector illustrations from the ground up, use the Pen tool.

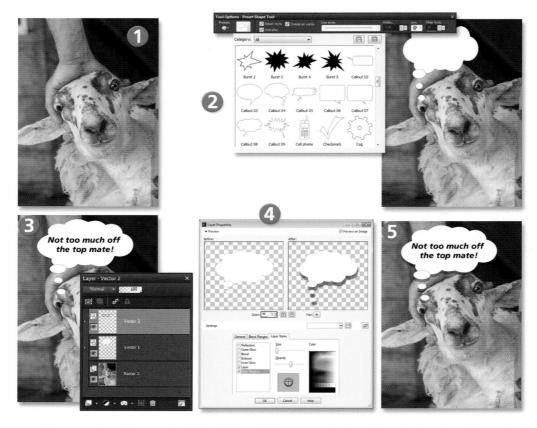

FIG 7.13 Adding a vector shape and text to a photo. (1) Open the photo. (2) Choose a preset shape from the drop-down Preset Shape Tool menu. Use the handles to reposition and rescale the shape if necessary. (3) Reposition, rotate, or flip the vector shape using the Pick tool, then choose the Text tool and enter appropriate text (do not click directly on the shape with the Text tool, or the text will follow the path); now press "Apply." (4) Once you're happy with the size and positioning of the new text, use PaintShop Pro's Drop Shadow filter to add an effect to the speech bubble and save as a .pspimage file. (5) The finished result.

Working with the Pen Tool

The Pen tool is the ultimate vector shape creation tool. With it, illustrators and graphic designers can create any type of shape. line, or layer object they care to imagine. The Pen tool gives you scope to design any shape; however, because the shapes it creates are formed using vectors, whatever is created remains infinitely editable at all times.

Drawing tools rely on manual actions for their accuracy, and we all know how silly it is to try and draw with a mouse! It's like sketching with a house brick, only less accurate. The Pen tool allows you to ignore many of the physical limitations of the mouse and to apply extreme linear accuracy to the most delicate of shapes.

The principal driving force behind this is the ability to draw using Bezier curves. These are infinitely editable lines that can be used to describe mathematically perfect shapes such as curves and circles. The curves were invented by Frenchman Pierre Bezier, who worked for the car manufacturer Renault. If you are not into vector illustration, then this might not be a tool that you are likely to need, but for the designers among us it's essential. Check out the stack of controls provided in the Options palette and you'll get an idea of how powerful this tool is. Here are some of its most important features:

- · Draws lines and shapes of any size, freehand
- · Draws myriad shapes using point-to-point techniques
- Fills objects with color, texture, and transparency using the Materials palette

The Pen tool works by dropping editable nodes into the picture, whether blank canvas or an existing picture. Each mouse click adds another node that's automatically joined to the previous one with a straight or curved line, depending on the type of drawing implement chosen. Clicking a node back onto the original start point completes the shape. You can add as many or as few nodes as needed, though the fewer nodes you use, the smoother your shapes will look.

The Pen tool can be used to create new vector shapes and edit existing pictures in a wide range of styles. You can change any aspect of the Pen tool at any time—for example, thickness of line, color fill, texture, linear aspect, curve aspect, and more. Right-clicking displays its principal attributes, which include Edit, Node Type, and Transform Selected Nodes. Using these allows you to perform more than 30 different edit functions.

The Pen tool has several uses:

- Creating accurate masks
- Creating complex vector shapes and illustrative elements using rectilinear or Bezier-controlled lines
- · Creating perfectly curved lines around irregular objects

Here's how to make a vector illustration:

- Step 1. Create a new document with a white background and a resolution of your choice (File > New).
- Step 2. Click the Pen tool icon on the Tools toolbar and select a line style and width from the Tool Options palette.
- Step 3. Select a line application—Lines and Polylines, Point to Point (Bezier curves), or Freehand—from the Mode section of the Tool Options palette. You'll need to experiment to discover which suits the task in hand; see the notes that follow to learn the differences between these methods.

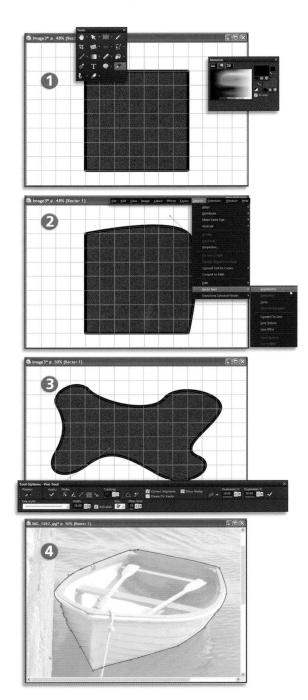

FIG 7.14 (1) Creating geometric shapes with the Pen tool is easy—but you can use the Symmetric Shape tool for that. (2) Change node properties by right-clicking or (3) create curves of any shape by click-dragging. (4) Use the Pen tool to trace shapes from photo layers.

Step 4. When you've drawn your path, select it with the Pick tool to display its bounding box. The handles on the box allow you to rotate, stretch, and deform the vector shape without losing detail. To change the appearance of the line, open the Layers palette, select the vector layer, and click the "+" tab. This opens the vector layer to display the individual elements. Double-click an element to open the Vector Properties box.

Note the following:

- · "Draw Lines and Polylines" draws straight lines between two points.
- "Draw Point to Point—Bezier Curve" is an infinitely editable freeform line controlled by Bezier technology—grab a controlling handle to bend the line any which way; Bezier curves are ideal for creating seamless freehand shapes.
- · "Draw Freehand" is the same as drawing on a piece of paper.

Step-by-Step Projects

Creating a Type Effect Using Text Selections

As we saw earlier in this chapter, Effects filters don't work with vector layers, which must first be rasterized. The same goes for text, which by default is rendered as a vector layer. One of the easiest ways to create stunning type effects, however, is to make a selection from your type and then apply the effect to an image using that selection. Here we're going to produce a beveled... glass... type effect in four steps.

The success of type effects like this depends very much on choosing the right typeface. The Inner Bevel filter works well on big, bold type. So, avoid script fonts or anything with fine detail and keep the word count to a minimum—make a bold one-word statement.

STEP 1 Open your image and create a copy of the background layer by right-clicking it in the Layers palette and selecting Duplicate.

STEP 2 Select the Text tool, click on the image, and enter the type. For maximum effect, keep it short—one or two words at most—and use a bold typeface; use capital letters for improved readability and make the type as large as you can. Click the Apply button in the Tool Options palette when you are happy with how it looks, then position the type where you want it on the background with the Move tool.

STEP 3 Choose Selections > From Vector Object (keyboard shortcut Ctrl + Shift + B), then turn off the type layer by clicking its layer visibility toggle (the eye) in the Layers palette. Click the copy of the background layer in the Layers palette to make it active.

STEP 4 Choose Effects > 3D Effects > Inner Bevel and apply the filter using the default settings. Click the Preview icon to see the result in the main image window. You can experiment with angle, smcothness, depth, and other settings, or try one of the available presets, but the default setting gives a pretty good result. Click OK to apply the bevel, then press Ctrl + D to deselect all.

Special Effects *Advanced Editing Techniques*

What's Covered in this Chapter

- In this chapter you'll learn how to add special effects to your digital photos.
 Applying a special effects filter may be all you need to turn a so-so image into something special. But, with a little more effort, you can create jaw-dropping effects that defy reality—or what passes for reality in a photo.
- This chapter really covers two things; the first half is all about PaintShop Pro X4's painting and drawing tools, and the remainder explains how to create special effects.
- If you want to create illustrations from scratch, you'll need to familiarize yourself with the workings of the Materials palette and PaintShop Pro's Brush tools. All of this is explained in detail in the next few pages. Creating illustrations from a blank canvas can be a demanding task, even if you're a competent illustrator, but, by using a photo as a source image and painting over it using layers, you can achieve professional-looking results. PaintShop Pro's Art Media tools mimic real-world materials such as oils and pastels, and you'll learn how to use these to turn photos into paintings.

- Later in the chapter you'll find a comprehensive run-down of PaintShop Pro's
 filter effects, where to find them, and how to use them. You'll discover how to
 use the Deformation tools to distort photos as well as how to correct distortion
 caused by ultrawide-angle lenses using the distortion correction filters.
- Special effect filters and distortion tools are often knocked for not being very "useful." That's not a criticism you could apply to PaintShop Pro X4's lighting effects, which allow you to add lighting to a photo after you've taken it. Lighting effects are great for adding spotlights or colored lighting to a scene, or simply to shine some illumination and add depth to a picture that suffers from flat, featureless light. Turn to page 230 to find out how.
- There are lots of step-by-step projects at the end of this chapter. We kick off
 with a look at how to create realistic depth effects—making type follow the
 contours of a surface as if it has been painted on. Following this advanced
 project, we'll tackle something a bit simpler—having a bit of fun with
 PaintShop Pro's Picture Tube and adding edges and frames to your photos.
 The final step-by-step project in this chapter shows you how to respray your
 car using the Color Changer tool.

Using the Materials Palette

One of the most used palettes in PaintShop Pro is the Materials palette. This is where you go to change the colors used in any of the program's paint or drawing tools. In this section we look at how the Materials palette can be used in the creation of special effects and how it's used for mixing colors.

Choose the Materials palette from the View > Palettes menu (keyboard shortcut F6). There are three modes in which to work with this tool: Frame, Rainbow, and Swatch modes.

The Frame mode provides a quick and fairly intuitive method of picking colors. First, left-click to select a foreground hue from the outer hue rectangle (right-click to select a background color), then click in the inner saturation rectangle to alter the saturation and brightness for the selected hue. If you hold down the mouse button and drag within the Saturation rectangle, the value updates and a tool tip window tells you the RGB values at the cursor position. Alternatively, you can fine-tune the saturation and brightness by adjusting the triangular sliders at the bottom and side of the Saturation rectangle.

On the Rainbow, tab position the cursor over the central colors panel; it changes to an eyedropper and a tool tip wincow displays the RGB values of the color beneath. Left-click to select the foreground color and right-click to select the background color. The Rainbow tab only needs one click to select a color, but it provides less accuracy than the Frame tab.

If you're working with a limited palette, you may find Swatch mode simpler to use because you can make your own swatches. In many ways it's faster and more accurate to work with.

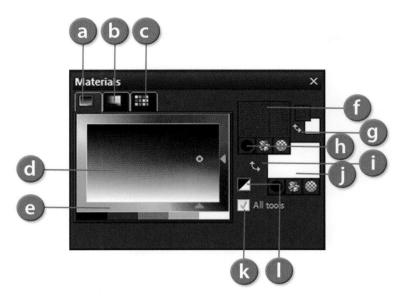

FIG 8.1 (a) Frame tab. (b) Rainbow tab. (c) Swatches tab. (d) Inner saturation rectangle. (e) Outer hue rectangle. (f) Foreground and Stroke properties. (g) Swap foreground and background colors. (h) Click the left button to change the Color/Gradient and pattern selected, click the middle button to change the texture, and click the right button for transparency. (i) Swap foreground and background materials. (j) Background and fill color. (k) Apply Materials palette settings to all tools. (l) Select default (black and white) foreground and background colors.

The two large colored boxes on the right of the palette influence the Foreground and Stroke properties (upper left) and the Background and Fill properties (lower right). Underneath the Foreground and Background Properties boxes a Style button provides three options: Color, Gradient, and Pattern. To these three modes can be added texture or transparency using the appropriate buttons. Two smaller colored boxes to the upper right are used to set the foreground and background colors.

Double-click either the Foreground or the Background Color box to open the Color picker. Use this to choose more colors. To modify the gradient or texture, double-click the Foreground and Stroke box or the Background and Fill Properties box to open the Material Properties dialog box.

- Use the Swap buttons (double-headed arrows) to swap foreground and background colors and materials.
- Click the Style button at the base of the Foreground/Background
 Properties boxes to choose any of the three styles you wish to work with;
 color, gradient, or pattern.
- Click the Texture button to add texture to the paint strokes.
- · Click the Transparent button to add transparency to the brush.
- If you are happy with a particular combination in the palette, click the "All tools" checkbox to lock it and to apply the settings to all the tools.

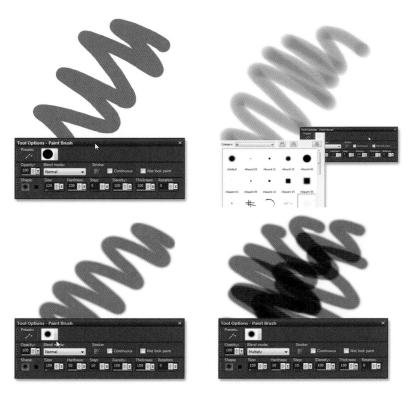

FIG 8.2 (*Top left*) Click once in the Color picker to set the foreground color and paint. (*Top right*) Select from one of the available brush tips to quickly alter the stroke appearance. (*Bottom left*) Even with the default brush tip you can create a wide range of variation using the tool options palette; here I've created a softer edge by changing the hardness to 50. (*Bottom right*) Use blend modes to alter the way new brush strckes interact with existing ones; here Multiply mode overlays strokes to build up color.

FIG 8.3 To draw a line between two points with the Paint Brush, click once, move the cursor to the next point, and Shift-click again. I'm still using the Multiply blend mode here, which is why each end point appears as a darker spot.

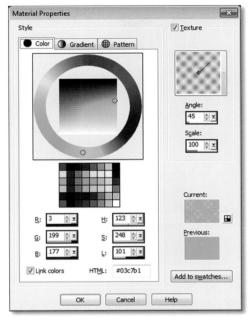

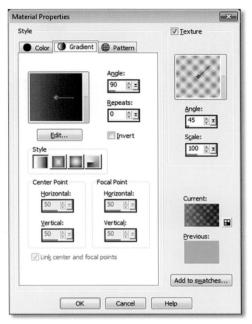

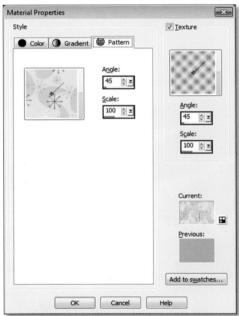

FIG 8.4 The Material Properties dialog box appears when you click the foreground or background color swatch in the Materials palette. It's divided into three tabs (*top left*) for selecting color, (*top right*) gradients, and (*bottom*) patterns. As well as choosing presets and changing parameters (for example, the start and end colors of a gradient), you can choose and apply a texture.

FIG 8.5 Click the Pattern swatch in the Pattern tab of the Material Properties dialog to see the list of available patterns.

FIG 8.6 You can apply a texture to a color, gradient, or pattern, but first make sure to check the Texture checkbox in the Material Properties dialog. Click the Texture swatch to see the range of available textures.

FIG 8.7 Of course, you can paint with a gradient and texture applied.

FIG 8.8 And with patterns too.

Working with Brush Tools

PaintShop Pro comes with a staggering array of brushes and brush tips, enabling the user to create a range of simple, or incredibly sophisticated, painting tasks. Brush tools introduce the photographer to the concept of original creativity—you can literally make something from nothing using one of PaintShop Pro's brushes (in the same way that you might with a crayon and a blank sheet of paper).

FIG 8.9 A staggering array of effects, textures, and "looks" can be produced with PaintShop Pro's Paint Brush simply by changing its tool set in the Options and Materials palettes. There are more than 20 preset stock tips that vary greatly in each brush.

FIG 8.10 This is an ordinary snap of a very pretty rose. There are a number of preset filter effects that I could apply to the entire photo or even to a selection. However, it is also possible to make radical changes merely by using a brush on the canvas. (1) Open the photo and enlarge the canvas to add a white border around the edges. (2) Duplicate the layer. (3) Desaturate the color. Reduce it almost to black and white.

Use the Tool Options palette to change the physical nature of all brushes. Use the Materials palette to choose different brush colors as well as textures and gradients in the brush action. Simply paint over the image to add texture and additional color.

An advantage of this process is that brushes can be used to add a nonphotographic influence to a picture in order to create the illusion that it's something other than a plain old photo. The most important thing to remember when you're doing this kind of work is to select a blend mode from the Brush Tool options palette that doesn't completely obscure the underlying detail but allows it to show through your brushstrokes.

Brush tools are infinitely variable in terms of size, density, opacity, and hardness. It's much easier to get good results using a graphics tablet than with a mouse. A graphics tablet allows you to draw, select, erase, and paint with the accuracy and delicacy of a real paintbrush, pencil, or crayon. Using the Brush Variance palette (F11), you can assign brush properties like size, opacity, and thickness to vary according to how much pressure you apply or, if your stylus supports it, the degree of tilt or rotation. The bottom line is that it's much more natural working with a stylus and you have a lot more control than with a mouse.

Besides the Paint Brush and Airbrush tools, PaintShop Pro has a number of other brush-based tools designed specifically for working on a photographic image for the purposes of adding impact:

 Dodge tool. Lightens pixels under the brush—good for extracting detail in dark areas.

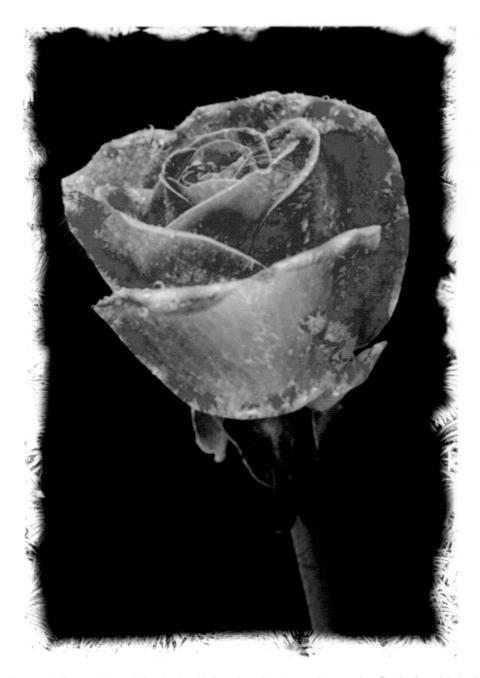

FIG 8.11 The textured effect can also be applied to the edges. Work at a lowered opacity to produce a seamless effect. Too fast and the brush marks become heavy and telltale, which is not usually desirable.

Original picture: John Shepherd, iStockphoto 1012211.

FIG 8.12 Use the Brush Options palette to change the properties of the brush tip. When overpainting, choose a blend mode like Overlay or Soft Light, which will interact with the detail on the image below rather than completely obscuring it. Use the Materials palette to choose different brush colors as well as textures and gradients in the brush action. Simply paint over the image to add texture and color.

- Burn tool. Darkens the pixels under the brush. Ideal for increasing density in overexposed pictures.
- · Smudge brush. Blurs and smudges the pixels under the brush action.
- Push tool. Makes all the pixels behave just like wet oil paint so that they can literally be pushed about the frame
- · Soften tool. Applies a localized soft focus effect.
- Sharpen tool. Increases the contrast, and therefore the apparent sharpness in the pixels.

Like the Paint Brush, PaintShop Pro's airbrush also has potential for terrific creativity. Once you hit on one combination, record it as a preset for use on other images.

Using the Art Media Brushes

PaintShop Pro X4 has a range of Brush tools called the Art Media tools. These tools are a radical departure from the usual kind of digital brush tool in that they mimic the behavior of real-world materials like oil paint and pastels.

Altogether there are nine Art Media tools: Oil, Chalk, Pastel, Crayon, Colored Pencil, Marker, Palette Knife, Smear, and Art Erasure. These tools can only be used on special Art Media layers; a new Art Media layer is automatically created for you when you start to paint with one of the Art Media tools.

Two of the Art Media brushes—Oil and Marker—are "wet'; they simulate the wetness of their real-world counterparts. With a "normal" PaintShop Pro

brush, if you paint by holding down the mouse button, or maintain pressure on the stylus tip, the paint just keeps on coming, but with a wet Art Mediabrush it runs out, just like the real thing. You have to finish the stroke and start a new one with a reloaded brush. Oil and Marker strokes stay wet, so if you paint over them with a new color the paint smears on the canvas.

FIG 8.13 PaintShop Pro's Mixer palette works like the real thing, allowing you to partially mix colors and apply a smeared combination with the Oil Brush or Marker tool. (a) Mixer Tube. (b) Mixer Knife. (c) Mixer Dropper. (d) Tool size. (e) Mixer area. (f) Load Mixer Page button. (g) Open Page button. (h) Navigate button. (i) Unmix and (j) Remix buttons. (k) Mixer Palette Menu button.

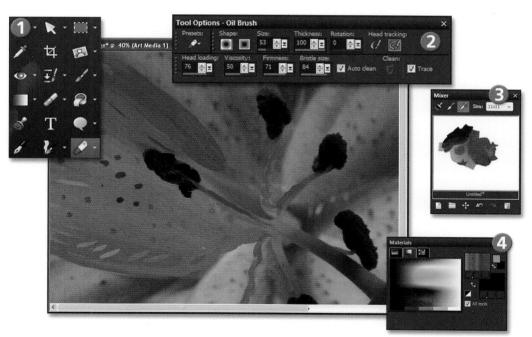

FIG 8.14 Select the Oil brush from the Art Media tools fly-out (1) and use the Tool Options palette (2) to set brush parameters. Head loading determines how much paint is on the brush and how quickly it will run out. Click the Trace checkbox to automatically sample the color from underlying layers. Add color to the Mixer palette (4) using the Mixer Tube and mix the hues together with the Mixer Knife. Sampling an area of the Mixer palette with the Mixer Dropper adds the mix to the Foreground/Stroke swatch in the Materials palette—now you're ready to paint.

Another aspect of real media that these wet brushes emulate is the ability to paint with multiple colors. A real brush might have mostly blue paint on it with a little bit of yellow, producing a smeared blue/green color, and you can simulate this effect with the Oil Brush and Marker tool. There's also a Mixer palette on which you can smear colors around and produce a messy mix of several colors to load onto your brush.

When using the Oil brush or the Palette Knife, the size of the area sampled from the Mixer palette is determined by the brush size setting in the Tool Options palette, so the bigger your brush, the more paint variation you can have. For other Art Media tools, set the sample size using the Mixer palette's Size slider or the up and down arrows, or enter in a value with your keyboard.

When using the wet painting tools, painting over existing strokes causes them to smear. You can "dry" an Art Media layer or make it wet again at any time by choosing Layers > Dry Art Media Layer or Layers > Wet Art Media Layer.

You can save and load Mixer palette pages and switch between them by choosing Save Page and Load Page from the Mixer Palette menu.

Deformation Tools

Altering the shape or alignment of a layer is easy using PaintShop Pro's Deformation tools. Why use the Deformation tools?

- · To change the alignment of a layer
- · To modify the size of a layer
- To modify the perspective and skew of a layer
- To significantly change the appearance of a picture

There are four to choose from:

- · Pick tool. Used for relatively simple layer changes.
- · Straighten tool. Especially handy for straightening horizons in scans.
- Perspective Correction tool. For adding exaggerated (or corrective) perspective to objects.
- Mesh Warp tool. The "big daddy" of the subset. Mesh Warp gives you the freedom to bend, distort, warp, and buckle sections within a layer.

The procedure is simple enough: open the document and select the layer that needs deforming. Choose the Pick tool from the Tools toolbar. Note the bounding box and "handles" that appear at the corners of the layer. If you hold the cursor over any of these handles, the normal four-pointed arrow Move symbol changes to a rectangle, indicating that you can scale the layer while maintaining its original proportions. If you don't want to maintain the original proportions—in other words, if you want to stretch or squeeze the layer—drag one of the handles located on an edge midway between the corners.

FIG 8.15 The most obvious or immediate use for the Mesh Warp tool is fun. Choose the tool, stretch the wire frame that appears over the picture, and watch PaintShop Pro treat those pixels like so many rubberized elements!

MadJack Photography, iStockphoto 2126391.

You can further change the type of the deforming action by holding down the Shift key for a shear action or by holding the Ctrl key to change it to Perspective Deform. The handle in the center that resembles a stroked circle moves all the contents in the bounding box. The Rotation Handle to the right of this (prerotation) rotates the layer. Use similar mouse actions to directly change the perspective (Perspective Correction tool) and to align the horizon (Straighten tool). Advanced users can use the Deformation tools to manipulate selected layers to create super-real perspective effects or to add extra realism such as shadows to product photos.

Lens Correction Filters

PaintShop Pro also has a range of filter effects specifically designed for correcting the detrimental effects caused by poor-quality lenses. These are Barrel, Pincushion, and Fisheye Distortion Correction filters.

Tip

Many criteria come into play to influence the success or failure of a filter effect. Factors include the quality, focus, color, and contrast in the original snap. Don't use a filter to mask the fact that a snap is no good—because the filter effect will invariably be no good either!

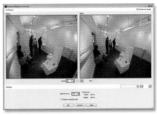

FIG 8.16 PaintShop Pro X4 has three distortion correction filters—Barrel, Cushion, and Fisheye—designed to correct for lens distortions. These distortions are often found in less expensive lenses, but they are usually minor and difficult to spot. Very wide angle lenses, though, and in particular "fisheye" lenses with a 180-degree field of view, suffer from severe barrel distortion. The original *(top left)* was shot with an ultra wide angle lens—notice how the straight lines (e.g., the lighting rail and skirting board) curve toward the edges of the image. The Fisheye Distortion Correction filter does an excellent job of straightening everything out.

Applying Filter Effects

Photo editing applications are used to improve the look of digital pictures. Most contain filter sets. These are prerecorded visual effects that can be applied to a picture at the press of a button (OK, at the press of two buttons).

PaintShop Pro has many filters, designed not only to improve the quality of your work but also, in some examples, to radically change the nature of the picture. For example, you can increase or decrease color, contrast, hue, sharpness, and even black-and-white tone in a photo at the press of a button. These filters are regarded as standard issue for most photo editing products. PaintShop Pro also has a range of creative and esoteric filter effects that are used to change the nature of a picture from a photo into something different, like a drawing, a painting, or even a sketch. In fact, with a bit of patience, you can create almost any type of special effect you care to think of, such is the power of the software filter set.

Tip

Effects filters usually work best when applied to one part of an image (e.g., to text or a specific area). You can use the selection tools and masks to achieve this outcome, and there's a step-by-step project that shows how to apply filter effects using masks at www.gopaintshoppro. co.uk

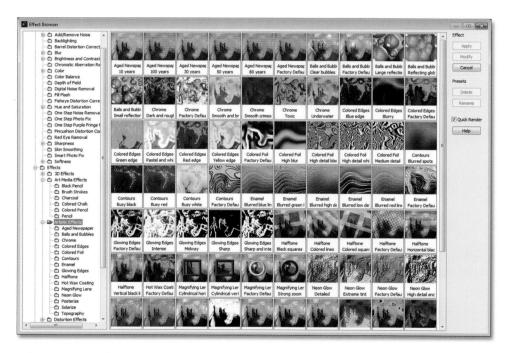

FIG 8.17 This is what the Filter Effect Browser looks like. You can make it display a thumbnail of every filter in PaintShop Pro, or you can be more specific by choosing filters from individual subsets. Double-click the window that you like the look of to apply that filter to the picture open on the desktop.

PaintShop Pro has dozens of filters. The program is also compliant with a range of plug-in-type filters. These are manufactured by third parties, like Flaming Pear and Auto F/X. These are loaded into the Effects menu just as if they were original integral products.

Most of PaintShop Pro's filters are subdivided into types under the Effects menu. These include the following:

- Photo Effects
- · 3D Effects
- · Art Media Effects
- · Artistic Effects
- · Distortion Effects
- · Edge Effects
- · Geometric Effects
- Illumination Effects
- · Image Effects
- · Reflection Effects
- · Texture Effects
- · User Defined

There's also a User Defined Filter, which opens a dialog box in which you can enter parameters to define your own filter. It's not very easy to work out, though, and I'm not going to say any more about it here, but feel free to experiment.

The last item on the Effects menu is Plug-ins, and this item lists any third-party plug-ins you may have installed. Plug-ins are a great way to add to PaintShop Pro's features, and there's a wide range available including lots of special effects. If you register your copy of PaintShop Pro with Corel, you can get a free copy of the KPT Collection of filter effects.

You'll also find more filters under the Adjust menu. These include the following:

- Add/Remove Noise
- Blur
- Sharpness
- Softness
- · Red-eye Removal

There's also a powerful filter Effects Browser. This previews all the filter effects as thumbnails so that, if you've no idea what to use, you can make an educated, illustrated guess.

Each filter subfolder contains effects that can be applied to any picture globally, to a layer in a document, or to a specific selection. For example, Art Media filter effects include Black Pencil, Brush Strokes, Charcoal, Colored Chalk, Colored Pencil, and Pencil. Select any of these, and the dialog that appears offers further refinements to the filter action. Some are quite basic while others have a range of controls.

There's no "correct" use of a filter. Try to go for the subtle use, although, in some cases, blatant can also work quite well, especially if you need to change the nature of the entire picture.

Tip

If you hit on a filter effect that works really well, save it as a preset that you can later apply to other images with a single click. Click the Save Preset button (the disk icon) at the top of the Filter dialog box.

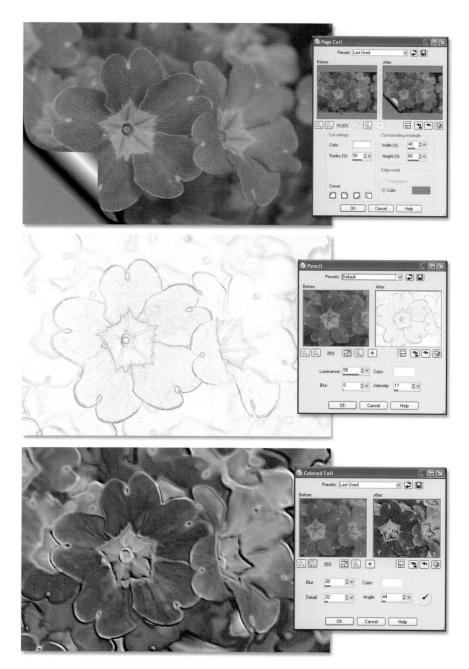

FIG 8.18 (Top) Page Curl. (Middle) Pencil. (Bottom) Colored Foil.

FIG 8.19 (Top) Balls and Bubbles. (Middle) Halftone. (Bottom) Soft Plastic.

FIG 8.20 (Top) Aged Newspaper. (Middle) Lights. (Bottom) Black Pencil.

FIG 8.21 (Top) Kaleidoscope. (Middle) Lens Distortion. (Bottom) Displacement.

Adding Lighting Effects

PaintShop Pro has a powerful feature that allows you to add real studio-lighting-type effects after the shot has been taken. It's a pretty cool filter-type effect that, when used with care, can add depth to an otherwise flat or lackluster picture. You'll find it on the Effects menu—Effects > Illumination Effects > Lights.

FIG 8.22 Lighting effects allow the image maker to add lighting effects to the shot after it has been captured. This is done via a clever combination of directional contrast and brightness enhancements, simulating the effect of a floodlight or a spotlight. Though you should never use this as a substitute for shooting a frame properly, the addition of a lighting effect like the ones seen here can make or break a picture that is not as strong as it possibly could be. The first step is to use the Histogram Adjustment dialog to improve the tones and contrast in the photo.

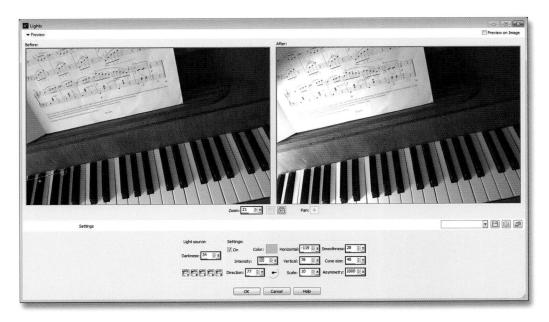

FIG 8.23 The Lights dialog box displays a before-and-after preview. Drag the lights in the "before" thumbnail to position them and alter their "cone size"—narrower angles produce a spotlight effect, broader angles a more diffuse style of light. There are five lights in all, but two, or at most three, will be adequate; uncheck the "on" box to turn unwanted lights off. Here, I've used a spotlight (cone size 11) to ill_minate the keyboard from a low angle and a more diffuse light above for the sheet music. You need to be careful not to overdo the intensity and create "blown" highlights with no detail. Often, the best way to avoid this and produce creative lighting setups is to position the lights outside the image, shining onto it.

PaintShop Pro offers several light sources, exactly as you'd have in a real photo studio. Click on one and you'll be able to edit its behavior—widening or narrowing the spread of light has the effect of increasing or spreading the flood of light onto the picture. A narrow beam intensifies the concentration of added light, so take care not to overdo this effect, otherwise you'll end up adding overblown highlights that take away from the subject matter. A little, in this case, will always produce a better result. The great thing about this tool is that its five light sources are infinitely adjustable. If you only need one or two lights, switch the others off by lowering their intensities to a zero value. Take care, though, because you might end up spending a lot of time moving the "lights" around the studio floor (i.e., the canvas). Keeping it simple will produce realistic and genuine improvements to any picture.

FIG 8.24 This is the final result—a snapshot with all the flair of a professional photo studio!

Step-by-Step Projects

Creating Realistic Depth Effects Using Displacement Maps

The displacement map effect was introduced in PaintShop Pro 9. Displacement maps have been a feature of that other professional image editing application (okay, Photoshop!) for some time, but even professionals are often at a loss to know what to do with this effect. This is a shame, because you can use displacement maps to create amazingly realistic three-dimensional overlay effects.

Let's say, for example, you want to overlay some type on a heavily textured background—a brick wall or a rocky cliff face—but you want it to look like it's been painted on, following the contours of the surface below, rather than floating on top the way a normal text layer would. Displacement maps allow you to do just that.

STEP 1 Open the base image (the rock face or your own textured backdrop) in PaintShop Pro and resave it as a copy (File > Save Copy As) into the folder containing PaintShop Pro's displacement maps. To find out the location of the displacement maps folder, choose File > Preferences > File Locations.

STEP 2 Add the type, the bigger and bolder the better. Here I've added two layers so that the number "X" can be sized and positioned independently. Right-click the Type layers in the Layers palette and select Duplicate from the contextual menu.

STEP 3 Select the duplicated Type layer in the Layer palette and choose Convert to Raster Layer from the Layers menu. If you used more than one Type layer, turn all the other layers off by clicking their Layer Visibility button (eye icon) in the Layers palette and choose Layers > Merge > Merge Visible to combine them. Double-click the merged layer and rename it "Type" in the Layer Properties dialog box.

STEP 4 Turn the background layer back on, make sure the Type layer is selected, and choose Effects > Distortion Effects > Displacement map. Click the Displacement Map button underneath the "before" thumbnail, make sure "All" is selected from the category pull-down menu, and locate the copy image you saved in step 1.

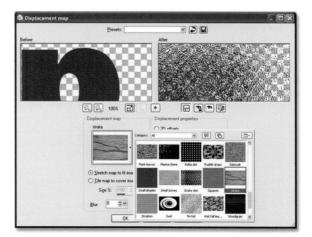

Tip

You can use the background from the current image as a displacement map if you turn off visibility for all the other layers. But make sure you have the (invisible) Type layer selected before you apply the displacement effect.

Tip

Sometimes you can get a more realistic overlay effect by switching the layers around and placing the Background layer on top of the Type layer and choosing an appropriate Blend mode. You'll need to promote the background layer to a full layer to do this.

STEP 5 You should now see the type deform in the preview window. The displacement map moves pixels in the target image depending on the value of corresponding pixels in the map. There are two buttons in the Displacement Map pane that allow you to stretch or tile the map, but our map is the same image and, therefore, the same size as the target, so we don't need to bother with these.

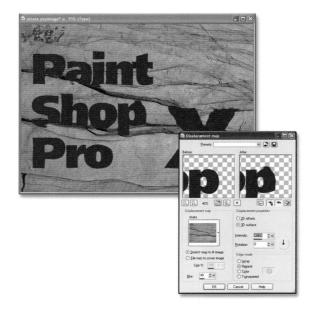

STEP 6 In all likelihood, the default settings won't produce a satisfactory distortion; there will either be too little or too much. There are two ways to control this. First, click the 3D Surface radio button in the Displacement Properties pane and change the intensity. The Displacement Map dialog box only shows the Type layer. If you want to see the effect overlaid on your background image, click the Proof button (the eye icon). Clicking the Auto Proof button will update the proof each time you make a change, but this can be time-consuming, especially with larger images.

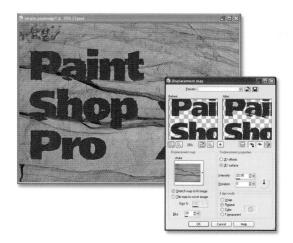

STEP 7 Generally, it's sufficient for the type to deform along the larger cracks and fissures in our background image, but ordinarily every little detail would produce unwanted distortions. The effect of the finer detail can be reduced by blurring the image. Drag the Blur slider until only the edges of the type are deformed and appear to be following the contours of the background image. Using trial and error, find the best combination of Blur and Intensity and, when you're happy with the result, click OK.

STEP 8 The type is now following the contours of the rock, but it doesn't look painted on and has an unnaturally flat look. Real paint would allow some of the rock texture and detail to show through. You can create this effect using a layer blend mode; here I've set the blend mode for the Type layer to Burn. Hard Light, Color, and Multiply are also worth trying—different images require different approaches. Sometimes, reducing the layer opacity heightens the realism of the effect.

STEP 9 PaintShop Pro X4 has an assortment of readymade displacement maps, including geometric patterns and texture photos, which you can use to distort images. You can also make your own—save them in the Displacement Map folder or use the File Locations button on the Displacement Map dialog box to add a folder of displacement maps. Grayscale images work best. Midgray pixels produce the least distortion; black and white pixels distort pixels in the target image the most.

STEP 10 This technique can be used to apply all kinds of images to all kinds of surfaces. You can use it for lighting effects: to make a laser beam deform as it passes over objects, to produce realistic shadow effects, and to superimpose designs onto all kinds of backgrounds from crumpled material to water.

Having Fun with the Picture Tube

PaintShop Pro's Picture Tube tool is one of the weirdest around. What does it do? The Picture Tube literally "pours" pictures out of a tube onto the canvas.

Using graphics and photos rather than flat color as "liquid paint" is an interesting concept, but it's one of those esoteric-type tools that it's almost impossible to find a proper use for. Unless, of course, you create your own specific Picture Tube files.

Use the Picture Tube to have fun, create borders, and even to decorate artwork destined for an inkjet printer. Consider the following Picture Tube applications:

- · Creating fun effects
- Creating cool edges and borders for pictures
- Making unusual picture frame effects
- · Entertaining your kids (and yourself)
- Creating textured backgrounds
- Adding specific, custom views to a picture (such as image grain, noise, and even textures)

How to Create a Picture Tube File

STEP 1 Open the pictures chosen to be in the set, ensuring that they are dust free and clear from JPEG artifacts (use PaintShop Pro's JPEG Artifact Removal filter to do this). Ensure that all pictures are a similar resolution and physical dimension.

STEP 2 Create a new document (File > New) with a transparent background to accommodate the picture elements. For example, if you are making a four-image Picture Tube, set the fields to 800 pixels wide and 200 high. Choose "Transparent" as the background color and then click "OK."

STEP 3 Open PaintShop Pro's Rulers palette (View > Rulers) and drag the guideline to the 200-pixel mark. Drag another to the 400-pixel mark and a third to the 600-pixel mark.

The Picture Tube icons can be of different sizes and randomness. Shift-clicking creates a point-to-point straight line.

STEP 4 You should now have a document with a transparent background (a checkbox pattern indicates transparency) with colored grid lines dividing a long, wide frame into four sections. Copy and paste (Edit > Paste as New Layer) the four pictures into this document. At this stage it's a good idea to save a copy of the file in case the resulting tube is no good. Give it a unique name and save it as a .pspimage (layered) file for later use.

STEP 5 Merge all the layers (Layers > Merge Visible) that PaintShop Pro has created (don't flatten this as it will produce a default background color, which is not required at this stage). Once merged, the four pictures should be sitting on a single layer that has a transparent background.

STEP 6 Select File> Export > Picture Tube and another dialog opens. Enter the number of cells that you have made for the tube (in this case, four). Make a unique name for the tube and click OK. To test the tube, create a new document with a white background (any size and resolution will suffice) and select the Picture Tube tool. Open its Options palette and, after pressing the Image Selection tab, scroll through the preset tube files to find your alphabetically placed file. Select it and paint away to test the tube.

Tip

In the Picture Tube Tool Options palette, you can control the scale of the Picture Tube elements, the frequency of their placement, and selection modes (how they are placed from the file).

By setting the randomness to a high value and reducing the frequency, you can use the tube to paint individual objects one at a time over the canvas.

You can use the tube to create cartoon-like effects.

Another use for the tube is to create "edgy" backgrounds for website projects. Lower the opacity on the layer so that text can be read more clearly over the top.

You'll soon discover whether the selections you made, the scale of the images, and their colors are attractive or not. If you are not happy with the result, it's simple enough to open the .pspimage version again, make changes, save it over the previous tube file, and try again.

Further Fun

Although a few photo purists might swear at the Picture Tube, a heap of devotees will swear by it—so many that there are entire websites dedicated to its use, offering loads of free tubes. Start by visiting Corel's site for further resources and downloads at www.corel.com.

Tip

If you don't want the frame to cover part of your picture, select "Frame outside of the image" in the Picture Frame dialog box. Paint-Shop Pro will automatically increase the canvas to make space for the frame. This option is particularly useful with the larger frames.

Adding Edge and Framing Effects

PaintShop Pro gives you the power not only to add frames to any picture you import into the program but also to add a great range of frame edges to the file as well, using the Picture Frame tool.

PaintShop Pro's Picture Frame tool is fantastic, providing a great range of paint style edges (among others) that normally would take hours to create or several hundred dollars to buy. Why use edges? Photographers live in a rectangular world, so it is great that we can now change that to re-create the look of a painted or sketched edge, film, crayon, and heaps more edges. If you habitually work with the program's specialist filter effects, you'll find this extremely useful.

Technique: How to Add an Edge or Frame to a Picture

STEP 1 Open the picture in the Edit workspace, choose Image > Picture Frame, and choose a frame or a picture edge from the dialog's many options.

STEP 2 Once the frame dialog is open, choose a frame or edge that you like the look of and click OK to add it to the full-resolution picture. If you don't want the frame to obscure detail at the edges of your photo, check the "Frame outside of the image" radio button.

Just some of the frame styles available with PaintShop Pro's Picture Frame feature.

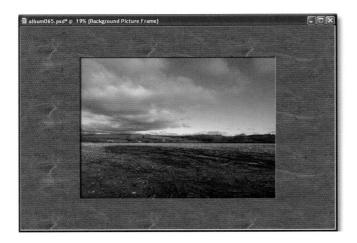

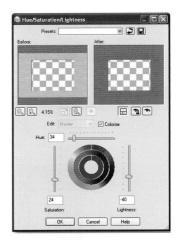

STEP 3 PaintShop Pro puts the frame on its own layer, so you can apply adjustments to the frame, leaving the photo untouched. Here I've used the Hue/Saturation/Lightness tool to change the frame color. You could just as easily change the Layer Blend mode, transparency, or apply any of the Effects filters.

Using the Color Changer Tool

Changing colors in a photo is something you'll find yourself wanting to do all the time. Whether it's someone's shirt, a front door, or a car, PaintShop Pro has the tools you need to make a neat job of it. In a previous edition of this book I showed how you could use the Color Feplacer tool to change a front door from red to green. The Color Replacer tool remains a good choice for some color-change jobs, but PaintShop Pro X[∠] has a tool that is much easier to use called the Color Changer tool.

One of the advantages of the Color Changer tcol is that it works on the entire image. The Color Replacer tool is a brush tool—you paint over the parts of the image you want to recolor and, depending on the color of the original pixels and the tolerance setting, the pixels the brush touches are changed to the new color. The Color Replacer tool remains the best option for fiddly detail, but to change large areas of similar color in a photo the Color Changer tool is the way to go. Here's how to use it to respray your car or change the color of any other large object.

STEP 1 Right-click the background layer in the Layers palette and select Duplicate from the context menu. You can make your changes to the duplicate layer and still have the original to fall back on if anything goes wrong. Select the color you want to change to on the Foreground color swatch in the Materials palette.

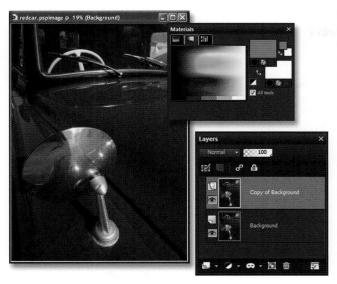

STEP 2 Select the Color Changer tool from the Flood Fill fly-out on the toolbar. There are only two settings on the Tool Options bar for the Color Changer tool—Tolerance and Edge Softness—and you'll need to experiment with both to get the results you want.

STEP 3 The Tolerance setting determines the extent of the color change. If you set a low value, only pixels that closely match the color of the pixel you click on will be changed. Here I've set a tolerance of 10 and, although there's a lot of red, only the red pixels that are very close in terms of color to the red pixel I clicked on have been changed. One great feature of the Color Changer tool is that you can adjust the tolerance after you've clicked to change pixels and the preview updates to color new pixels using the new Tolerance settings.

STEP 4 Rather than trying to get all of the red paintwork in one hit, you can use the Color Changer repeatedly, clicking on different parts of the car to add to the original selection. Continue clicking with the Color Changer tool until most of the paintwork is the new color.

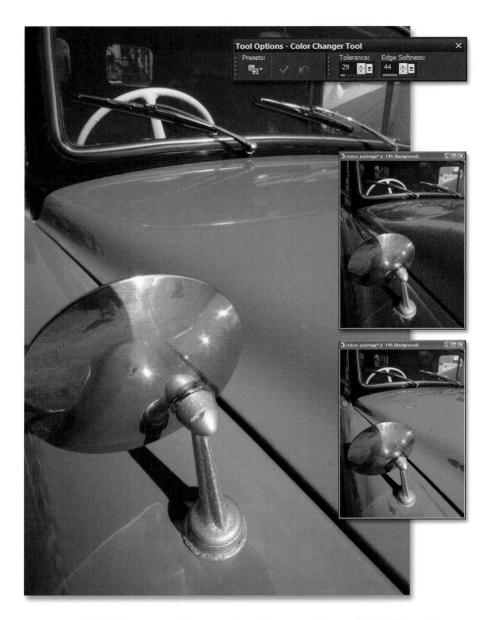

STEP 5 Incrementally increase the Tolerance setting until all of the red goes green. Incrementally increase the Edge Softness setting to produce a soft, more natural-looking edge to areas of changed color. When you're happy with the new paint job, press the Apply button to apply the color change.

What's Covered in this Chapter

- This chapter is short, but it contains a lot of things worth knowing if you ever want to turn your photos into real physical things that you can hold in your hand rather than something you only ever see on a screen. What with web photo sharing sites, email, and Wi-Fi-enabled electronic photo frames, most of your photos may never find their way onto paper. Believe it or not, though, not everyone owns a PC, and, even among those who do, there are people who will always prefer a physical printed photograph over an electronic one. Some photo competitions still insist on you sending hard-copy prints, and, if you want to exhibit your photos or just hang them on the wall, you'll need to know how to print them.
- This chapter kicks off with a discussion about resolution and how it affects
 print quality, and if you read nothing else you should at least try and get
 your head around this concept as it's one of the most important factors
 affecting print quality.
- If you're having problems getting what comes out of your printer to match
 what you see on the screen, you're not alone; it's one of the most common
 problems digital photographers face. Read the section on monitor
 calibration and color management to find out how to overcome the
 problem and stop wasting precious ink and paper.

- Another way to save on expensive consumables is to print several photos on one sheet of paper. PaintShop Pro's Print Layout application is designed to help you do just that. The step-by-step project at the end of this chapter shows you how.
- Printing can be a frustrating business because many factors affect final print quality—the quality and resolution of the digital image, the type of printer, the inks and paper used, color management, and printer settings. By following the advice provided here, you'll be able to consistently produce the best results possible from your printer.

Image Resolution

To get good results when printing, it's important to understand a little about image resolution. If you've bought an inkjet printer recently, one of the factors that may have influenced your decision is the printer resolution. Your inkjet printer may boast a resolution of 1440 dots per inch (dpi) or even more. Similarly, if you've recently bought a digital camera, somewhere on the box it will say 10 or 12, or even 16 megapixels.

Like printer and digital camera manufacturers, makers of flatbed scanners use resolution as a selling feature—the higher the better. But what do all these numbers mean and how are they related? Perhaps more importantly, how does the size of a camera's sensor affect how your photos will look when they are printed?

FIG 9.1 At 100% magnification, only a small part of this 2592 \times 3888-pixel image is visible; to see the whole thing it's necessary to reduce the magnification using Window > Fit to Window.

When it comes to digital images, cameras, scanners, printers, and PaintShop Pro all deal in the same currency—pixels. The starting point with any digital image, therefore, is its size in pixels. Figure 9.1 has a size of 3888×2592 pixels, giving a total pixel count of 10,077,696. If you viewed this image in PaintShop Pro at 100% magnification, you would only be able to see a small part of it. As well as the number of pixels in an image, we also need to take account of the resolution, measured in pixels per inch (ppi). The resolution of most screens in use today is around 100 ppi. If you divide the pixel dimensions by the resolution, you get the physical size of the image. 3888/100 = 38.8 and 2592/100 = 25.9, so a 10-megapixel photo would measure approximately 39×26 inches on screen at 100% magnification.

FIG 9.2 There's an inverse relationship between resolution and print output size — doubling the resolution halves the output size.

Shuffling Pixels

Open an image in PaintShop Pro and select Image > Resize. The Pixel Dimensions pane in the Resize dialog box tells you the pixel dimensions of the photo, in this case 3888 \times 2592 pixels. The Print Size pane shows the physical dimensions of the image at the specified resolution; at 72 ppi this image measures 54 \times 36 inches.

Click the Advanced Settings box and make sure the "Resample using" box is unchecked and enter 144 in the resolution field; notice how the width and height print dimensions halve when you double the resolution. If you enter 288 in the resolution field, the print size decreases again by a factor of 2. All you are doing here is rearranging the same information—the 10,077,696 image pixels—into a progressively smaller space.

On the screen at 72 ppi, the pixels are packed so closely together that you can't see them individually. But inkjet printing technology requires images of higher resolution to produce good-quality results. Generally, your photos should have a minimum resolution of 200 ppi to print well.

There's an inverse relationship between resolution and print output size—doubling the resolution halves the output size.

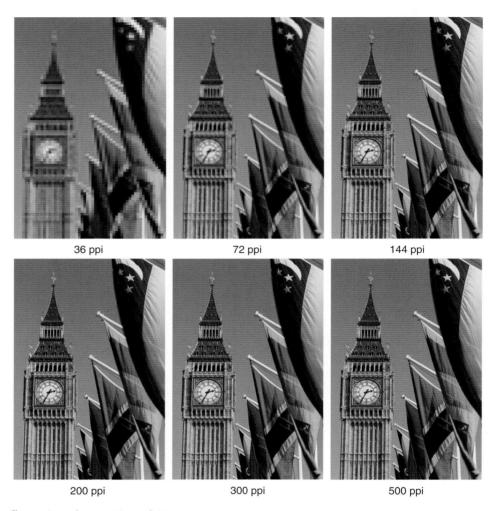

FIG 9.3 The same image shown at various resolutions.

Though the commercial printing process used for this book is technologically dissimilar to inkjet printing, these images nonetheless provide a good example of what you could expect to see if you were to output images at these resolutions to a desktop inkjet. At low resolutions, pixelation is clearly visible. A good-quality image is produced at 200 ppi, but at higher resolutions no improvement in picture quality is discernible. The minimum recommended resolution for the offset litho process used to print this book is 300 ppi, so you may see some improvement from the 200 ppi to the 300 ppi image in Figure 9.3 (look at the detail in the clock face), but this is unlikely to be the case with an inkjet printer. Try carrying out your own resolution tests to determine the point at which increasing the resolution produces no apparent quality improvement on your printer.

Resampling

Go back to the Resize dialog box and enter a value of 200 in the Resolution field. This gives a print size of roughly 10×15 inches. What if you don't want to make a print almost A3 in size? That's easy. Just enter the size you want in the Width or Height box—changing one automatically changes the other to maintain the aspect ratio. Say you want to fit the photo on a 6×4 -inch piece of photo paper. Enter 4 in the Width field (for a portrait-shaped photo), and the Height field automatically changes to 6. Wait a minute, though. Now our image resolution is 648 ppi, far higher than the 200 ppi required for inkjet printing. This doesn't really matter too much and it certainly won't affect the print quality, which will be no better and no worse than at 200 ppi. It will take longer, though, for your computer to send all that data to the printer and for the printer to process it. You can speed things up by down-sampling the image—removing the extra pixels that aren't required for printing at this size.

Down-sampling

Check the "Resample using" box and select either Smart Size or Bicubic from the Interpolation pull-down menu. Now enter a value of 200 in the Resolution field. This time, rather than changing the physical dimensions to accommodate all the image pixels at the new resolution, PaintShop Pro has done something different. It has removed pixels to produce the requested resolution at the existing size (it hasn't done it yet, but it will when you press OK). Take a look at the Pixel Dimensions pane and you'll see the new pixel dimensions are 800×1200 . If you do the math yourself, you'll discover that this does indeed produce a 6×4 -inch image at 200 ppi.

FIG 9.4 The photo on the left has been down-sampled from an original 2560×1920 -pixel image to 6×4.5 inches at a resolution of 300 ppi—suitable for printing. Its pixel dimensions are now 717×538 . The smaller middle photo was down-sampled to 2×1.5 at 300 ppi, giving new pixel dimensions of 237×178 . The middle photo was then up-sampled to the original 6×4.5 size at 300 ppi. You can clearly see the loss of detail and sharpness caused by the interpolation, hardly surprising as only one third of the pixels in this image are original. You can improve things marginally by unsharp masking, but there's no substitute for the original pixel data, so always make sure you back up your originals before resizing!

Removing pixels in this fashion will not affect the picture quality. This 4×6 -inch print will be indistinguishable from one printed at 512 ppi, but you'll have it in your hand much sooner. But what if you change your mind and decide that an A3-sized print would look pretty cool after all (assuming you're lucky enough to own an A3 color inkjet printer)?

Up-sampling

Open the Resize dialog box once more. (In PaintShop Pro Photo XI and earlier, when you open the Resize dialog, it applies the last-used settings to the current image. To get back to the current image size, select "Percent" in the Pixel Dimensions units pull-down menu and enter 100 in the Width field.) Make sure the "Resample using" box is still checked and enter the original pixel width of 2592 in the Width field (the Height box will automatically increase to 3888). Click OK and PaintShop Pro will up-sample the image, taking us back where we started, right? Wrong!

Take a look at the new image and you'll notice it's not quite as sharp as it was to begin with. PaintShop Pro has added new pixels in between the existing ones to bring the image up to size. The values of these new pixels are based on those of neighboring ones using a process called "interpolation." Interpolated pixels are OK if you're in a fix, for example if you need to make a large print from a small digital file, but they are no substitute for the real thing.

So you can take pixels out of a digital photo with no loss of quality, and this can help speed up printing, but you can't put them back without things starting to look mushy. What are the implications of this for storing and printing your digital pictures? If you follow one simple rule you won't go wrong. Always keep a full-sized original copy of your digital photos backed up on removable media (i.e., CD or DVD). Then you can down-sample your images for printing, emailing, uploading to the web, or whatever, but, if you need to make a full-sized print that requires the maximum image resolution, you'll always have the original to fall back on.

Printing with PaintShop Pro

Having opened the picture, make sure that the quality is the best possible and choose Print Layout from the File menu. The Print Layout dialog shows the files selected for printing in the left margin. Click "Open Template" to view your options. The default template group is Avery. This group has more than 50 templates, which cover most everyday options, but you can also make your own and save them in the template library (File > Save Template).

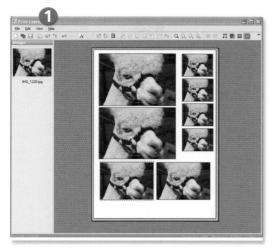

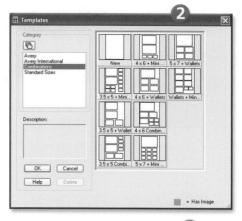

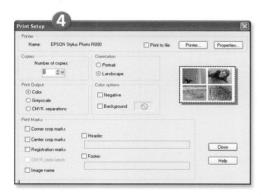

FIG 9.5 (1) Print Layout provides an easy way to print multiple copies of the same photo or a selection of photos on a single sheet of paper, saving you time and money. (2) A range of templates is available, including Avery standard sizes, so you can, for example, produce one large print for your album or for framing, and several smaller versions to send to friends. (3) You can print multiple photos by selecting thumbnails in the Manage workspace and choosing File > Print Layout. The selected images appear in a strip on the left and are dropped in position on the template layout. (4) Click the Print Setup button to change the paper orientation and add captions (though this is better done in the Print Layout dialog box). Most of the settings here are for producing film separations for commercial printing.

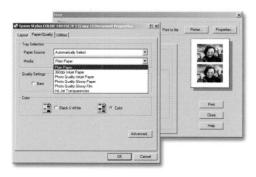

FIG 9.6 Don't forget to select the appropriate inkjet paper type. If you don't, the color may not come out as you'd hoped.

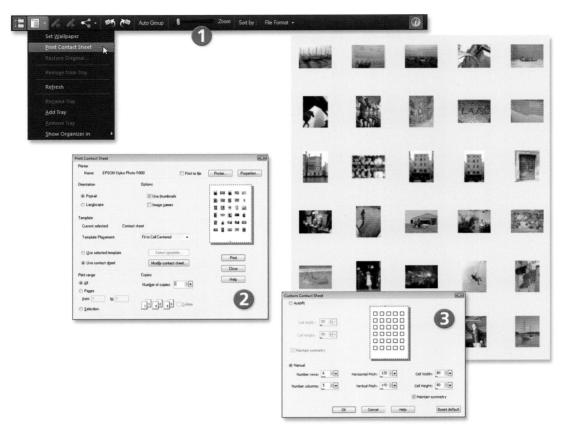

FIG 9.7 Select Print Contact Sheet from the More options menu in the Manage workspace (1) to quickly print a sheet of thumbnails for the current folder. This opens the Print Contact Sheet dialog box (2), where you can use the default template or chocse another. Click the Modify Contact Sheet button to open the Custom Contact Sheet dialog box (3) and produce your own layout. Doing this with a folder containing a large number of images may take a while.

What can you use templates for?

- · Creating unique contact sheets
- · Customizing cards, receipts, invitations, business cards, and the like
- · Making ministickers
- · Creating your own business and address labels

Color Management

If you've ever asked the question, "Why don't my prints match what I see on the computer display?" then you need to know about color management. A color management system (CMS) ensures that individual devices—digital cameras, scanners, computer monitors, and printers—all treat color in the same way so that you get consistent color from one to the other.

FIG 9.8 A color management system can help you avoid problems like unexpected variations in color from monitor to printer by ensuring consistent color from your digital camera to your monitor and finally to printed output.

To return to the original question, it is in fact impossible for your printer to reproduce exactly what's on your monitor as the two devices use different physical systems to produce color. The monitor transmits light using red, green, and blue phosphor dots (or, in the case of a liquid crystal display (LCD) panel, a fluorescent backlight passing through a colored filter), and a color print uses pigment or dye-based inks to reflect light. As we saw earlier in the chapter, color printers can use up to seven inks; even so, it is not possible for them to reproduce all the colors on your computer display. In color reproduction terms, the two devices are said to have different gamuts.

It's not just different devices that vary in the way they handle color. As anyone who has visited the TV department of a high street electrical store can verify, no two TVs look the same. A picture viewed on your PC at home will probably look different on your work PC, and if you email it to your friends each one of them is likely to see a slightly different version because of the individual color characteristics of their displays.

Color Profiles

To try and sort out this mess, an organization called the International Color Consortium (ICC), which has as its members companies like Adobe, Apple, Agfa, and Kodak, developed a system of profiling for color imaging devices. Each device has a profile that describes its color characteristics and can be read and understood by imaging software. Windows has built-in support for ICC-compliant color management.

Using ICC profiles, a color management system can accurately convert color information from one device to another. In short, this means more accurate color from your camera to your monitor and finally out to your printer. It also means that, providing they use a CMS, what everyone else sees on their monitor is the same as what you see.

Calibration

For color management to work successfully, it's important that your monitor is correctly calibrated. To do this, select File > Color Management > Monitor Calibration and complete the Monitor Calibration wizard. Once your monitor is calibrated, the next step is to ensure you have profiles installed for all of your devices, or at least for your monitor and printer. These should have been installed automatically when you installed the devices, but it doesn't hurt to check. To find out what profile your monitor is using in Windows XP, right-click on the desktop and select Properties from the contextual menu. Click the Advanced button on the Settings tab and then the Color Management tab. In Windows Vista, right-click on the desktop, select Personalize, and select Display Settings. Click the Advanced Settings button, select the Color Management Tab, then click the Color Management button.

FIG 9.9 A color management system can help you avoid problems like unexpected variations in color from monitor to printer by ensuring consistent color from your digital camera to your monitor and finally to printed output. Monitor calibration is important for accurate color management. Let your monitor warm up for half an hour before running the wizard.

In Windows 7, select Control Panel from the Windows 7 start menu, then choose Adjust screen resolution under the Appearance and Personalization heading. Click Advanced settings then select the Color Management tab followed by the Color Management button.

If your monitor profile isn't listed, click the Add button and try to find it. All Windows color profiles are stored in the folder C:\Windows\system32\spool\drivers\color. If you can't find it here, check any disks that were supplied with the monitor, or visit the manufacturer's website.

For your printer, select Printers and Faxes from the Start menu, right-click the printer icon, select Properties from the contextual menu, and click the Color Management tab. It's not always easy to identify the correct color profile from its name. Windows should automatically assign the right profile, if it's available, though you can add it manually if necessary. As with monitor profiles, if one wasn't supplied with your printer the best option is to check the manufacturer's website.

FIG 9.10 You can check the currently installed default profiles for your monitor and printer by opening the Display and Printer Properties dialog boxes.

FIG 9.11 In Basic mode (*left*), the printer driver for the Epson Stylus Photo R800 helpfully indicates the ink quantities remaining. Advanced mode (*right*) provides a range of color controls, but these should be avoided if you are using color management.

Printer profiles are less straightforward than monitor profiles because they are designed to work with a specific combination of inks and paper. A profile generated for photo-quality glossy paper is unlikely to produce satisfactory results with matte paper. Furthermore, there s wide variation in different manufacturers' paper characteristics, so a profile designed, for example, for Epson Premium Glossy Photo Paper will not provide good results with another manufacturer's glossy photo paper.

Color Management in PaintShop Pro X4

PaintShop Pro X introduced support for ICC color profiles, which has made getting consistent color from your monitor to your printer that much easier. To turn on color management, select File > Color Management > Color Management and check "Enable Color Management" in the Color Management dialog box.

FIG 9.12 Use the Color Management dialog box to turn on color management and configure your display and printer profiles.

Select your monitor and printer profiles from the pull-down menus—unless you have several profiles installed, there will be only one: the default profile for the device that you installed previously. That's nearly all you need to do.

If you have an image open, the color profile, if it has one, will be displayed at the top, after the message "Image, graphic, or text generated by:." Not all images are tagged with a profile, but if it's a photo from a digital camera it will most likely have an embedded sRGB profile.

FIG 9.13 To produce a "soft proof"—an onscreen view that accurately simulates output from your printer—check the Proofing radio button and select your printer profile from the "Emulated device profile" pull-down menu.

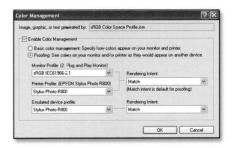

Don't worry if the image has no embedded profile; you will still be able to see how it is going to look when printed. All of the elements for a color-managed workflow are in place, and the color management system can correctly interpret the numbers in the profiled image and translate them for display on your monitor or printer using the profiles for those devices.

Despite all of this, for the reasons explained earlier, it's still not possible for the image displayed on your monitor to match that from your printer. But PaintShop Pro can show you onscreen what an image will look like when printed on your desktop color inkjet, or any other printer for which you have a profile. This is called "soft proofing" as opposed to "hard proofing," which involves making a hard-copy print.

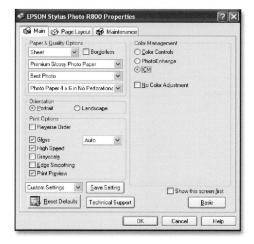

FIG 9.14 Click the ICM checkbox to enable color management using the currently installed default printer profile.

To display a soft proof on your monitor, open the Color Management dialog box and check the radio button labeled "Proofing." To see colors on your monitor or printer as they would appear on another device, select your printer in the "Emulated device profile" pull-down menu and click OK to view the proof.

Printing Using Color Management

How your Print dialog box looks will depend on the printer you are using and the driver software. The examples shown here use the Epson Stylus Photo R800 printer, but other printer drivers will provide similar options. First, make sure your image is the correct size and resolution for printing on your chosen paper as described earlier in this chapter. Select File > Print and click the Properties button on the Print dialog box.

The Stylus Photo R800 driver provides Basic and Advanced options. It also provides an extremely useful graphical representation of the ink levels. Click

the Advanced button and select the paper type, size, orientation, and other print options.

On the right-hand side of the dialog box you'll find the Color Management settings. In Color Controls mode you can alter the brightness, contrast, saturation, and color balance of the print output using the slider controls. Only use these controls if you don't want to use color management. Photo Enhance mode allows you to apply a number of effects to the printed output, including monochrome and sepia toning and soft focus, canvas, and parchment texture effects.

The button we are interested in is the one marked "ICM." Click this and the driver will use the color management system to correctly interpret and print the colors in the image. Once you click the ICM button in the Epson R800 printer driver dialog box, the other color controls disappear as you won't be needing them. Don't check the No Color Adjustment box, as this is intended for use where the conversion to the printer color space has already been made in the image-editing software. There's a Save button that lets you save this configuration. I'd recommend you use it, as it's easy to miss just one thing if you have to do all this manually each time you print.

No Profile?

If you can't get a color profile for your printer and ink/paper combination, three options are available to you. You can pay a company to produce a profile for your individual setup. The way this works is that the company supplies you with a set of images composed of color swatches that you print out and return to the company. The company then analyzes these using sophisticated spectrophotometry equipment and produces a profile based on the results. This kind of profiling is very accurate because it is tailor-made for your specific printer, paper, and inks, as opposed to a generic profile. Epson provides a bespoke profiling service; details can be found on the Epson website at www.epson.co.uk. Another company that also produces printer profiles is Chromix (www.chromix.com). These services aren't cheap, but, if accurate color is important to you and certainly if you are producing images for commercial use, they are well worth the cost.

The second option is to produce your own color profiles using a device such as the Datacolor Spyder 3 Express or the X-rite eye-one display LT. These are spectrophotometer devices that you connect to the front of your monitor so that they can take readings and compile a profile. These monitor profiling devices used to be the expensive preserve of imaging professionals but are now very affordable.

If you are making prints for personal use and can't justify the cost of a profiling service or dedicated hardware, you can make your own printer adjustments. As I said at the beginning of this chapter, you will never get your printer to emulate exactly what you see on your monitor (even professional setups have to content themselves with soft-proofing—getting the monitor to show what the print will look like), but you should be able to improve an existing unsatisfactory setup.

FIG 9.15 Use a target such as this one to compare printed output with what's on your screen.

You can do this in one of two ways. Either use the printer driver's color adjustment controls to alter the color balance, or use PaintShop Pro's adjustment layers to make temporary adjustments prior to printing. In either case you will need to compare printed output to what is on your screen and for this you should use a test calibration image that displays a wide range of colors, including naturally occurring hues like sky, foliage, and skin tones. Professionals use specially designed color targets for this, but you can easily create your own, like the one pictured here. If you haven't got time to make your own, you can download this target image from www.gopaintshoppro.co.uk.

Step-by-Step Projects

Printing Multiple Photos with Print Layout

Print Layout is a straightforward layout application that you can use to make multiple prints on an inkjet printer, saving time and money. Using Print Layout, you can print several copies of one photo on a single A4 sheet of paper, cut them out, and send them to friends and family. You can print out multiple photos for passport or driving license applications, or you can use Print Layout to arrange different images on the same page for quick and convenient printing. There is a range of templates, which you can adapt to fit your own needs and save for future use.

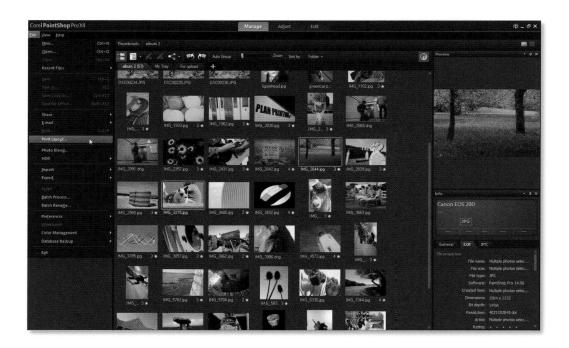

STEP 1 We're going to use Print Layout to print a selection of photos onto template pages. Select the images you want to print in the Manage workspace and select File > Print Layout. The photos you selected appear in the Images window on the left. The default template is 21.59 \times 27.94 cm. Drag the images to the layout window and size and position them.

STEP 2 If the images exceed the size of the template you will get an alert box telling you they won't fit and asking if you want to resize them. This can happen if you have not resized your image. Click OK, and they will be scaled to fit the width of the default template. Drag a corner handle to make them smaller—the proportions are automatically retained so you don't need to worry about stretching or squeezing them.

STEP 3 Don't worry too much about neatly laying everything out at this stage; just get the pictures in the layout window at roughly the size you want them. If you want to get four pictures on a template, make them slightly smaller than a quarter of the page size to allow a border around them.

Tip

If you're printing multiple images on a page for cutting out, it helps to minimize wastage if you sort your photos into landscape and portrait format and print only one kind at a time. Don't mix landscape and portrait format photos on the same layout.

STEP 4 You can position the images manually, but Print Layout has a few auto-positioning features to help out. The four buttons in the center of the toolbar will position an image in any of the four corners of the page or dead center. To the left of these, you'll find the Auto Positioning button. Roughly arrange your images on the page, click the Auto Arrange button, and they will be automatically sized and positioned for the best fit.

STEP 5 Manually arranging images like this is the best way to create poster layouts. Use the Text tool to add a headline at the top of the page and to put a caption under each image.

STEP 6 To choose a template layout, click the Open Template button on the toolbar or select File > Open Template. Select a category, click on one of the template thumbnails, and click OK. This will replace your previous layout, so, if you want to keep it, save it first using File > Save Template.

STEP 7 To add photos to the template, just drag and drop them from the Images window onto the "cells" in the template. If the image isn't an exact fit, you can drag a corner handle to resize it and drag it around within the rectangle to change the crop, or click the Fill Cell with Image button; there are buttons to help with this on the right of the toolbar.

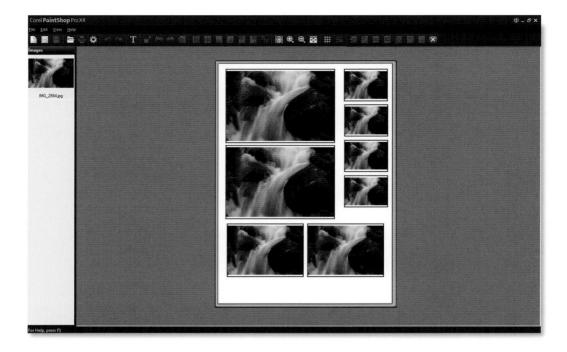

STEP 8 If you are making a page that contains only one image, click the Fill Template with Image button to copy the image to every cell on the template. Otherwise, drag the remaining images into position and resize them. Right-click on any of the images and select "Apply placement to all cells" to have the positional changes you make to one image automatically applied to all of the others.

STEP 9 Add captions using the Text tool and click the Print button on the toolbar, or select File > Print to print the page.

The Web Optimizing Images

What's Covered in this Chapter

- In this chapter you'll discover how to produce pictures for the web.
 Whether you want to share images on social networking sites like Facebook
 and Flickr, to produce a decent photo of your old camera to put on eBay, or
 to email a few snaps to friends, or whether you have something more
 ambitious in mind like an entire website, the following pages will tell you
 everything you need to know.
- If you're not sure of the difference between GIFs and JPEGs and when and how to make use of the different web image file formats, then read through the opening pages. Experiment with PaintShop Pro's GIF and JPEG optimizers and try to reproduce some of the examples shown here, and you'll soon understand what optimization is all about.
- In these days of fast broadband connections, it's tempting to think that file size doesn't matter, but even a broadband link can sometimes slow to a crawl. If your site downloads in a flash, regardless of connection speeds, you'll get and keep your visitors' interest.

Toward the end of the chapter we take a look at specialized web graphics
that make your site easier to build and maintain and provide a more
interactive experience for users. We take it for granted that websites
integrate pictures and words seamlessly, but producing images for the web
requires a little knowledge of how the web works as well as a practical
grasp of digital image-making.

Sharing Photos on the Web

PaintShop Pro X4 introduces a new feature that allows you to upload and share your photos on Facebook and Flickr. Obviously you'll need a Facebook or Flickr account to be able to do this, but, if you're part of the dwindling minority yet to have discovered social networking, here's the opportunity you've been waiting for.

These new upload features are pretty basic—they'll allow you to upload a bunch of photos, but that's about it, and they have some shortcomings, which I'll discuss as well as looking at ways to overcome them.

Uploading Photos to Flickr

If you want to upload your photos directly to Flickr you first need to authorize PaintShop Pro X4 for access to your Flickr account. This happens automatically the first time you attempt an upload. First, though, you'll need to select the photos you want to upload, and the easiest way to do this is in Thumbnail mode in the Manage workspace. One way to do it is to organize all the photos you want to upload into a tray. Click the New tray + button at the top of the Organizer and give the tray a name. Select the folder containing the images you want to upload in the Navigation palette (Ctrl-click to add to your selections), then drag them to the tab of your new tray and drop them in.

FIG 10.1 Organize all the photos you want to upload into a tray, click on one thumbnail, then press Ctrl + A 10 select all. Create a new tray, and drag the images to its tab.

With the contents of the new tray visible in the Organizer, press Ctrl + A to select all, then click the Share button on the Organizer toolbar and choose Flickr from the menu. A window like the one in Figure 10.2 will appear; enter your Yahoo login details and click the Sign In button. Next, Flickr will ask you to authorize PaintShop Pro to access your Flickr account and upload, edit, and delete photos; click OK to agree to this and the Social Sharing window, shown in Figure 10.3, will appear with your selected photos ready to upload. In the future, you'll come straight to this without having to go through the login and authorization screens.

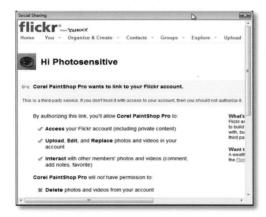

FIG 10.2 The first time you upload photos to Flickr, you'll be asked to authorize PaintShop Pro to access your Flickr account. You can later withdraw the authorization if you decide you no longer want to use PaintShop Pro to upload photos to Flickr.

At the top of the Social Sharing panel you'll see your Flickr user name; click the button on the right if you want to log in as another user—this is useful if you have more than one account or your computer and PaintShop Pro X4 are shared. The Save to Album pull-down menu should list all of your Flickr sets (for some reason, Corel likes to call Flickr sets "albums" instead of giving them their proper name), but only your public sets are shown here. If you have sets containing photos that are private (viewable only by you, friends, and family), they won't appear in this list.

That leads us to a more serious privacy issue with the PaintShop Pro X4 Flickr uploader—you can't set privacy preferences. Any and all photos you upload to Flickr from PaintShop Pro X4 will, at least initially, be public. Once your photos are uploaded you can visit your photostream in your web browser and edit the privacy settings (fortunately Flickr makes this easy and I'll show you how to do it in a moment), but I think that this is a pretty serious omission and hopefully one that Corel will address soon.

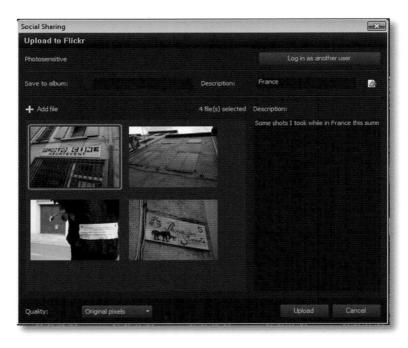

FIG 10.3 The Social Sharing dialog with a tray of photos ready to upload to Flickr.

In the meantime, the best you can do is upload your photos, then immediately change the permissions on the Flickr website using your browser. Your photos will only be publicly visibly for the time it takes between uploading and changing the permissions, but, if absolute privacy is important to you, I'd recommend you use the Flickr uploader.

Even though you can't see sets with private photos, you can create a new set by clicking the New Album button. Of course, you don't have to add photos to a set at all, in which case they'll just appear in your photostream. The only thing that remains to be done is to select the maximum size of your uploaded photos from the Quality menu at the bottom. If you leave this on the default, "Original Pixels," then the largest size will be the same as the original. If you'd rather restrict your Flickr uploads to smaller images, choose one of the options from this menu; 1280 pixels is plenty big enough for display on most screens, and Flickr will automatically create smaller versions as usual. Now all you have to do is press the Upload button and wait for the process to complete. When the upload is finished, an alert box will appear to tell you so.

If you do decide to upload your photos to Flickr from PaintShop Pro X4, here's how to change the permissions for the whole batch. Launch your browser and sign in to your Flickr account. From the Organize and Create menu, choose Most Recent upload and your newly uploaded photos will appear in

the Batch Organize window. Select "Who can see, comment, tag?" from the Permissions menu and make the appropriate selection from the popup box—for example, check the Only You (private) radio button plus the "Your friends" and "Your Family" checkboxes—then click the Change Permissions button.

FIG 10.4 Though you can't assign privacy settings to your pictures when uploading from PaintShop Pro to Flickr, you can easily do so subsequently using Flickr's batch organize feature.

If at some point you decide you no longer want to use PaintShop Pro X4 to upload photos to Flickr, you should deauthorize the permission you granted for the application to access your Flickr account. You do this on the Flickr website. Select Your Account from the You menu, and click the Sharing & Extending tab at the top of the page. Scroll down to Account links and click the Edit link on the right. Click the "Remove permission?" link opposite Corel PaintShop Pro and follow the instructions on the next page. If you want to reenable permission for PaintShop Pro, you can do so by following the process described at the beginning of this section.

Uploading Photos to Facebook

PaintShop Pro X4 also provides a convenient way to upload photos to Facebook. As with Flickr, the best way to organize this is to create a new tray

containing all the photos you want to upload (discussed earlier), then click one of the thumbnails, press ${\sf Ctrl} + {\sf A}$ to select all, and choose Facebook from the Share button on the Organizer toolbar.

Now you'll need to sign in to your Facebook account. Enter your details and click the Login button, then click the Allow button to let PaintShop Pro access your Facebook account. Once you've done this, you'll be presented with the Facebook upload screen. You only need to do the authorization stuff once, then you'll come directly to this window when you select Facebook from the Share menu.

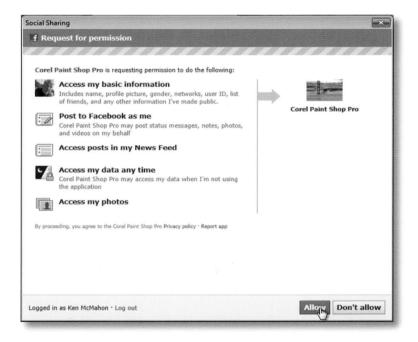

FIG 10.5 The first time you upload photos to Facebook, you'll be asked to authorize PaintShop Pro to access you'r Facebook account. You can later withdraw the authorization if you decide you no longer want to use PaintShop Pro to upload photos to Facebook.

All the pictures you selected are shown in this window. You can add more by clicking the Add File button, but then you need to locate the image files on your hard drive, which isn't very clever. If you don't have all the photos you want, the easiest way to get them is to hit the Cancel button and redo your selection in the Manage workspace.

You can select an existing Facebook album to upload your images to or create a new one, and, as with the Flickr uploader, you can also select from one of the available resizing options. The other thing you can do here is add a description to each picture by selecting it and filling in the Description field.

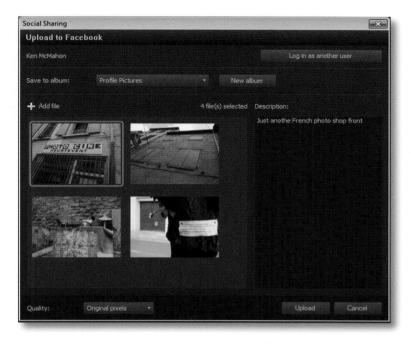

FIG 10.6 Uploading to Facebook works a little better than the Flickr uploader. You can add photos to existing albums, create new ones, and add a description for each photo.

When all is ready, click the Upload button. The photos will be uploaded to the album you selected using your default privacy settings and an alert box will appear to tell you when the upload is complete. If you're uploading a lot of photos or have a slow connection this could take several minutes.

Once your photos are uploaded to Facebook, you'll need to log in to your Facebook account using your browser if you want to view your photos, change the privacy settings, edit, or delete them.

Creating Your Own Images for the Web

Social networking sites have made it easy to upload and share photos, but PaintShop Pro X4 has a range of tools that you can use to prepare photos for your own websites. If you have your own business website, or a blog, or you want to upload photos to an online forum or auction site or enter them for a competition, you'll want to produce the best possible quality of image without creating an enormous file. The rest of this chapter is devoted to the tools PaintShop Pro X4 provides to help you do just that. Even if you're content to use the Share button to upload and email photos, you might find the explanation of web files formats and image compression useful.

How the Web Displays Images

You're probably aware that web pages are written in HTML (Hyper Text Markup Language) and that your web browser interprets that code to display formatted text and pictures on your screen. To see what HTML looks like, in Internet Explorer select View Source from the Page menu. You don't need to be able to write or even understand HTML in order to produce web pages, as there are plenty of applications that will help you do this while keeping the code at arm's length.

Picture files are loaded into a browser page by HTML code, which looks something like this:

```
<imq src="images/pelican_02.GIF" width=234 height=53>
```

The HTML code tells the browser what the image is called, where to find it on the server, and what size it is. Once the browser interprets this line of code, it will download the image and display it.

FIG 10.7 You can display the HTML code for the currently displayed browser page by selecting View Source from the Page menu in Internet Explorer. The source code is opened as a text file in Notepad, where you can edit and save it.

If it's a large image, or if the PC on which the browser is running accesses the Internet via a slow connection, it could take a while for the image to download and display, and trying to keep this delay as short as possible while maintaining good image quality is the main aim of web image editing.

The first, and most often overlooked, method of reducing image file size is to reduce the size of the image itself. The resolution of most display monitors is around 100 pixels per inch (ppi), so the first thing to do is open the Image Resize dialog and change the resolution to 100 ppi. If you work at a higher resolution than this, your images will simply appear bigger on the web page. Because of this, most web designers prefer to work in pixels rather than other units and, if you are doing a lot of web work, you should try to get into this habit. If you make an image 100×100 pixels, it will be roughly an inch square on screen.

If you want to include big images, link them to a smaller thumbnail and give your viewers the option to sit through a lengthy download if they wish. Another effective but little-used file-shrinking strategy is to aggressively crop images. Get rid of extraneous background detail and crop right in on the subject.

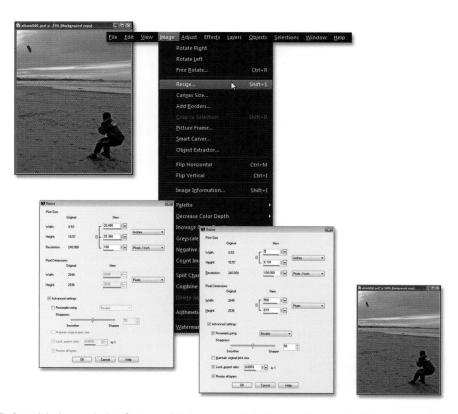

FIG 10.8 The Resize dialog box provides lots of options, and it's important to pick the right ones. First, check the "Advanced settings" box, uncheck the "Resample using" box, and enter 100 pixels per inch in the Resolution field. This 5-megapixel image would be approximately 20×25 inches on a web page if we didn't down-sample it. Check the "Resample using," "Lock aspect ratio," and "Resize all layers" boxes and enter the 100 ppi size in the Width box of the Print Size pane. Click OK, and view the image at 100% to see how it will look on the web.

FIG 10.9 If you want to upload larger images, link them to a page of thumbnails so visitors can pick which ones to view and not be overwhelmed with lengthy downloads.

Web File Formats

Nearly all images on the web are saved in one of two file formats: JPEG and GIF. If you own a digital camera, you'll know about JPEG even if you don't know much about the web. GIF has been around even longer than JPEG and is used pretty much exclusively for web graphics. There's a rule of thumb that says you should use JPEG for photographic images and GIF for graphics with flat color and, like most rules of thumb, it's a good one 99% of the time, but there are situations when it's best ignored. As always with web images, the objective is to produce the smallest possible file size while maintaining the best possible image quality. By experimenting with both JPEG and GIF compression, you'll soon learn what works best for particular images.

If you look hard enough, you'll find some web images that are saved in the PNG format. This relative newcomer was introduced in an effort to combine the strengths of JPEG and GIF and eliminate some of their shortcomings. Despite some advanced features, like drop shadows and support for layers, PNG has never really taken off, though you can easily create PNG files using the PNG Optimizer from PaintShop Pro's Web toolbar.

JPEG in Depth

JPEG is actually a compression algorithm, a process that reduces the size of digital picture files, but it's come to be used to describe the file format that uses it. JPEG is a lossy compression method, which in plain English means that when you use it some loss in quality occurs and the compressed file won't look the same or as good as the original. Compression algorithms that maintain the exact same data and image quality are called "lossless." Although JPEG doesn't offer lossless compression, at low compression settings it comes pretty close. A newer version of JPEG, called JPEG 2000, provides a lossless option as well as other advantages, but, like PNG, hasn't gained widespread support. JPEG is pretty good at removing quite of lot of picture detail, and thereby considerably reducing file size without anyone noticing, because the algorithm is designed to remove the kind of color information that the human eye doesn't perceive that well. You can compress image files by a factor of about three and you would have to look very hard to spot any degradation in image quality.

Using the JPEG Optimizer

Most image editors, and PaintShop Pro is no exception, leave it to you to make the decision about how much compression to use. It's up to you to decide just how much image quality you are prepared to sacrifice in return for smaller file sizes.

To make this decision you need to know two things. What will the image look like if you compress it using a given JPEG setting? And how long will it take to download? The answers can be found in PaintShop Pro's JPEG Optimizer, which you launch by clicking the JPEG Optimizer button on the Web toolbar or selecting File > Export > JPEG Optimizer.

The JPEG Optimizer has three tabs—Quality, Format, and Download Times—and Before and After preview windows. Make sure the preview is set to 100% view so you can see the image exactly as it will appear on the web page; enlarge or maximize the dialog if necessary. Enter a number between 1 and 100 in the "Set compression value to" box, or use the slider. The higher the value entered here, the more compression is applied, resulting in a smaller, lower-quality image: 1 is virtually no compression, you'll start to see the preview deteriorate at around the 20 mark, and beyond 60 things will start to look very bad indeed.

Bear in mind that these figures are not percentages, and if you enter the same values in a different web optimizer you're unlikely to get similar results. These values just represent PaintShop Pro's maximum and minimum JPEG compression settings.

Tip

The most effective way to reduce the size of images is to crop them. A good-quality, closely cropped photo is always better than a highly compressed one with lots of extraneous detail, so get into the habit of making the Crop tool your first step in web image preparation.

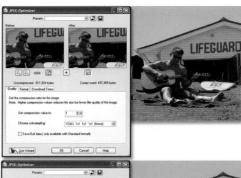

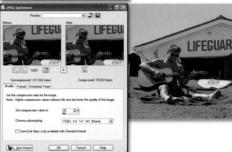

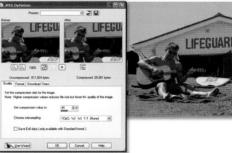

LIFEGUAR

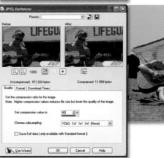

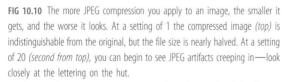

Increase the compression setting to 40 (third from top) and the file size drops to a mere 25 Kilobytes (KB)—down from an original 784 KB. On a cable or DSL Internet connection, this would take a fraction of a second to download, but the image quality has suffered badly, with JPEG blocking visibly just about everywhere you look.

If 40 is a step too far, 80 (at the bottom) is just ridiculous. It's interesting to note that, beyond a certain point, not only does the image quality suffer horrendously but file size savings get correspondingly smaller. A setting of 20 slices 670 KB from this file; increasing it to 80 gains you only another 53 KB.

Judging Picture Quality

Just below the Before and After preview windows you'll see two figures. The left-hand one under the Before window says "Uncompressed" followed by the file size in bytes and, on the right, the compressed size is given, again in bytes. Notice that, even at the lowest compression setting of 1, the size of the compressed file is only about half to one third of that of the uncompressed one. If you want the approximate file size in kilobytes, just divide by a thousand. Generally speaking, compression settings in the range of 10 to 30 will give acceptable-quality images with high compression ratios, but let your eyes be your guide and as soon as the image becomes unacceptably grubby drag the slider back toward the low side.

Feel free to experiment with the various Chroma subsampling presets on the pull-down menu, though it's unlikely you'll achieve any improvement by changing this setting. Even the PaintShop Pro Help file recommends leaving it on the default setting.

Use the Format tab to select either Standard or Progressive format; the latter preloads a low-quality preview into the browser so that the viewer has something to look at while waiting for the real thing. With the standard format, nothing is displayed until the entire image is downloaded.

Estimating Download Time

The Download Times tab provides the answer to our second question. In actual fact it provides several answers, any one of which might be true, depending on the kind of link visitors to your website are using to access the Internet. Four download times are displayed. These provide a guide to the time it will take to download the optimized file on links operating at 56, 128, 380, and 720 kilobits per second (Kbps).

It's a little disappointing that Corel has passed up the opportunity to update the JPEG Optimizer for several years now, with the result that the download speeds in the JPEG Optimizer are looking pretty archaic. For example, 56 Kbps is the speed at which someone using a modem connects to the Internet; 720 kbps would be the speed of a very slow broadband connection. These days, most web connections are broadband ones operating at speeds measured in megabits per second (Mbps) rather than kilobits and, depending on where in the world you live, average broadband speeds are in the 5 to 20 Mbps range and getting faster all the time.

Of course, a 10 Mbps line doesn't guarantee 10 Mbps transfer rates. Speeds could be affected if the line is shared via a network router, or if there's Internet congestion, or if the server can't cope with the level of traffic. So, regardless of the increase in the speed of net connections, it still makes sense to optimize your images.

Tip

You can increase the JPEG compressibility of images by blurring them slightly before compressing them. A small degree of blur softens the contrast in edge detail, which is where JPEG artifacts are most noticeable. Use the Gaussian Blur filter with a radius of between 0.5 and 1 before JPEG optimizing.

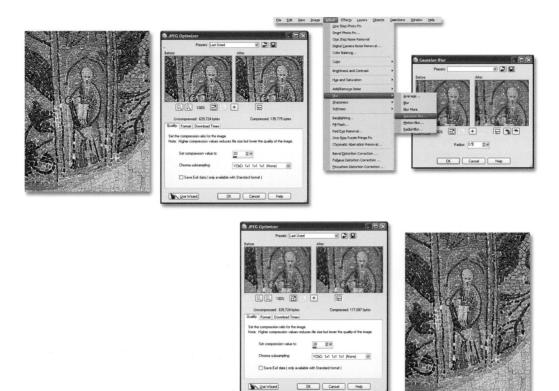

FIG 10.11 Compressing the original (top left) with a compression value of 20 produces a 135 KB JPEG. By first applying the Gaussian Blur filter with a radius of 0.5, compressing with the same settings produces a file that is 20 KB smaller. The resulting image is slightly softer but perfectly acceptable.

It's good practice to ensure that most people can access your site without having to wait all night for the images to download, so, if the JPEG Optimizer is telling you that just one of the many images that may end up on your home page will take several seconds to download on a 720 Kbps link, you need to think about how you are going to speed things up. As a general rule, you can use the 720 Kbps readout to estimate the worst performance someone on a broadband connection is likely to experience.

Once you're happy with the quality and size of the optimized file, press the OK button to save the file.

GIF in Depth

Whereas JPEG images are full-color 24-bit files, GIFs make use of an indexed color palette to help keep file sizes down. Each pixel in a JPEG file needs 24 bits (or 3 bytes) of data to describe it. But the same pixel in a GIF needs only 8 bits and in some circumstances even fewer. GIF does this by referencing each pixel to a color lookup table, or palette. The palette has 256 colors. The first color is numbered 0, the next 1, and so on all the way up to 255; to describe the color of a pixel, all you need is its number and, as there are only 256 possibilities, 1 byte is sufficient to describe them all.

One shortcoming of this approach is that, compared with the 16 million or so colors that a 24-bit format like JPEG can display, 256 seems a bit meager. This is one of the reasons GIF is often recommended for graphics images that contain very few colors. Indeed, some graphics contain far fewer than 256 colors, and in such cases it's possible to make further file size economies by reducing the color palette to as few as four, or even two, colors. A four-color palette can be defined with 2 bits. That's 2 bits for every pixel in the image compared with 24 for JPEG—a massive saving.

Although 256 colors may not sound like a lot, it's surprising how little image quality suffers when you convert even complex photos containing lots of colors into GIF format. GIF can also expand the palette of perceived colors using a process called "dithering" in which colors are combined to produce intermediate hues.

Once the palette has been defined, GIF further reduces the file by applying a lossless compression algorithm called "LZW" (after its creators—Lempel, Ziv and Welch). So, GIF has two methods of reducing image file size: color palette reduction and LZW compression. Typically, LZW compression reduces the file size by a factor of two—in other words, halves it—so most of the work involved in reducing GIF size involves making careful choices about how the color palette is created so you can represent all the colors in your image with the smallest possible palette.

Using the GIF Optimizer

To open the GIF Optimizer, click the GIF Optimizer button on the Web toolbar or select File > Export > GIF Optimizer. Expand the window so you can see the previews at 100%, and click the Colors tab. The first input field, "How many colors do you want?," lets you specify, well, just that. The maximum and minimum values depend on the method of color selection and there are four choices here: Existing Palette, Standard/Web-safe, Optimized Median Cut, and Optimized Octree.

Tip

Avoid using drop shadows on images that you intend to convert to GIF. It's impossible to render subtle gradations of tint with a limited color palette.

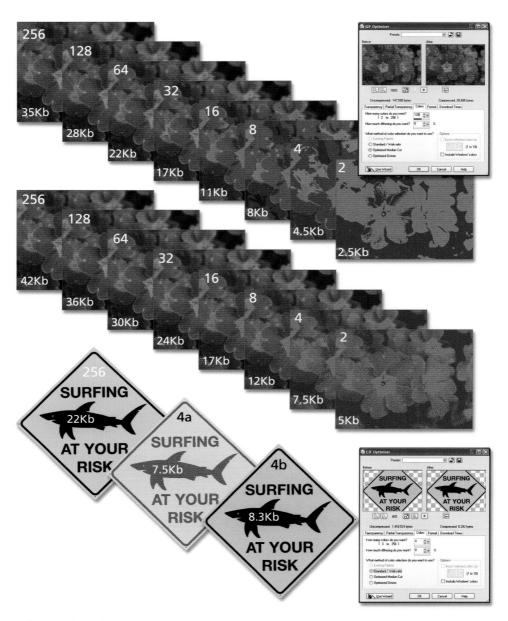

FIG 10.12 The top row shows what happens when you progressively reduce the GIF color palette from 256 to two colors. The second row shows the same process with 100% dither selected. GIF is best suited to graphic images like the bottom one. Reducing the palette to four colors produces little noticeable quality loss because there were few colors to begin with. The GIF Optimizer doesn't always select the best cclor palette (4a). In this case choose Image > Decrease Color Depth > X Colors, then optimize using the existing palette (4b).

The Existing Palette option will be grayed out unless the image was an 8-bit indexed image to begin with, or you converted it prior to opening the GIF Optimizer. The Standard/Web-safe option uses a palette of standard colors devised to provide the best viewing experience for those using Internet Explorer or Netscape on an 8-bit display, but, now that 24-bit color displays are commonplace, this isn't such an important consideration and you can safely ignore this setting—unless, of course, it provides better results than the others.

Optimized Median Cut and Optimized Octree are two different algorithms designed to derive the most representative palette of 256 colors from all of those in the unoptimized 24-bit image. If your existing image contains only a few colors, use Optimized Octree; if you want to reduce the image to fewer than 16 colors, use Optimized Median Cut.

For now, select Optimized Median Cut and drag the slider under the "How many colors do you want?" box as far as it will go to the left until the box contains the value 2. This is what your image will look like if it's displayed with 1 bit per pixel, allowing two colors. Unless there were only two colors to begin with, the odds are it will look terrible. Highlight the "How many colors do you want?" box with the mouse and enter the value 4. Things will look a little better, but not much. Double the number of colors to 8, then 16, 32, 64, 128, and finally 256, taking a look at the compressed preview each time.

Dare to Dither

Assuming your original image was a color photo, it probably will have begun to look something like normal when you got to 16 or 32 colors. Even so, some of the colors may not look right and you may get "banding"—discrete bands of color where the original showed subtle gradations—in skies, for example. What's happening is that the original colors in the image are being mapped to the closest one available in the palette, which is one of the reasons GIF is a poor choice if your original contains lots of colors (but a good one if it only contains a few).

There is something you can do about banding. Enter 100 in the box marked "How much dithering do you want?" This will considerably reduce and perhaps even eliminate the banding and posterization, but will also introduce a speckly graininess into the image, which you may find no more acceptable than the banding. Another drawback is that dithered files are slightly larger than undithered ones. By dragging the dithering slider, you should be able to reduce the graininess to an acceptable degree without reintroducing the banding.

Try Transparency

One useful feature of the GIF format is that it supports transparency. You can tell the Optimizer to use the existing image or layer transparency, or define a color from within the image as transparent. The advantage of including transparent areas in the GIF is that you can place irregular graphics—logos or text, for example—over different backgrounds on your web page and the background will show through. The Partial Transparency tab of the GIF Optimizer provides sophisticated controls to deal with semitransparent pixels (for example, those around the edges of antialiased text), which can cause problems.

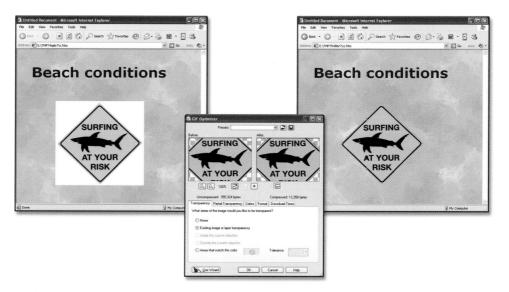

FIG 10.13 The Transparency tab of the GIF Optimizer allows you to use existing layer transparency, or specify a color from the image (usually the background). Use the Partial Transparency tab to specify a blend color for the edge pixels that is similar to the background on your web page.

Whatever file format you choose, Optimization is a trial-and-error process. Every image is different, and, although you can batch process similar images using the same settings, if you want to get the best possible quality at the smallest file size you will need to give each one individual attention, selecting the settings you think will provide the right balance between quality and download times, and then fine-tuning depending on what you can see in the Optimizer preview window.

Step-by-Step Projects

Protecting Your Photos

Adding a Copyright Message and Watermark

If you're going to put your photos on the web, you need to be prepared for the risk that they may be used without your permission. Horror stories abound of how people's snaps have ended up on advertising hoardings or worse, and, though you can't entirely avoid the risk (except by not uploading your photos), there are some steps you can take to reduce it. In this step-by-step project, you'll learn how to add a copyright message to your photo file metadata that tells people they can't use it without your permission. We'll also look at how to add a discrete, but visible, watermark.

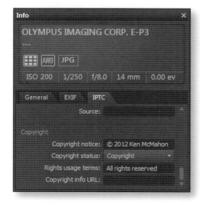

STEP 1 First, add a copyright statement to your image metadata. You should add this to all your photos as a matter of course. Select the IPTC (International Press Telecommunications Council) tab in the Info palette and scroll down to the copyright pane. In the Copyright notice field type "©2012 Ken McMahon" (substituting your own name and the correct year). To add the © copyright symbol, hold down the Alt key and type 0169. Select Copyright from the Copyright status pull-down menu and type "All rights reserved" in the Rights usage terms field.

STEP 2 Now we're going to create a semitransparent watermark that will appear across the bottom (or wherever you want) of your photos using the same type effect described in Chapter 7. This time, though, we're going to save the process as a script so you can add it to other images. First, you need to display the Scripts toolbar; from the View menu Select Toolbars > Script. Then click the red record button on the Script toolbar to begin recording. From here on in, everything you do is recorded, so don't mess up! If you do, you'll have to press the cancel script recording button (the X button to the right of the record button) and start again. If you're not sure about a step, you can click the Pause Script Recording button, try it out, then undo back to where you were before unpausing and continuing.

STEP 3 Duplicate the background layer. This is just a precautionary step in case anything goes awry. Eventually you'll "Save as" to create a new watermarked file. Right-click the background layer in the Layers palette and select Duplicate.

STEP 4 Now click the Set to Black and White button in the Materials palette. It's important not to skip this step even if the colors are already set to the black-and-white defaults as this may not be the case when you run the script in the future. As we'll be making a selection from the text, the color doesn't actually matter, but it doesn't hurt to get into the habit of being thorough when recording scripts.

STEP 5 Select the Text tool and type your watermark message; for mine I've used the copyright statement "©2012 Ken McMahon." Choose a bold typeface, and make the type big enough to be clearly visible but not so large as to overwhelm the image. Click the Apply button on the Tool Options palette to approve the text, then select the Pick tool and position it.

STEP 6 With the text box still selected, go to the Selections menu and choose "From Vector Object" to turn the text into a selection (or press Ctrl + Shift + B). You should now see the selection marquee surrounding the text. Select the Copy of Background layer in the Layers palette, and turn off the text layer by clicking its visibility (eye) icon.

STEP 7 Select Effects > 3D Effects > Inner Bevel to apply a bevel effect to the Copy of Background layer using the text selection. The default bevel is a bit clunky, so I've reduced the width to 2. Click OK to apply the bevel, then press Ctrl + D to deselect all and get a proper look at your handiwork. For the sake of tidiness, you can now delete the Vector 1 type layer.

STEP 8 Press the Save Script button at the end of the Script toolbar, and when prompted for a name type "Add Watermark." Now you can add the watermark to any image with a single click by selecting it from the pull-down menu in the Scripts toolbar and clicking the Run Selected Script (play) button.

STEP 9 If you can't get to grips with script recording (or can't be bothered!), you can get the Add Watermark script from the gopaintshoppro.co.uk website. I also provide details on how to edit it to add your own custom message as well as how to use batch processing to watermark an entire folder of images at a stroke.

Appendix 1 Jargon Buster

Use the jargon buster to increase your understanding of the digital techniques discussed in this book.

- **Adjustment layer** A special layer that permits users to change a wide range of elements in the picture (tone, etc.) without affecting the rest of the layer data. Ideal for experimentation, as you can have as many adjustment layers as you have the time for and they never change the integrity of the original image data.
- **Batch (processing)** Technique for applying the same photo editing action to more than one file at a time.
- **Bezier curve** A type of line used to draw vector objects. The shape of the line is altered using control handles, making it possible to draw any irregular shape. See **Vector**.
- Bit The smallest unit of computer information.
- **Bit depth** The number of bits used to represent each pixel in a digital image. A 16-bit image can hold more information (and, therefore, tonal detail) than an 8-bit one.
- **Bitmap** Term describing a digital image made from pixels laid in a grid pattern.
- **Blend mode** Blend modes alter the way pixels react with each other. Especially useful for creating effects between layers in a picture. Many tool actions can also be heavily influenced by changing their respective blend modes before applying them to the canvas.
- **Blown highlights** Term used to describe highlights (usually skies) that have been overexposed and lack any detail (i.e., are totally white).
- Burn (tool) Brush-driven technique for increasing the local density in a picture.
- **Canvas** The entire picture area. Enlarge the canvas of a picture and you add pixels to its overall dimensions, although the picture itself never changes size.
- **CCD** Charge-coupled device—the digital sensor (the "film" equivalent) found in a scanner or digital camera. CCDs are made up of light-gathering photosites. The more photosites in the CCD, the higher its resolution. Some digital cameras now use complementary metal-oxide semiconductor (CMOS) sensors.
- **Chromatic aberration** A lens defect that causes (often purple) colored fringes to appear on high-contrast edges. PaintShop Pro's "One Step Purple Fringe Fix" deals with it.
- **Clone (tool)** Cloning is used simply to copy and paste pixels from one part of a digital image to another so that it can be repaired, retouched, or replaced.
- **CMYK** A system of color representation that uses cyan (C), magenta (M), yellow (Y), and black (K) to produce all colors. CMYK is the basis for most commercial color printing.
- **Colorize** Effect that changes a color image to monochrome and then adds a single color tint. Similar to a duotone.
- **Color profile** A file describing the color characteristics of a device such as a camera, scanner, monitor, or printer.

- **Color Management System (CMS)** A means by which color can be consistently displayed across a range of devices (e.g., from your camera or scanner to your monitor or printer). A CMS "translates" color data using color profiles for each device.
- **Contrast** A measure of the tonal values in a picture between black and white. The fewer the tones, the higher the contrast.
- **Cropping (tool)** The Crop tool is used to remove or cut pixels from a digital image. Cropping reduces the total file size.
- Curves Sophisticated tool for adjusting image contrast and brightness.
- **Deformation (tool)** Technique used for distorting, rotating, turning, and bending objects on a layer.
- **Dialog (box or window)** A generic term describing a window that displays certain controls or options within a photo editing program.
- **Displacement map** A grayscale image that is used to displace pixels in a photo to give the appearance that the photo has been projected on an uneven or textured surface. Displacement maps can be used effectively to make text look like it has been painted onto an object.
- **Dither** A technique used to provide the illusion of additional colors in low-bit-depth images such as GIF files. See **Indexed color**.
- **Dodge (tool)** Brush-driven technique for reducing the local density in a picture.
- **Dots per inch (dpi)** System of measuring the pixel spread in an image. The higher the dpi value, the clearer the detail in the photo.
- **Feather** Process of softening or blurring the edges of a selection. Feather is typically used to produce a vignette effect, where the edges of a photo fade away rather than having a well-defined, crisp edge. Feathered selections are also used to soften the boundary of effects filters.
- **File format** The form in which a computer, scanner, or camera saves digital data. Each file format has slightly different characteristics. For example, .jpg files are ideal for storing many pictures in a small space (as they can be compressed) whereas .tif files are there for preserving the best possible image quality.
- **Filter** A preset software action that applies a certain effect to a digital file, layer, or selection. Most filter effects can be adjusted through their respective dialogs. Examples include Digital Camera Noise Removal, Gaussian Blur, Soft Focus, and Unsharp Mask.
- Flat (contrast) Term used to describe a photo with low contrast levels.
- **Flatten (layer)** Command used to "squash" all layers into one document so that it can be resaved in another, nonlayered, format, like JPEG.
- Gamma (adjustment) Term given to the brightness values in the image.
- **Gaussian blur** A type of blur filter. Can be used to soften the edges of shadows and to produce out-of-focus effects.
- GIF (file) A special file format used for saving and displaying graphics on the Internet.
- **Grayscale** An image type that contains only shades of black and white. An 8-bit grayscale contains 256 tones from black (0) to white (255). Grayscale images can't contain color data, so to add, for example, colored text, they must first be converted to 8-bit RGB.
- **Grids/guides** Lines that can be overlayed on a photo to aid positioning of elements (e.g., text) but that do not print. Snap to grid/guides pulls dragged objects onto guides like a magnet when they get close.

- **Halftone** A method by which photos are prepared for commercial printing that involves applying a screen. The screen enables the range of tones and colors to be reproduced on a printing press using different-sized dots. PaintShop Pro has a halftone filter, but this is purely for effect and is not suitable for preparing photos for commercial printing.
- **High Dynamic Range (HDR)** A composite image made from several photos taken with different exposure settings and capable of displaying the entire dynamic range of a high-contrast scene, from dense shadows to bright highlights.
- **Highlights** The brightest tones in a photo, represented on the right-hand side of a histogram.
- **Histogram** A graphic representation of the tones captured in a scan or digital photo. Represented as a mountain range where the darkest tones lie to the left-hand side of the range and the highlights to the right.
- Hue Another word for color (values).
- **Hue/Saturation/Lightness** A system of representing colors using three values—one each for hue, saturation, and lightness. Also the name of a PaintShop Pro feature that allows you to change the hue, saturation, and lightness values for all or a specific range of colors in a photo.
- Indexed color A system that allocates color in an image using a palette usually consisting of 256 colors that can be referenced in a single byte (8 bits). Indexed color images (e.g., GIF files) are usually smaller than equivalent 8-bit file types like TIF or JPEG and are therefore well suited for web use. See GIF.
- **Interpolation** The process of increasing image resolution by adding pixels. The new pixels' values are based on those of neighboring pixels.
- JPEG (file) A type of file used to save and store scanned images. JPEG files can be compressed (squashed) so that you can get more pictures onto a disk drive. Once opened again, they revert to the original proportions. Too much compression introduces errors or ugly "artifacts."
- Layer A second (or more) level within a single digital picture. Layers add editability to a file. Text, multiple images, masks, and special effects can be applied to separate layers, and these in turn can be edited for greater creative control. Layered documents must be saved in the .pspimage file format, but they can be flattened (layers are squashed together) so that they can be reconverted into any other picture file format like TIFF or JPEG.
- **Layer mask** Used to hold back parts of an underlying layer to create a blended or merged effect. Layer masks are simple black-and-white layers that can be edited using any of PaintShop Pro's paint or drawing tools.
- Levels Sophisticated tool for applying changes to image contrast and brightness.
 Metadata Text information included in a photo either by the camera when the picture is taken or added later. Metadata can include exposure information, date and time, title, caption, and keyword tags. The standard format for camera-recorded metadata is called EXIF (Exchangeable Image File Format) and another standard for added metadata is IPTC (International Press Telecommunications Council).
- **Midtones** The midrange tones in a photo, represented by the central section of a histogram.
- **Moiré** The odd, checkerboard pattern displayed when you scan a commercially printed document like a magazine page. Use a softening filter to remove or to soften this detrimental effect.

- **Noise** Ugly speckling apparent in underexposed digital camera images. Setting your camera to a high OSO sensitivity rating also introduces excessive noise. PaintShop Pro ships with a number of filters designed to minimize this problem.
- **Opacity** Density or translucency of an image or layer. All tools and layers have opacity settings (default at 100). This value can be lowered for more subtle effects.
- **Palette** A dialog window that relates to a specific photo editing tool. Palettes give access to a wide range of controls that permit you to fine-tune that feature. Palettes can be docked or floating.
- **Plug-in** A piece of specialist software that operates from within a host software program such as PaintShop Pro.
- **PNG** A slightly newer file format for displaying photographic data on the Internet that supports transparency. Historically, browser support for PNG has been poor, but the situation is improving.
- **Posterization** Drastically reduces the number of colors used in a picture, typically to fewer than eight colors. Produces an Andy Warhol-type visual.
- **Print resolution** Typically this is about 300 dpi for inkjets, although equally good quality is attainable from resolutions of 200 dpi and sometimes even lower.

Raster Same as.

- **Red-eye** An undesirable effect where subjects' eyes appear red as a result of flash reflecting off the eye's retina. PaintShop Pro's Red-Eye Tool fixes it.
- **Resampling** The process of changing image resolution, either by removing or adding pixels. See **Interpolation**.
- **Resolution** Typically a measurement of the number of pixels in a digital image. The more pixels there are, the more detail is visible and therefore the higher the resolution of the image.
- RGB A color system used to represent all colors by combining red, green, and blue light. When combined in equal quantities, red, green, and blue light make white, so these three colors are known as the additive primaries. Nearly all digital photo hardware and software, including your digital camera and PaintShop Pro, is based on the RGB model. See CMYK.
- **Saturation** Term used to describe the intensity of color. A fully desaturated picture, though still technically a color image, appears black and white.
- **Scripting** Technique for recording certain PaintShop Pro actions (rather like using a video recorder). Can then be replayed on other files for batch processing techniques.
- **Selection** Isolating part of a digital photo for the purposes of additional editing or the addition of special effects. Selections can be made automatically, freehand, or geometrically. Selections protect everything outside the selection marquee.
- **Shadows** The darkest tones in a photo, represented by the left side of a histogram.
- **Sharpening** A software technique used to apply the effect of making an image crisper by applying specific contrast adjustments. Too much sharpening gives files an ugly, brittle texture.
- **Solarization** Similar effect to film solarization—highlights turn to shadows and shadows to highlights. Particularly effective in color photography.
- **Thumbnail** A small representation of the original picture file. In PaintShop Pro, thumbnails are displayed in the Organizer.
- **TIFF** A file type typically used to save and store high-resolution digital scans or camera files. Unlike JPEG files, TIFF files are not lossy. This means that, though they can be compressed slightly (up to 30%), they do not suffer from image degradation or artifacts.

- **Toolbar** Generic term for the part of an application that displays certain functions. Toolbars can be docked or "floating."
- **Unsharp mask** A filter that makes photos look sharper by enhancing edge contrast. Most digital cameras have built-in unsharp masking. Even so, most photos benefit from the application of PaintShop Pro's Unsharp Mask filter.
- **Vector image** Unlike bitmap, or raster, images, vector images are represented by mathematical formulae, rather than pixels, as, for example, a circle might be described by a pi-based formula specifying the radius. In PaintShop Pro, text is produced using vectors, as are objects created using the Preset and Symmetric shape tools.
- Warp (tool) Effect used for bending and distorting parts of an image.

Appendix 2 Keyboard Shortcuts

Keyboard shortcuts are probably the last thing on your mind when learning a photo editing program—there are too many other considerations to take on board. However, learn a few of these keystrokes and not only will you increase the speed at which you can perform basic actions with PaintShop Pro but you'll also have more time to do other things—such as experiment more with your photos. Not all of the keyboard shortcuts are listed here, just some of the more useful ones. But you can find them out for yourself easily enough, as they are listed alongside each menu item.

General

Open a File	Ctrl + O
Save a File	Ctrl + S
Delete	Ctrl + Del
Undo Previous Keystroke	Ctrl + Z
Repeat Previous Keystroke	Ctrl + Y
Repeat New File	Ctrl + Shift + Z
Cut	Ctrl + X
Load New Workspace	Shift $+$ Alt $+$ L
Save Workspace	Shift + Alt + S
Delete Workspace	Shift + Alt + D
Start Screen Capture	Shift + C
Print	Ctrl + P
Сору	Ctrl + C

Paste

As a New Image	Ctrl + Shift + V
3	
As a New Layer	Ctrl + L
As a New Selection	Ctrl + E
As a Transparent Selection	Ctrl + Shift + E
Into a Selection	Ctrl + Shift + L
As a New Vector Selection	Ctrl + G

View

View: Full Screen Edit	Shift + A
view. Full Screen Edit	
View: Full Screen Preview	Ctrl + Shift + A
View: Rulers	Ctrl + Alt + R
View: Grid	Ctrl + Alt + G
View > Palettes: Brush Variance Palette	F11
View > Palettes: Histogram	F7
View > Palettes: Lavers	F8

View > Palettes: Learning Center F10 View > Palettes: Materials F6 View > Palettes: Mixer Shift + F6 View > Palettes: Overview F9 View > Palettes: History F3 View > Palettes: Tool Options F4 View: Magnifier Window Ctrl + Alt + MView > Palettes: Organizer Shift + F9

Image

Flip Image	Ctrl + I
Mirror Image	Ctrl + M
Free Rotate Image	Ctrl + R
Resize Image	Shift + S
Crop to Selection	Shift + R
Image Information	Shift + I
Load Palette	Shift + O
Decrease Color Depth > 2-Color Palette	Ctrl + Shift + 1
Decrease Color Depth > 16-Color Palette	Ctrl + Shift + 2
Decrease Color Depth > 256-Color Palette	Ctrl + Shift + 3
Decrease Color Depth > 32k Colors	Ctrl + Shift + 4
Decrease Color Depth > 64k Colors	Ctrl + Shift + 5
Decrease Color Depth > X Colors (4/8 bit)	Ctrl + Shift + 6
Increase Color Depth > 16-Color Palette	Ctrl + Shift + 8
Increase Color Depth > 256-Color Palette	Ctrl + Shift + 9
Increase Color Depth > RGB-8 Bits/Channel	Ctrl + Shift + 0

Adjust

Adjust Color Balance > Red/Green/Blue	Shift + U
Adjust Brightness and Contrast > Brightness/Contrast	Shift + B
Adjust Brightness and Contrast > Equalize	Shift + E
Adjust Brightness and Contrast > Gamma Correction	Shift + G
${\it Adjust \ Brightness \ and \ Contrast} > {\it Highlight/Midtone/Shadow}$	Shift + M
Adjust Brightness and Contrast > Histogram Adjustment	Ctrl + Shift + H
Adjust Brightness and Contrast > Histogram Stretch	Shift + T
Adjust Hue and Saturation > Colorize	Shift + L
Adjust Hue and Saturation > Hue/Saturation/Lightness	Shift + H

Layers

New Mask Layer > Hide All	Shift + Y
Select All	Ctrl + A
Select None (Deselect)	Ctrl + D
Make Selection > From Mask	Ctrl + Shift + S
Make Selection > From Vector Object	Ctrl + Shift + B
Invert Selection	Ctrl + Shift + I
Hide (Selection) Marquee	Ctrl + Shift + M
New Window	Shift + W
Duplicate (Window)	Shift + D
Fit to Image	Ctrl + W

Index

Note: Page numbers followed by f indicate figures.

Avery templates, 250-252, 251f

0 - 9

Background, 111-115, 111f, 113f, 134, 139-141, 145f, 3D Effects, 194-196, 208, 223f, 224, 234-235, 287 149-150, 161, 167-169, 180-184, 199f, 207, 16-bit support, 26, 45-48, 64, 97-102 210-211, 234, 283-288 Eraser, 139-140, 151, 180-184 A layers, 167-169 Background and Fill, 211, 211f Add Noise, 109f, 110-111, 110f, 182, 224 Backlighting, 14, 77-80, 80f Add Watermark script, 288 backups, 21, 34, 45, 116-118, 250, 285 adding basic text, 190-192, 202f Adjust menu, 11-12, 12f, 67-80, 86-96, 104-109, 144, Balls and Bubbles, 223f, 226f 150, 182 Barrel Distortion Correction filter, 221, 222f the basics of PaintShop Pro X4, 1-34 Adjust palette, 3f, 8-9, 9f, 60-65 Batch Organize, Flickr, 268-269, 269f Adjust workspace, 1f, 3f, 7-11, 9f, 35-36, 60-65, Batch Processing, 126-127, 288 67 - 73,86adjustment layers, 121-122, 161, 166f, 171-174, 172f, Bevel, 21, 22f, 195, 201f, 206-208, 287 184-187, 259 Bezier curves, 202-205 Advanced Adjustments, Learning Center, 3f, 10-11, bitmaps 27-28, 27f, 31-32, 31f see also pixels; raster... Advanced Features, 4 concepts, 190, 200 advanced layout tools, 169-171 Black Pencil, 224, 227f Advanced Options, 67-69, 86-93, 118-121, 257-258 black and white conversion filter, 26, 77, 115-118, 116f, Aged Newspaper, 223f, 227f 117f, 132-136 Black and White Film, 116-118, 117f, 199f Airbrush, 133, 215f, 216-218 Alpha channels, 140-141, 144, 146-147, 147f, 162, black and white images, 26, 69, 77, 86-93, 115-121, 116f, 117f, 119f, 120f, 121f, 132-136, 199f 168-169, 174 Anti-aliasing, 138, 192, 193f Blemish Fixer, 25 blemishes, 8-9, 23, 25, 104-107, 106f, 111-115, Apply button, 32-33, 101, 104-107, 191-192, 191f, 202f, 207, 244, 286 128 - 131Apply Editing, 20, 54-57, 56f blend modes, 112-114, 113f, 138, 173-174, 175f, 212f, Arrange layers, 171 215-220, 218f, 232-236 Blend Range, 121-122, 123f Art Erasure brush, 218-220 Art Media, 166f, 196, 218-220, 223f, 224 blending, 17, 112-114, 113f, 121-122, 123f Blur, 14, 84-85, 149-150, 149f, 182, 224, 235, 277, artifacts, 237, 275 artificial point of focus, selections, 149-150 Brightness, 3f, 9f, 12, 12f, 45-48, 60-65, 64f, 74, 74f, 98 Artistic Effects, 196, 224 Author, 41-42, 41f Brightness/Contrast, 12, 12f, 63, 64f, 74, 74f, 144, 152, Auto Arrange, 261-262 161, 173, 181 Auto Hide, 40-41 broadband connections, 277-279 Auto-Preserve Originals, 21 Browse More Folders, 38 Automatic Small Scratch Removal, 104-107, Brush Options, 218f 114 Brush size, 112-114, 113f, 139

Brush Strokes, 14, 212f, 224

В

Brush tools, 8–9, 9f, 15–16, 25, 104, 106f, 111–115, 111f, 113f, 122–124, 128–131, 143f, 146–147, 153–159, 174, 177, 212f, 215–220, 242–244	combining layers, 178 compressed images, 45–48, 94–102, 274–282 computer monitors, Color Management, 253–259, 253
Brush Variance, 128, 216 Burn, 114—115, 114f, 115f, 216—218, 235	Computer tab, Navigation palette, 5–9, 6f, 37–38, 38f 42–43
Buttonize, 14–15	contrast, 15, 80—84, 96—102, 114, 150—153, 173
	Convert RAW, 35, 102
_	Convert Text to Curves, 198–199
C	Copy Merged, 130
Calibration, 254-256, 259	copyright messages, 283–288
Camera data, EXIF tab, 40-41	Corel Painter, 23
Camera RAW Lab, 18, 21, 35-36, 45-48, 46f, 48f,	Corel Photo Downloader, 4
54-57, 61, 97-102	Correction Blend, 65
Canvas Size, 181	Crayon Art Media brush, 218—220
captions, 5, 7, 7f, 19, 35—37, 40, 41f, 49—54, 125, 251f,	Create As, 192, 199—200
262, 264	Credit, 41—42, 41f
Capture Editing, 20, 54—57, 55f, 56f, 57f	Crop Image, 32—34, 93
cartoon effects, 238–239	cropping, 8–9, 12–16, 20, 32–34, 104–107, 129, 140f
Chalk Art Media brush, 218—220	181, 273, 275
Channel mixer, 69, 116—118, 173	Ctrl + A, 40, 51, 266f, 267, 269—270
Charcoal, 224	Ctrl + Alt + N, 94
Chisel, 196	Ctrl + Alt + R, 170
Chromatic Aberration, 14 Chromix, 258	Ctrl + C, 162 Ctrl + D, 130, 150—151, 176, 208, 287
Clarify, 75, 80—84, 114	Ctrl + E, 162
Clarity, 9, 9f, 18, 18f, 63–64	Ctrl + O, 12
clipping, 26, 66f, 80–84, 82f, 94–96	Ctrl + Shift + B, 196, 207, 286
Clone brush, 8–9, 9f, 25, 104, 106f, 111–115, 111f, 113f,	Ctrl + Shift + F, 130, 192
128–131, 174	Ctrl + Shift + I, 140, 143f, 162
Coarse Draft, 124	Ctrl + Shift + M, 144, 162
Collage, 10–11	Ctrl + Shift + P, 162, 192
Collections tab, 5-9, 6f, 37-38, 40f, 41-44, 54f	Ctrl + Shift + S, 176
Color	Ctrl + Y, 83
blend mode, 173-174, 235	Ctrl + Z (Undo), 33, 114f, 126, 146, 161, 165, 171,
corrections, 8-9, 67-73	181, 187
overlay effects, 95, 121-122, 177, 185, 212f, 218f,	Curl, 225f
232-236	Curves, 75–77, 75f, 78f, 173, 198–205
picker, 211, 211f, 212f, 213f, 214f, 216, 218f	Customize, 125
Color Balance, 9, 9f, 25–26, 63, 67–69, 68f, 72, 86–93,	cutout techniques, 161–162, 196
97—102, 118—122, 119f, 126, 173, 259	
Color Changer, 22, 242—244	n
Color (Legacy), 134, 174, 175f	D
Color Management, 26, 253–259	damaged pictures, 104, 111–115, 111f, 113f, 128–131
color profiles, 254–259	Darken blend mode, 173–174, 175f
Color Temperature, 45—48, 67—73, 100, 158	Datacolor Spyder 3 Express, 258
Colored Chalk, 224	Deformation tools, 22C—221, 221f, 236
Colored Foil, 14, 223f, 225f	Delete, 49-54

depth effects, Displacement Maps, 228f, 232-236

Depth of Field, 24, 24f, 149-150

Despeckle filter, 107

Colored Pencil, 218-220, 224

combining images, 163-188

Colorize, 72, 120, 121f

Detach Object, 197–198 Digital Camera Noise Removal filter (DCNR), 14, 107–111, 107f, 108f	Export, 238–239, 275, 279 exposure problems, 8–9, 45–48, 60–61, 65, 66f, 74–77, 97–102, 150–159
Digital Noise Removal (DNR), 9, 9f, 14, 26, 65, 107—111, 107f, 108f	Express Lab, 8, 39 eyedroppers, 61–62, 62f, 91, 210–211
Displacement Maps, 228f, 232–236	
Distortion, 196, 221, 222f, 223–224, 223f, 233, 236	_
dithering, 281	F
DNR see Digital Noise Removal	F4, 112, 210
docking toolbars, 13–14	F7, 76—77, 78f, 96
Dodge, 114–115, 114f, 115f, 175f, 216–218	F10, 10
down-sampling, 249—250, 249f	F11, 216
Download Times, 275—279	Facebook, 18, 266, 269—271, 270f, 271f
dragging boundaries, 37, 49–54, 61, 86–93, 112–114,	Fade Correction, 69–70, 70f, 114
125, 144, 150, 168, 204f	feathered edges, 111–115
drawing tools, special effects, 210—211, 215—220	Feathering, 138, 144—147, 147f
Drop Shadow, 14, 21, 22f, 180—184, 195—196, 195f,	file formats, 15, 18, 21, 23, 45–48, 54–57, 167–169, 178,
201f, 202f, 279 Dry Art Madia brushos, 220	274—282
Dry Art Media brushes, 220 dust spots, 8–9, 104–107, 106f, 128–131	see also GIFs; JPEGs; PNG; PSD; PSPIMAGE; RAW; RGB;
dust spots, 6 9, 104 107, 1001, 120 131	Riff; TIFF
	File Locations, 232 File Open Pre-Processing, 26
E	File properties, EXIF tab, 40—41
Edge Effects, 224, 240—242	Fill Cell with Image, 263
Edge Preserving Smooth filter, 106f, 107–108	Fill Flash, 14, 77—80, 79f, 171
Edge Seeker, 150	Fill Light/Clarity, 9, 9f, 18, 18f, 63—64, 173
Edge Softness, 243–244	Film and Features, 24
'edgy' backgrounds, website projects, 238–239	filters, 9—12, 14, 195—196, 206—208, 221, 223—224,
Edit Mask, 20	223f
Edit Selection, 140—141, 143f, 151, 162, 166—167, 166f	Fine Tune, 159
Edit workspace, 1f, 3f, 7, 9–16, 27–28, 35–36, 46–48,	Fisheye Distortion Correction filter, 221, 222f
60, 63–64, 67, 86–102, 168–169, 240	Fit, 194, 246f
editing	flatbed scanners, 104–107, 246–247, 253–259
see also Adjust workspace; Edit workspace	Flickr, 17–18, 266–269, 267f, 268f, 269f
basic tools, 59–102	floating toolbars, 13–14
text shapes, 198–199	Flood Fill, 186, 243
Effects, 3f, 10–14, 13f, 117f, 118–121, 194–196,	focus, 17, 17f, 49-54, 92, 150
206-244, 223f, 287	Foreground and Stroke, 211, 211f, 242
menu, 223–224, 223f	Format, 275–277
toolbar, 13-14, 13f	Frame mode, 210-211, 211f, 240-242
Effects Browser, 14	Freehand, 138, 141f, 149-150, 203-205
Emboss, 14, 21, 22f, 195, 195f, 199f	functions, basic tools and functions, 4
Enhance Color Balance, 67-69, 118-121, 119f	Fur, 14
enhanced features, 16-19	
Epson Premium Glossy Photo Paper, 256	_
Epson Stylus Photo R800, 255f, 256-258	G
Epson website, 258	Gaussian Blur, 14, 84-85, 149-150, 149f, 182, 277, 278f
Eraser, 111, 139—140, 151, 180—184	General Info tab, 7, 7f, 39-42, 49-54
EXIF tab, 7-8, 7f, 39-41, 125	Geometric Effects, 224, 236

Existing Palette GIF algorithm, 279—281

Geometric Marquee selection tool, 138, 140-141, 144

Get Photos, Learning Center, 3f, 10-11, 27-28, 27f

image manipulations, 103-136 ghosting, 156, 158 GIFs, 15, 274, 279-282, 280f, 282f Image Mapper, 15 Gradient, 184-187, 211, 211f, 213f, 214f, 216, 218f image resolution see resolution graduated effects with masks, 184-187 Image Slicer, 15 grainy appearances, 107-111 improving your photos, 59-102 Graphics, 3f, 10-11, 216 Increase Color Depth, 132, 132f Info palette, 1f, 5-9, 5f, 7f, 36-37, 36f, 37f, 39-42, 39f, Gray Accent, 186 Grayscale, 116-118, 116f, 146-147, 177, 187, 236 49 - 54,283Grid, Guide and Snap Properties, 169-171, 169f infrared conversion filter, 26 ink, 246-250, 253-259 Guides, 169-171, 169f inkjet printers, 246-250, 260-264 Inner Bevel, 14, 196, 206-208, 287 н Inner Glow, 21, 22f, 195 International Color Consortium (ICC), 254, 256-257 Halftone, 223f, 226f International Press Telecommunications Council (IPTC), hand-coloring black-and-white photos, 132-136 5, 7, 7f, 26, 283 hard disk drives, 4-9 Hard Light, 95, 235 Internet Explorer, 272-273, 272f Invert, 144, 145f, 173 'hard proofing', 257 IPTC (International Press Telecommunications Council), HDR (high dynamic range) tools, 16-17, 64, 153-159 5, 7, 7f, 26, 283 Hide Mask, 139, 148, 176 IPTC tab, 7, 7f, 39, 41-42, 41f, 283 Hide Selection, 176, 176f hiding toolbars, 13-14 ISO sensitivities, 65, 94-96, 107-108, 108f High Pass Sharpen, 9, 9f, 25, 64, 83-84, 83f, 94-96 highlight recovery, 45-48 Highlight/Midtone/Shadow, 76-80, 78f, 121-122, 161 JPEGs, 15, 45-48, 94-102, 160f, 167-168, 167f, 237, Highlights, 3f, 9f, 60-65, 76-80, 78f, 96-102, 121-122, 274-279, 276f 161, 177 Histogram Adjustment tool, 74-80, 78f, 86, 94, 114, 173, Κ histogram displays, 3f, 8-9, 9f, 15-16, 60-65, 66f, 76, Kaleidoscope, 228f 86 - 93keyword tags, 5, 7, 7f. 19, 35-37, 39-40, 39f, 40f, Histogram Equalize, 76-77 42-44, 49-54 Histogram palette, 15-16, 60-65, 72, 76-77, 78f, 96 Histogram Stretch, 76-77 History palette, 15-16, 126 Hot Wax, 14 landscape format photos, 261-262 HTML (Hyper Text Markup Language), 272-273, 272f Layer Styles, 21, 22f, 194-195, 194f, 195f Hue Map, 73, 73f, 184 Layer Visibility, 197-198, 199f, 207 Hue/Saturation/Lightness (HSL), 20, 70, 71f, 72-73, 73f, Layers, 3f, 9-12, 15-16, 121-122, 130, 132-136, 144, 116-118, 116f, 117f, 120, 120f, 134, 172f, 173, 148, 150-153, 163-188, 191 184-187, 210-211, 216f, 242 concepts, 164-167, 164f, 171-173 Hyper Text Markup Language (HTML), 272-273, 272f disadvantages, 165 palette, 15-16, 121-122, 150-151, 166-170, 166f, 172f, 173, 180-184, 186, 191, 194-195, 199, 203-206, 232-236, 242, 285-286 step-by-step projects, 180-187 ICC (International Color Consortium), 254, 256-257 ICM, 257f, 258 Layers and Selections. Learning Center, 3f, 10-11, Illumination Effects, 224, 229-230 27-28, 27f

layout tools, 169-171

Image Effects, 224

image combining, 163-188

Learning Center, 3f, 10-16, 27-34, 67 Multiphoto Editing, 19-20 lens correction filters, 221, 223-224 multiple colors, 220 Lens Distortion, 228f multiple photo printing with Print Layout, 250-252, Levels, 77, 78f, 150-153, 173 Lighten blend mode, 173-174, 175f, 235 Multiply blend mode, 173-174, 175f, 212f, 235 lighting effects, 229-230, 229f, 230f, 231f My Documents, 178 Lightness, 20, 70, 71f, 72-73, 73f, 116-118, 116f, 117f, My Pictures folder, 1f, 6-7 120, 120f, 134, 172f My PSP Files folder, 178 Lights, 14, 227f, 229-230, 230f Lines and Polylines, 203-205 N liquid crystal displays (LCDs), 253 Load/Save Mask, 178, 179f Navigation palette, 1f, 5-9, 5f, 6f, 36-40, 36f, 37f, 38f, Local Tone Mapping, 173 42-44, 49-54 lossless/lossy compression methods, 275, 279 Nearly New Features, 9, 19-24 Luminance blend mode, 175f New Album, 268 LZW compression, 279 new and enhanced features, 16-19 New Mask Layer, 148, 150, 176 New Raster layer, 130, 133-134, 183 M nodes, Pen, 198-199, 202-205, 204f Magic Wand, 138, 140-141, 141f, 142f, 144-146, 145f, Noise Correction, 107-111 noise reduction, 9, 9f, 26, 45-48, 64-65, 96, 107-111, 151, 161 makeover tools, 8-9, 25, 27-28 182, 224 see also blemishes; Brush tools; scratches; spots; noise removal, 14, 107-111, 107f, 108f, 182 Suntan; Toothbrush Manage workspace, 1f, 5-9, 5f, 35-58, 67, 97, 155, 251f, 252f, 260, 260f, 266-271 manipulating images, 103-136 object cutout techniques, 161-162 Marker Art Media brush, 218-220, 219f Object Extractor, 20, 139-140, 139f masks, 3f, 9-12, 25, 148, 148f, 150, 152, 166f, 174-178, Object Remover, 25, 112-114 184 - 187Offset, 197-198 Match, 138, 146 Oil Art Media brush, 218-220, 219f Material Properties, 186-187, 211, 213f, 214f On-Image Text Editing, 20-21 Materials palette, 15-16, 16f, 111, 177, 183, 191, One Step Noise Removal, 26 196f, 200f, 210-211, 211f, 213f, 215-220, One Step Photo Fix, 15-16, 26 215f, 242, 285 One Step Purple Fringe Fix, 25 Maurellas folder, 1f opacity, 112-114, 113f, 120, 135, 170, 173, 183, Median filter, 106f, 107-108 199-200, 216, 217f, 235 menu bar, 3f, 10-12, 12f Optimized Median-Cut GIF algorithm, 279-281 merging layers, 163-188, 238 Optimized Octree GIF algorithm, 279-281 Mesh Warp, 220-221, 221f optimizing images for the web, 265-288 metadata, 1f, 5-9, 5f, 7f, 19, 26, 36-37, 36f, 37f, 39-42, see also GIFs; JPEGs 49 - 54Organizer palette, 1f, 3f, 5-10, 5f, 12, 16, 18-20, metering systems, 153-159 36-37, 36f, 37f, 45-48, 54-57, 101-102, 267, Midtones, 76-80, 78f, 121-122, 161, 236 269-270 Mixer palette, 219f, 220 Outer Glow, 21, 22f, 195 modifying masks, 177 overexposures, 45-48, 61, 65, 66f, 77-80, 97-102, Monitor Calibration, 254-256, 259 150-159 More Purple/More Green slider, 118-121, 119f overlay effects, 95, 121-122, 177, 185, 212f, 218f, Motion Blur, 84-85 232-236 Move tool, 168, 207

overview of the book, 4

P

r	down-sampling, 249—250, 249f
Paint Brush, 15—16, 133, 212f, 215—220, 215f	multiple photo printing with Print Layout, 250—252,
PaintShop Pro X4, the basics, 1—34	251f
Palette Knife Art Media brush, 218—220	resampling, 247—250
palettes, concepts, 15–16, 210–211	resolution, 246—250
Pan, 94-96	step-by-step projects, 260—264
paper, 250—252, 251f, 256, 258—259	up-sampling, 250
Paste, 167-169, 238	privacy issues, the web, 267–269, 283–288
Pastel Art Media brush, 218–220	Process button, 157, 159
paths, adding text to paths, 197-198, 197f, 198f	productivity-enhancing features, advanced layout tools,
Pattern, 184-187, 211, 211f, 213f, 214f	170
Pen, 198-199, 202-205, 204f	
Pencil, 224, 225f	Promote Background Layer, 180
perfect shadow-creation using layers, 180—184	Proofing, 234—235, 256f, 257, 258—259
Perspective Correction, 28, 31–32, 220–221	PSD, 178
Photo Blend, 17	PSPIMAGE, 46—47, 164f, 167—169, 167f, 178, 202f, 238,
Photo Effects, 117f, 118-121, 224	240
Photo toolbar, 13-14, 13f	purple fringing, 25
Pick, 197-198, 202f, 203-205, 220-221	Push, 216—218
Picture Frame, 240—242	Python, 125
Picture Tube, 237—240	
Pincushion Distortion Correction filter, 221, 222f	Q
Pixel Dimensions, 247f, 249-250	Quality, 275—277
pixels, 7, 7f, 22, 45–48, 60–65, 66f, 75–77, 80–84,	
97-102, 111-115, 122-124, 144-147, 147f,	
171-174, 190, 237-240, 242-244, 246-250	
see also bitmaps; blend modes; histogram displa	Quient memory is a first or a
raster; resolution	Zuickscript, 120
concepts, 190, 246-250, 273, 273f	_
shuffling, 247–248	R
PNG, 15, 274—275	Radial Blur, 84–85
point of focus, selections, 149–150	Radius, 80-84, 82f, 94-96, 182
Point to Point, 203–205	Rainbow mode, 210-211, 211f
Polished Stone, 14	RAM, cheapness, 166
portrait format photos, 261–262	Randomize, 85
posterization, 26, 123f, 173	raster images, 190-191, 195-196, 198-201, 206
PowerPoint, 22	see also bitmaps; pixels
Preferences, 14, 21, 170—171, 232	raster layers, 130, 133—134, 166f, 183
Presets, 32, 201, 201f, 202f, 208, 216f	ratings, 5-7, 7f, 18-19, 19f, 35-36, 39, 42-44, 49-54
pressure-sensitive stylus and tablet, 128, 133	RAW, 18, 21, 35–36, 45–48, 46f, 48f, 54–57, 61, 97–102
Preview mode, 3f, 5f, 6, 8–9, 36–37, 36f, 37f, 40–4	
49–54, 86–93, 104–107, 208	Red-Eye tool, 25, 126
Print Layout, 250—252, 251f	Red/Green/Blue, 70, 71f, 146—147
Print Layout, 230–232, 2311 Print and Share, Learning Center, 3f, 10–11, 27–28,	
	Reflection, 21, 22f, 195, 224
printers Enson Stylus Photo P200, 255f, 256, 259	Remove Specks and Holes, 151, 162
Epson Stylus Photo R800, 255f, 256—258	resampling, 247—250, 273f
inkjet printers, 246—250, 260—264	Resize, 13, 27–28, 247–250, 247f, 261, 268, 270, 273,
printing, 3f, 10–11, 13, 32, 34, 245–264	273f
Color Management, 26, 253—259	2/31

color profiles, 254-259

resolution, 7, 7f, 246—250, 273, 273f	sepia, 117f, 118–121, 125
Restore, 3f, 10-11, 27-28, 27f, 97-102	Shadows, 3f, 9f, 26, 60-65, 76-80, 78f, 96, 99, 121-122,
restoring damaged pictures, 104, 111–115, 111f, 113f,	161, 180—184, 236
128-131	shapes, 189-208
Retouch and Restore, 3f, 10-11, 27-28, 27f,	see also vector graphics
97—102	adding text to shapes, 197–198, 202f
retouching tools, 3f, 10–16, 23, 103–136, 174	concepts, 190, 200—205
RGB, 45-48, 48f, 54-57, 64, 97-102, 118-121, 129,	Share, 267, 269–271
132-136, 146-147, 210-211	sharing photos on the web, 266-271
Riff, 23	Sharpen, 83, 216—218
rotations, 10–11, 13, 15, 18, 37, 49–54, 112–114, 193f,	Sharpen More, 83
220-221	sharpening, 9, 9f, 25, 75, 80–84, 82f, 94–96, 114,
Rulers, 169–173, 169f, 238	216-218
	shear, 193f
_	Shift keyboard shortcuts, 14, 33, 45, 126, 140-141, 144,
S	145f, 146, 151, 182, 212f, 221, 238
Salt and Pepper filter, 106f, 107—108	Show Selection, 176, 176f
Saturation, 3f, 9f, 20, 25, 45–48, 60–65, 70, 71f, 72–73,	shuffling pixels, 247—248
73f, 77, 92, 99—100, 116—118, 116f, 117f, 120,	Sign In, 267
120f, 134, 172f, 184-187, 210-211	skies, overexposed skies, 150–153
see also Hue	Skin Smoothing, 23
Save, 14-15, 21, 43-44, 48, 107, 144, 147, 162,	skin tones, 135
167—169, 178, 250, 287	slideshows, 19–20
As, 21, 34, 116—118, 127, 285	SLR cameras, 45, 106f
Copy As, 178, 232	Small Scratch Remover, 104–107, 114
Mask to Disk, 178, 179f	Smart Carver, 20, 140, 140f
for Office and Copy Special, 22	Smart Collections, 6, 39, 42-44, 42f, 43f, 44f
Page, 220	Smart Edge, 150
Selection, 147, 162	Smart Photo Fix, 3f, 9, 9f, 19—20, 25, 60—65, 61f, 62f, 64f,
Template, 250—252, 263	66f, 86-93
to Album, 267	Smear Art Media brush, 218–220
saving masks, 178	Smoothing, 138, 150, 192, 193f, 208
scanners, 104—107, 246—247, 253—259	Smudge, 216–218
Scratch Remover, 104—107, 106f, 112, 114	Snap to Guides, 169–171, 169f
scratches, 104–107, 106f, 112–114, 128–131	social networking, 266–271
Script toolbar, 13–15, 13f, 124–127, 126f, 284–285,	see also Facebook; Flickr
287	Social Sharing, 267, 270f
scripting, 13–15, 13f, 124–127, 125f, 126f, 206,	Soft Focus, 84–85, 85f
284–285, 287–288	Soft Light, 95, 218f
Seamless Tiling feature, 15	Soft Plastic, 226f
searches, 6, 18, 37—38, 42—44, 42f, 43f, 44f, 51	'soft proofing', 256f, 257, 258–259
Selection Modification tools, 138–141, 151	Soften, 216–218
selections, 3f, 9–16, 121, 137–162, 174, 184–187, 192,	special effects, 166f, 195—196, 209—244
286	special text effects, 193–196, 206–208
see also Alpha channels; Freehand; Geometric;	Specify Print Size, 34
Magic Wand; masks	Split Channel, 129
step-by-step projects, 139—140, 149—159, 161—162,	spots, 8–9, 104–107, 106f, 128–131
184—187, 206—208	Standard toolbar, 3f, 10, 13, 13f
text, 199–200, 206–208	Standard/Web-safe GIF algorithm, 279—281
Selective Focus, 17, 17f	Status bar, 12

Straighten, 29-30, 220-221 Topography, 14 straightening, 8-9, 12-16, 28-30, 93, 220-221 Trace, 219f Strength, 80-84, 82f, 94-96 transparency, 168-169, 184, 211, 211f, 237-238, Stroke and Fill colors, 200f 281-282, 282f Style, 211, 213f trays, uploading photos to the web, 266-271 submenus, 12, 12f tripods, 155-156 Suggest setting button, Smart Photo Fix, 60-65, TVs, 254 61f type effects, 206-208, 232-236, 284-285 'Sun exposure' preset, Red/Green/Blue, 70, 71f Sunburst, 14, 186 U Suntan, 25 Swap, 211, 211f, 213f underexposures, 45-48, 61, 65, 66f, 77-80, Swatch mode, 210-211, 211f, 219f 153 - 159Symmetric Shape, 200f, 204f Undo feature, 33, 61, 114f, 126, 146, 161, 165, 171, 181, 187 Unsharp Mask, 75, 80-84, 82f, 94-96 Т up-sampling, 250 tabbed workspaces, 19 uploading photos to the web, 4, 266-271, 283-288 Templates, 250-252, 251f USB ports, 4 Use All Layers, 113f, 161 text, 3f, 10-16, 27-28, 27f, 189-208 User Defined filter, 224 see also vector graphics user interfaces, 19 Text Entry, 190-192, 197-198 Text and Graphics, Learning Center, 3f, 10-16, 27-28, 27f Text tool, 189-208, 262 Texture, 196, 211, 211f, 213f, 214f, 215-220, 215f, 217f, vector graphics, 189-208, 284-285, 287 218f, 224, 236 see also Pen; shapes; text... Threshold, 77, 173 concepts, 190, 200-208 thumbnails, 1f, 3f, 5f, 6, 21, 36-37, 36f, 37f, 39-42, disadvantages, 190 49-57, 101, 266-273, 274f step-by-step projects, 206-208 TIFF, 46-47, 167-168, 167f Vibrancy, 20, 173 Time Machine, 23, 23f View menu, 11-13, 170, 210-211 View Source, Internet Explorer, 272-273, 272f Tint slider, 45-48 tinting black and white images, 118-121, 119f, 120f, Vignette effect, 17, 125 121f, 132-136 Visibility toggle, 165, 166f Tolerance, 138, 145-146, 161, 243-244 visible watermarks, 22, 283-288 tonal adjustments, 25-26, 45-48, 64, 74-80, 78f, 115-118, 124-127 W Tool Options palette, 3f, 9-12, 15-16, 20-21, 31, 112-114, 114f, 124, 138, 140-141, 144-146, Warp brushes, 122-124, 124f 149, 151, 161, 174, 177, 190-192, 199-200, 200f, watercolor, 125 206-208, 212f, 215-220, 286 watermarks, 22, 283-288 tool tips, 12, 13f the web, 13, 13f, 15, 32, 218-220, 238-239, 258-259, toolbars, 3f, 8-9, 8f, 12-16, 13f, 37 265-288 see also Effects; Photo...; Script...; Standard...; concepts, 15, 32, 218-220, 238-239, 265-288 Tools...; Web... 'edgy' backgrounds, 238-239 tools, basic tools and functions, 4 Facebook, 18, 266, 269-271, 270f, 271f Tools toolbar, 3f, 9-16, 13f, 29, 32-34, 104-107, 144, Flickr, 17-18, 266-269, 267f, 268f, 269f

GIFs, 15, 274, 279-282, 280f, 282f

JPEGs, 274-281

Toothbrush, 25

186, 190—192, 203—205

privacy issues, 267–269, 283–288
step-by-step projects, 283–288
Web Browser Preview feature, 15
Wet Art Media brushes, 218–220
white balance controls, 45–48, 48f, 60–65, 67–69, 68f, 100
White Balance Temperature, 67–69, 100
Window, 246f
Windows, 37–38, 254–256
Windows Explorer, 4
Word, 22, 167–168

X X-Rite Eye-One Display LT, 258

Yahoo, 267

ZZoom, 79, 90, 92, 104–107

Check us out at masteringphoto.com

MasteringPhoto, powered by bestselling Focal Press authors and industry experts, features tips, advice, articles, video tutorials, interviews, and other resources for hobbyist photographers through pro image makers. No matter what your passion is—from people and landscapes to postproduction and business practices—MasteringPhoto offers advice and images that will inform and inspire you. You'll learn from professionals at the forefront of photography, allowing you to take your skills to the next level.